A PORTRAIT OF LOST TIBET

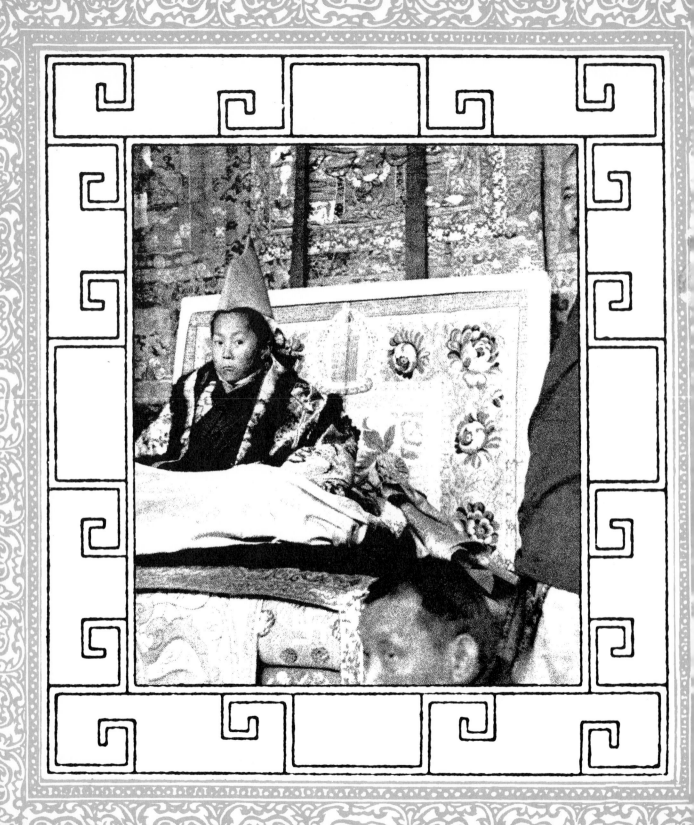

A PORTRAIT OF

LOST TIBET

ROSEMARY JONES TUNG

ORNAMENTAL ART BY ZLATKO PAUNOV

Holt, Rinehart and Winston / New York

Published by Holt, Rinehart and Winston,
383 Madison Avenue, New York, New York 10017.
Published simultaneously in Canada by Holt, Rinehart and
Winston of Canada, Limited.

Library of Congress Cataloging in Publication Data
Tung, Rosemary Jones.
A portrait of lost Tibet.
Bibliography: p.
1. Tibet—Description and travel. I. Title.
DS786.T86 951'.5 79-28406
ISBN: 0–03–050451–1

FIRST EDITION

Designer: Joy Chu
Printed in the United States of America
2 4 6 8 10 9 7 5 3 1

Portions of the text and photographs contained herein are
printed with the permission of Sarah Dolan Price.

TO THE PEOPLE OF TIBET—THOSE IN EXILE AND
THOSE WHO STILL LIVE THERE

CONTENTS

FOREWORD

I first met Colonel Ilya Tolstoy when I was living in a vodka factory
in Kunming in southwest China. Kunming was an air base and sup-
ply depot for the American forces, and most of the American officers
and G.I.'s would sooner or later come to the vodka factory, which
was owned by an extraordinary White Russian called Grigory She-
lestian. The G.I.'s and officers got on well together; Shelestian was
an admirable host except on the rare occasions when he went ber-
serk and threatened to kill people with a meat ax; and life in the
vodka factory was nearly always pleasant and diverting.

Ilya Tolstoy began coming to the vodka factory in the spring of
1945. He was tall, bronzed, impeccably dressed, and he stood out
from all the other officers by a certain refinement of manner. Sheles-
tian, who claimed to have read *War and Peace* seven times, was in awe
of him. "I must do something very special for him," he announced.
"I must give a party for him." Accordingly a superb party was ar-
ranged for him; there were gallons of the very best vodka, suckling
pig and roast pheasant. It was at this party that I learned for the first
time that he had been sent on a special mission to Tibet by President
Roosevelt. He did not talk about the mission at any length, perhaps
because it had been very secret, and he much preferred to talk about
his famous grandfather. He had enjoyed the rigor and harshness of
the Tibetan landscape but had no desire to return. Of his grandfa-

ther he said: "He was always talking about humility, but even though we were children we knew he was terribly proud."

Shelestian was fond of Tolstoy because they could talk Russian together and because the grandfather's shadow fell heavily on the grandson. Whenever Tolstoy appeared in the vodka factory, there was always a wild hubbub of greetings. And if Tolstoy looked like a prince and Shelestian looked like a Siberian peasant, they were happy together. They complemented each other. They were larger than life. On the evening of the party, after all the guests had left, we heard Shelestian running up and down the courtyard and waving his meat ax, shouting that he would defend himself to the death against any Chinese tax collectors who came over the high fortress-like walls.

In that strangely sumptuous house near the north gate of Kunming, with its artificial rock garden and great dining hall, most of us looked like interlopers. Before being converted into a vodka factory, the house had belonged to a local mandarin. He had exquisite taste, which was wasted on the officers and G.I.'s, who came with their empty jerricans and returned to their bases with jerricans overflowing with vodka. All day and all night the sweet smell of vodka hung in the air. Of all the people who came to the factory only Tolstoy looked as though he was at ease in that majestic house. He remained in Kunming for about eight weeks and then vanished, never to return.

I met him for the second time in the pages of this book and in the photographs he took with Brooke Dolan during his extraordinary march across Tibet in 1942 and 1943. The reason for the journey was a very simple one. China was hard pressed by the Japanese, the Burma Road had been cut, and President Roosevelt, studying a map of Asia, came to believe that military supplies could be transported to China over the ancient Tibetan caravan trails. He apparently did not look at a relief map. If he had, he would have seen that transporting supplies to China through Tibet was totally impractical. Nevertheless there were excellent political reasons for sending two highly skilled men to Tibet in order to establish contact with the government of the young Dalai Lama and make soundings

about that government's intentions. It was a time of great danger. The Chinese army was disintegrating; the Japanese were quite capable of thrusting deep into southwest China; and there was the very real possibility that the main bulk of the Chinese army might be forced back to the foothills of Tibet.

In fact Tolstoy and Dolan were sent on a diplomatic mission of considerable urgency and importance. They learned that the Tibetans were fearful of China and in no mood to help. They learned, too, that the Tibetan government was well disposed toward the Americans and to that extent their mission was successful. Ironically, just at this time Generalissimo Chiang Kai-shek was preparing a blueprint for the future expansion of China and he concluded that if by some miracle he would be able to sign a peace treaty with the Japanese, his first act would be the conquest of Tibet. Under Mao Tse-tung the Generalissimo's plan of expansion was carried out.

Today there are no virgin lands. The deserts of Arabia have been crisscrossed by the feet of travelers and pilgrims. The Himalayan kingdoms of Nepal, Sikkim, and Bhutan, once unreachable, are now available to tourists with credit cards, while the mysterious regions of central Africa, once marked on the maps, "Here are tigers," now possess their own skyscrapers and airliners. Today it is possible to fly from Peking to Lhasa by courtesy of the airline of the People's Republic of China. It was not like this in 1942. Tolstoy and Dolan had the luck to travel where no Westerners had ever been before. There were places in Tibet where they came as complete strangers and were welcomed as friends. They were very extraordinary travelers, very well aware that they were entering landscapes where not even Marco Polo had been. They took photographs which admirably convey the strength and sturdiness of a civilization that has now been irremediably weakened by conquest. This is no small glory, for a special grace is given to those who enter virgin lands. Both Tolstoy and Dolan are dead now, but this book and these photographs bring them to life again. We shall not see their like again.

ROBERT PAYNE

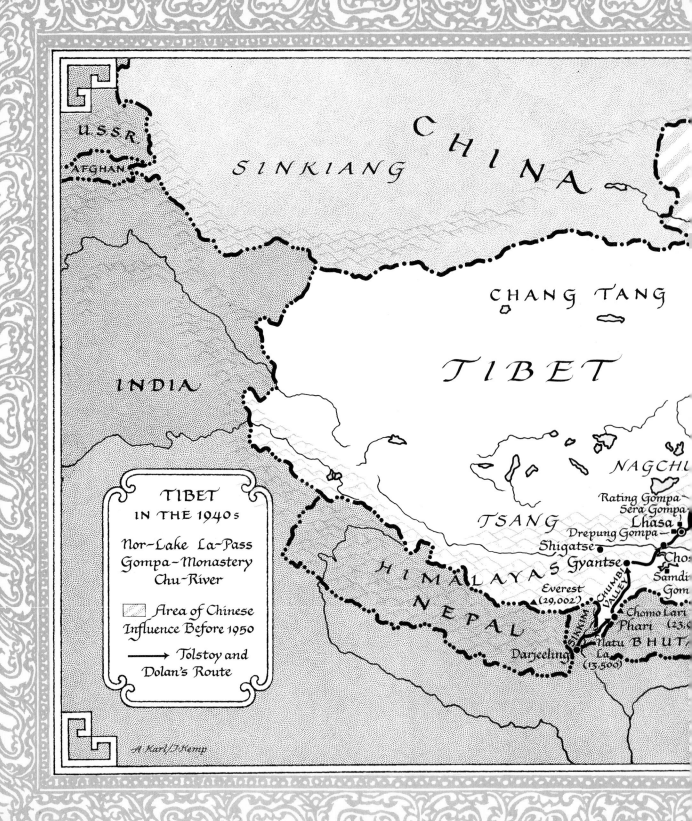

U.S.S.R.

AFGHAN

CHINA

SINKIANG

CHANG TANG

TIBET

INDIA

NAGCHU

Rating Gompa
Sera Gompa
Lhasa
Drepung Gompa
TSANG
Shigatse
HIMALAYAS Gyantse

TIBET
IN THE 1940s

Nor—Lake La—Pass
Gompa—Monastery
Chu—River

Area of Chinese
Influence Before 1950

→ Tolstoy and
Dolan's Route

Everest
(29,002')

NEPAL

Darjeeling

CHUMBI VALLEY
SIKKIM

Cho
Samdi
Gom

Chomo Lari
Phari (23,6
Natu BHUTA
La
(13,500)

A.Karl/J.Kemp

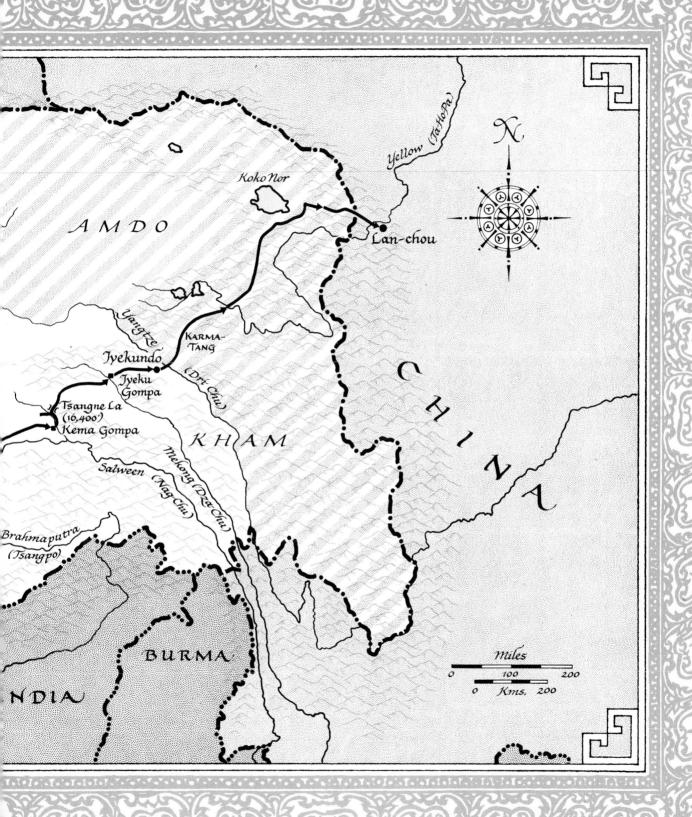

ACKNOWLEDGMENTS

I would like to thank the staffs of the Office of Tibet and the Tolstoy Foundation for their help in locating the original black-and-white negatives of the Tolstoy-Dolan photographs and Brooke Dolan's notebooks; the Dolan family of Philadelphia for their help in researching Brooke Dolan's biography—and especially Sarah Dolan Price for her help and support on every level and at all stages of the project. I would also like to thank Prince Bagration, Countess Catherine Wolkonsky, and Gen. A. C. Wedemeyer (U.S. Army, ret.) for their valuable information about Ilya Tolstoy's life. I would like to thank The New York State Council on the Arts, The Department of Cultural Affairs of the City of New York, and The Staten Island Council on the Arts for the grants received for this project.

For their help in the serious business of scholarly research into matters Tibetan, I would like to thank Braham Norwick, Jean Reiss, Molly McGinty, Jerome Lipani, and Bob Baker; and I would also like to thank the staff of the Wool Bureau in New York City for their help in placing Tibet in the historical development of the wool trade. I would like to thank Luben for finding and printing the photograph of Leo Tolstoy, and Tony Tung for his help with the architecture of Tibet.

And I am deeply grateful to the Tibetans who helped me. To Tsepon W. D. Shakabpa and Dorje Yudon Yuthok, who, with the

help of their daughters Chuki Wangdu and Thopchoe Yuthok as translators, made it possible to identify most of the people in the Tolstoy-Dolan photographs and shed light on the social conditions in Lhasa, their home, in 1942–43. And I am also grateful to Khempo Kathar, once abbot of a prominent monastery in Tibet, who in two interviews helped me understand much about Tibetan religious life.

And many thanks to Mr. and Mrs. Hal Groom in Philadelphia, close friends of Brooke Dolan, who helped me to understand his life. I should like to acknowledge the kind cooperation of the Academy of Natural Sciences in Philadelphia, where the materials relating to Brooke Dolan which I used in writing this book are now deposited.

And finally, thanks to Michael Spozarsky, who printed the photographs and retouched those that needed work; to my editor, Suzi Arensberg, for her help, support, and contribution on the nomads; and, most importantly, to John Ratti and Jerome Lipani for their help in the writing of the manuscript.

INTRODUCTION

Until 1959 Tibet was a place unique in the world. It was called the "Forbidden Land" because visitors from outside, especially Westerners, were not welcome. Furthermore, Tibet's location high in the Himalayas discouraged visitors at the very outset (the country's mean elevation is some fourteen thousand feet.) There were no modern roads, no modern transportation. Tibet was a theocracy. The religion was an unusual form of Vajrayana Buddhism. It encompassed tantric practices and some aspects of the ancient, shamanistic Bön religion prevalent in Tibet before Buddhism arrived in the seventh century. The secular ruler of Tibet was also its religious leader—the Dalai Lama—who was believed to be an incarnation of the country's patron deity.

Although traders had come to Tibet over the centuries and there had been periodic attempts to control the country on the part of outsiders—especially the Chinese—Tibet's rulers had kept their land basically intact over the centuries.

Because Tibet was remote and hidden, it was tantalizing and inspired speculation and romancing of all sorts. Richard Halliburton, the American travel writer, went there in the 1930s and thereafter delighted his rapt lecture audiences with his tales of the Potala and the fabulous child-ruler, whom he claimed he had rocked to sleep. British novelist James Hilton wrote *Lost Horizon*, transforming his conception of Tibet into a never-never land called Shangri-La—a place of escape from the darkening clouds of World War II. The truly amazing thing about Tibet was that it was even more extraordinary in fact than the romancers imagined.

In 1942 the U.S. Army, acting through the Office of Strategic Services (OSS), sent two officers on an expedition to Tibet. They were sent to request permission from the Dalai Lama to transport military supplies across the Tibetan caravan trails that connected British-controlled India and China. The vital Burma Road had been closed by the Japanese, and what supplies could be moved to China had to be flown over the "Hump," as the treacherous air corridor over the Himalayas was called. Never before had heavily loaded transport planes flown at such altitudes—seventeen to twenty-one thousand feet. The mountain passes the American pilots had to navigate were largely uncharted. The planes they flew did not have pressurized cabins, and the crews had to wear oxygen masks most of the time. Sometimes the pilots got lost, and there were no dependable radio signals to get them back on course. The real enemy was not the army of the Japanese emperor; it was nature—the weather and the uncharted mountains. Perilous as the mountain trails across Tibet were, experienced guides knew them, and pack animals could negotiate them. Although the 1942 expedition did not prove to be a diplomatic success, it almost inadvertently gave us an amazing photographic record of Tibetan society as it had been for a thousand years.

President Roosevelt asked Gen. "Wild Bill" Donovan, the head of the OSS, to organize a diplomatic mission to Tibet. He believed that a favorable response from the Dalai Lama might open the way to easing some of the pressure on the men who had to fly the Hump in overloaded, unwieldy planes. Roosevelt had been told that in the past Tibetan guides had actually been able to carry automobiles through the high mountain passes and that they had also transported steel to build a bridge over the Kyichu River outside Lhasa in the same fashion. There was no reason to assume that carrying military hardware from India to China over these same trails would be any more difficult. And certainly the problems involved and the relatively exotic nature of the mission would prove interesting to the OSS—which had the reputation of being a stalwart corps of gentlemen ad-

4

venturers par excellence. (Of course, not everyone in the United States took the OSS seriously. The irreverent had speculated that the famous acronym might well stand for "oh so silly," or "oh so secret," or even "oh so social.") General Donovan chose well—in fact better than he realized—when he asked Ilya Tolstoy, a grandson of Leo Tolstoy, to head the expedition.

Ilya Tolstoy was courageous and experienced as an explorer. He had fought with the White Russian cavalry during the Russian Revolution and, later in life, had led expeditions to central Asia and to Africa. He was also, in a special way, prepared for Tibet and its way of life. As a child he had, with his sister, spent his formative years with his grandfather at Yasnaya Polyana, his country estate (PLATE 1). The elder Tolstoy was profoundly interested in teaching children. He believed they should come to terms with nature and poetry, which he believed formed the foundation of religious thought. He also believed, as did the Tibetans, that students should begin early to develop their inner lives. And perhaps even more to the point, he believed that living was intertwined with, and even synonymous with, religious experience. Ilya and his sister had the benefit of their grandfather's educational theories and of the instructive tales he wrote for children.[1] It seems unlikely that the adult Ilya would have forgotten his grandfather's lessons when he went to Tibet. They had certainly helped prepare him to understand and to document quite sensitively the way of life he found there.

When Tolstoy was asked to choose a man to accompany him on the expedition, he immediately selected Brooke Dolan—a natural choice. Dolan was well educated (he had attended both Princeton and Harvard), perceptive, and an experienced explorer. He had already led two expeditions for Philadelphia's august Academy of Natural Sciences to the Kham and Amdo regions of eastern Tibet (an area which even then was partially controlled by China). He brought back several rare specimens from these expeditions, including a giant panda and a Tibetan takin. His takin specimen—the takin is a ruminant, a rare relation of the goat—is still the only such specimen in the West. Both panda and takin remain on exhibit at the academy.

Brooke Dolan's interest in Tibet was not confined to rare animals. He spoke several Tibetan dialects and had a personal library of most of the available written material on Tibet. Tolstoy reported in an article he wrote about the expedition that when their party reached the Tibetan monastery of Samden Gompa, "Brooke impressed even the monks with his knowledge of the images, which he recognized at a glance. I explained that he was a student of the Buddhist religion. Thereafter, this fact became known wherever he went and gained for our party a scholastic and religious aspect."[2]

In September 1942 Ilya Tolstoy and Brooke Dolan and their party left New Delhi carrying hundreds of pounds of equipment, as well as ceremonial gifts from President Roosevelt for the Dalai Lama (PLATE 2). They would go up through Sikkim and into Tibet. It would be a rare adventure for both men, though in retrospect it seems amazing that Washington entertained any hope of success on the diplomatic level. In a reading of even the most basic Tibetan history, one learns that since the beginning of the Ching Dynasty in China (1644), the aim of Tibetan foreign policy had been disassociation from China. Tibet did not want to be considered part of China, no matter how often the Chinese assured anyone who would listen that it was. It should have been clear from the start that Tibet would never break its traditional policy of remaining aloof from entanglements to allow supplies for China's war with Japan to be transported across Tibetan territory.

But whatever the Tibetan government may have thought about the nature of the American mission, it had nothing against the United States. All the Tibetans the Americans encountered, including government officials, were gracious and obliging hosts. And the visitors were men well prepared to appreciate what they found in Tibet—a society, for all the romantic speculation about it, almost unknown to the modern world.

Although their diplomatic mission was to fail, Tolstoy and Dolan did not come away from Tibet empty-handed. In the ten months it took them to cross Tibet—from the Sikkim border, through Lhasa the capital, to the northern border with China—they took over two thousand black-and-white photographs. These photographs consti-

tute the best pictorial study of Tibetan civilization in existence. Using 35-millimeter cameras and both pioneer Kodak 35-millimeter film and other film as well, Tolstoy and Dolan documented a society in all its aspects—a society that today is only a memory. Although neither man was a professional photographer, both showed considerable taste and sensibility. As for the artistry of the work, the photographs show good composition and a creative use of vertical and horizontal formats. They also had a good knowledge of exposure and of the conservation of film.

Brooke Dolan died in Chungking in 1945, still in the service of the OSS. Ilya Tolstoy lived on and continued for a while in government service. In 1945 he headed a top-secret mission into the interior of China in search of uranium. Eventually Tolstoy returned to the United States—to New York. For the rest of his life (he died in 1970) he carried on a correspondence with the Dalai Lama. When Tibet was invaded by the Chinese and many Tibetans were forced to flee, Tolstoy persuaded the Tolstoy Foundation (then headed by his aunt Alexandra Tolstoy) to break the precedent of helping only Russian and East European emigrés in order to aid Tibetan monks and students. Tolstoy also helped establish the Tibetan Foundation in the United States.

In 1942–43, the years of the Tolstoy-Dolan expedition, there were approximately five million indigenous Tibetans, two million of whom lived in Tibet proper. This Tibet is no more. The Tibetans in exile, from Dharamsala in India, where the Dalai Lama lives, to New York, where there are Tibetan lamas teaching the practice of their religion, must now confront the modern world. If the romantic Shangri-La is really just a state of mind, then it has moved closer to us with the arrival of those exiles into our world. But if the ideal Shangri-La could only exist in one small state in the Himalayas—then it is indeed lost forever. These photographs do not show the romantic fiction but the truly amazing fact of the place that was.

7

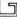

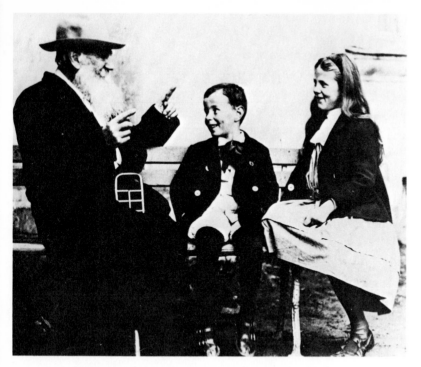

PLATE 1. *Ilya Tolstoy, about five, and his older sister, Sophie, with Leo Tolstoy, as he told them one of his instructive and amusing tales for children entitled "The Cucumber."*

PLATE 2. *Brooke Dolan (second from left) and Ilya Tolstoy (right) with their monk-interpreter, Kusho Yonton Singhe, standing in front of a traditional Tibetan tent set up outside Lhasa for the expedition's official greeting ceremony.*

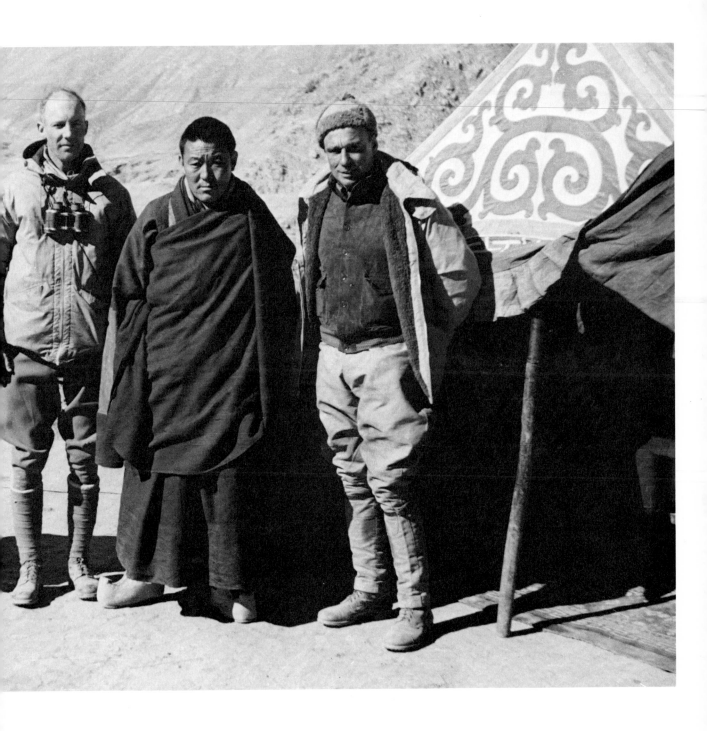

THE ENVIRONMENT

Landscapes at the Top of the World

Tibet is very beautiful. It is not a barren, frozen wasteland. For centuries otherwise well-informed people would have sworn that it was a wasteland. Even the occasional traveler or explorer who actually reached some portion of Tibet was more likely than not to deepen the confusion by describing only the small corner of the country that he had seen and assume that it all looked the same. The reason for the confusion is simple: the policy of the Tibetan government was to limit the number of people visiting Tibet or traveling widely within its borders, and the isolation of the country was and is a natural limitation to travel there.

It is largely the borders of Tibet that have earned the whole country the reputation of bleakness. The Himalayas, the world's highest and most forbidding mountains, form the country's southern border; the rugged Karakorams form the western border; and the great Chang Tang, a wilderness of mountain spurs, glaciers, and swampy marshes uninvitingly laced with quicksand, forms the northern border. The Takla Makan Desert lies beyond that. Thus, it is to the east, toward China, in an area of rolling hills and deep valleys, that Tibet is the most approachable.

The great surprise—and contradiction—of Tibet is the central plateau. There are secluded valleys and fertile farmland. Lhasa, the capital, is on the Tibetan Plateau. Lhasa has the same latitude as

Cairo, but because of its elevation the temperatures rarely exceed seventy-four degrees Fahrenheit. And although some early travelers called Tibet the Land of Snows, Lhasa has little snow, and in the winter the temperature rarely goes below fourteen degrees Fahrenheit. Lhasa and the surrounding countryside are wooded. There are fine willows, walnuts, and birches. Gardens and parks surround the city, and in the early summer months an annual custom of a long, communal picnic was observed—families would pitch tents in the parks and for more than a week celebrate the lovely, gentle season with elaborate feasts, games, and sports contests. All Tibetans come of nomadic stock, and this festive event was probably a reflection of that past.

The landscape of Tibet has great variety. There are indeed white mountain peaks standing against clear, blue skies. But there are also large lakes and plains of grass where yaks feed—in winter, by scratching away the ice if necessary. In the northern area of Amdo, the nomad peoples who move their tents seasonally to better grazing land have a genius for survival in the extremes of land and climate that surround them. Not surprisingly, the nomads are a larger and tougher people than the city dwellers of Lhasa.

It is possible to imagine that the special, interior character of Tibetan religion, with its deep awareness of life, was shaped, in part, by the startling and inescapable beauty of the country.

The Tolstoy-Dolan expedition was able to document a wide range of Tibetan landscapes because it was freer to move about and see more of Tibet than most expeditions.

On October 22, 1942, the expedition entered Tibet, coming over the crest of the Natu La, a high Himalayan pass linking Tibet and Sikkim. Tolstoy and Dolan had crossed into another world. As they were to learn later, it was a world so totally isolated that even cabinet ministers in Lhasa assumed the earth was not round but undeniably flat; they would not be persuaded otherwise.

The expedition, as its members soon discovered, had not entered an empty wilderness. They passed a mule caravan carrying Tibetan potatoes into Sikkim over a trail that was bordered with wild rhododendrons. Later in the day they were met by the headmen of the town of Yatung, in the valley of the Amo-Chu. In Tibet it is the

custom to go out and meet travelers as they approach a town and escort them in. Later, when travelers are ready to leave a town, they are usually escorted by townspeople for at least five miles. When Tolstoy and Dolan reached Yatung they were given ceremonial Tibetan greeting scarves, called *katas*. These were white silk scarves with long fringes; they were usually placed around the necks of visitors. Later, when Tolstoy and Dolan came to Lhasa, they presented a *kata* to the Dalai Lama.

After leaving Yatung, the expedition crossed the Tromo Valley and passed by the barley-growing village of Galinka. Then they entered the upper Chumbi Valley. Here they saw wild yaks grazing on the plain in the shadow of the huge mountain called Chomo Lari, which means "Queen of the Snow" (PLATE 3). It is almost twenty-four thousand feet high. The wild yak, or *Bos grunniens* ("grumbling ox"), is indigenous only to Tibet. The shaggy black animals can graze on the short, fine grass that grows at elevations of seventeen thousand to twenty thousand feet few other animals can. As the expedition went on, it passed spectacular peaks and even learned some Tibetan folklore about them. Brooke Dolan wrote this in his diary: "Ascending the Ralung Chu, in the middle of the afternoon we found a snowpeak in the V of the valley ahead. Subsequently, it was screened by intervening ridges but emerged in full grandeur as we rode up into the wide basinland at Ralung. The Tibetans call the mountain Ningchi Kongsar and hold it sacred. They say it is the male to Chomo Lari's female and visits her at night. A black spot on the Ningchi Kongsar is the smudge put on his nose by Chomo Lari on his wooing nights."[3]

On October 28 the party came upon one of the most beautiful places in Tibet—Rham Tso ("Otter Lake")—where the mountains are reflected in the clear, cold water (PLATE 4). In Tolstoy's description, " . . . the deep blue waters reflect for miles the Himalayan range beyond, with the vast mountain Chomo Lari towering over it. There was a little ice along the shores of the mirror-calm lake. Thousands of bar-headed geese lined the shore, and flocks of ruddy sheldrakes, or Brahmany ducks, were filling the air with a moaning cry."[4]

On October 30 the expedition passed another caravan. This one

was carrying wool and marmot hides to India. On November 1 they saw the classic, tiered chortens of Siling Gompa, an ancient monastery (PLATE 5). The chortens were actually giant reliquaries, sometimes holding the actual remains of holy men but quite often containing just the intimate possessions of the dead man—sacred books that had belonged to him or some often-used utensils, such as a plate or a cup. The chortens were often built on high points near the monasteries. They were reminders, with their spires, of the transcendence from earth to ether, and of the triumph of the spirit over worldly attachments, symbols of Buddhism's goal of release from the material world and its suffering.

Ilya Tolstoy and Brooke Dolan spent the month of November in Gyantse, Tibet's fourth largest city. It was a center of Tibet's wool industry. Wool was and is one of Tibet's main industries. Sometimes it was woven into cloth or rugs for export; sometimes it was exported as a raw material. Gyantse is surrounded by fertile plains that are ideal for grazing sheep (PLATE 6).

Soon the expedition was nearing Lhasa. But before they came to the city they had to cross the widest river in Tibet, the Tsangpo. The Tsangpo flows into India, where it is called the Brahmaputra. The high country of Tibet is actually the source for many of the great rivers of Asia—the Yangtze, the Mekong, the Yellow River, the Salween, the Irrawaddy, the Indus, and the Sutlej, among others. On December 10, 1942, the party crossed the Tsangpo near the town of Chosul (PLATE 7).

On December 11, Tolstoy, Dolan, and their guides were met by an official reception party at a small park outside Lhasa called Genza Lubting. They spent three months in Lhasa before they continued their unprecedented tour of Tibet. When they left Lhasa on March 19, 1943, they were given a farewell party in another garden—this time the garden of a villa three miles west of the city.

On March 23 they arrived at Rating Monastery, one of the most significant religious institutions in Tibet (PLATE 8). Rating was founded in 1056 by the Indian pandit Atisa. Atisa had come to Tibet in 1042 and remained to teach the form of Buddhism he had learned in the great universities of northern India. These universities were

16

destroyed by the Mogul invaders of India not long after Atisa left. But the Buddhist doctrine they had taught remained pure and intact in Tibet.

Rating was still a significant place in 1943. It was the monastery of the man known as the Rating Regent. The regent had acted for the Dalai Lama until the young incarnation was found and established on his throne. In the center of Plate 8 is the regent's palace. Rating was situated in a park that provided a sanctuary for wild creatures. Pheasants roamed in flocks along the walks and paths that connected the monastery buildings.

After leaving Rating, the expedition had to face some of the roughest terrain it would encounter, along the old trade route to China by way of Jyekundo and Lake Koko Nor (PLATE 9). This was the same route that the four-year-old Dalai Lama had traveled to reach Lhasa and his throne in 1939. They soon met a tea caravan coming from the opposite direction. The caravan's pack animals had been decimated by the weather they had encountered on the trail. Of a thousand yaks, only seven hundred had survived. Of twenty-five ponies, only fifteen had survived. The winter of 1943 was unprecedentedly harsh, and even in April, as the Tolstoy-Dolan party continued along this same trail, there were severe blizzards. One such occurred on April 24, on the ascent of Tsangne La, a pass more than sixteen thousand feet high (PLATE 10). The yaks sank belly deep into the snow.

The Tsangne La was at that time the political boundary between Tibet and China. China had gradually gained control of a large portion of the Kham and Amdo regions, starting in the seventeenth century, although the population remained indigenously Tibetan and lived the Tibetan style of life. Because of this cultural proclivity, scholars traditionally have treated this region as Tibetan.

By April 30 the expedition was on its way down through the Melo La, a pass that was almost as high as Tsangne La and had equally bad weather. Even in the snow and high winds, the party displayed the American flag, and after crossing into the Chinese-controlled province of Amdo, they displayed the flag at all times (PLATE 11). It is not certain why they did this aside from patriotism.

17

The party may have wanted to identify themselves in case they encountered Chinese troops.

On May 3 they reached one of the tributaries of the Dri-Chu River (in China the river becomes the Yangtze). The party had to ford the river—pack animals and all. However, by comparison with climbing mountain passes in blizzards, this probably seemed like child's play. The river ran through the countryside the Tibetans called Karma-Tang, which means "Plain of Stars" (PLATE 12).

On May 6, as they passed the small chorten of the Dsogchen Gompa Monastery, they saw a large pile of *mani* stones (PLATE 13). Tibetans believed that a *mani* stone left behind near a monastery would continue the prayer after the pilgrim had left.

As they neared the border of Amdo they had to cross one last river, the Ta-Ho-Pa (PLATE 14). The valleys that preceded the crossing were magnificent. Brooke Dolan wrote: ". . . The Ta-Ho-Pa is flowing at 11,000 feet, 450 feet below the level of the plain between spectacular escarpments. . . . The trench and slopes of the Ta-Ho-Pa—representing a different plant and animal zone—is a botanist's and zoologist's paradise. The flowers and shrubs which we can appreciate but not identify are legion. Laughing thrushes, blue-eared pheasants, jackdaws, pigeon, wagtails are obvious but there are dozens of other species."[5]

The record Tolstoy and Dolan made of the Tibetan landscape shows convincingly what diversity and beauty there was in the country. The photographs also show the serene, almost meditative quality of the Tibetan landscape, where there is a calmness in even the most perilous chasm, and a sense of infinite peace in the great mountain vistas.

Tibet's Unique Architecture

Like many other things in Tibet, the architecture is unique. It contributes prominently to Tibet's identity as another world, and it is wedded closely to the terrain and climate of the country.

The technical word that describes Tibet's architecture is *geomorphic*—growing from the physical factors that shape life. Technologically, the Tibetans did not progress beyond the basic concept of piling up stone walls so that the bottom of the wall is wider and thicker and can support the weight of what is built on top. The walls of Tibetan buildings slope inward. All early architecture, from the pyramids of Egypt to the ziggurats of the Middle East, uses this basic principle. However, the country's location and climate coupled with the uncanny sensitivity of the Tibetans to their environment led to the creation of an architecture that embodies the spirit and feeling of Tibet.

It is impossible to discuss any aspect of Tibetan building without mentioning the Potala, the Dalai Lama's palace in Lhasa and the crowning achievement of Tibetan architecture. The early central portion of the Potala was painted red. Red is a color that absorbs heat in the winter and sheds it in the summer. The general characteristic of the Tibetan climate is that it is cold at night, and, in the summer, warm in the day. Stone walls tend to collect heat in the day and gradually release the heat at night. Following the same principle, the windows of Tibetan houses, which are often merely narrow openings in a thick, stone wall, prevent the summer sun from entering the building when the sun is high in the sky. In the winter, when the sun is low in the sky, the rays can penetrate the windows and help make the rooms warmer.

Tibetans developed the post-and-lintel system of building used by many other societies. This meant that if they wanted to build a large interior space, they had to support it with columns; they had not developed the vault. Because of this, all interior spaces in Tibetan buildings were divided into smaller spaces that were either partitioned off into rooms or contained in some other way within a large, columned hall. But the lack of ample, interior spaces didn't inhibit the large gatherings that were so much a part of Tibetan religious and social life. Because the Tibetan climate is basically mild, with little precipitation in many months, large gatherings often were held in open courtyards.

More than any other factor, it is the form of the mountains that

dominate Tibetan building. The buildings grow out of the mountains—in the case of the great Potala, quite literally.

It is only the chorten, the reliquary building, that is borrowed from another culture. It came, along with the inspiration for Tibetan Buddhism, from India.

Phari, one of the first towns in Tibet visited by the Tolstoy-Dolan expedition, was a typical Tibetan town in many respects (PLATE 15). The ever-present group of yaks stands just beyond the houses. Although there were some one-story houses, most were two stories, built around an interior courtyard. An ancient fortress built in the classic Tibetan style dominates the town. In a community like Phari—in fact, in most Tibetan towns and cities—one of the main concerns of domestic architecture was the creation and preservation of heat. Wood always had been in short supply in Tibet, and dried yak dung was the most readily available fuel.

The houses had flat roofs, which were practical because much of populated Tibet had little lasting snow. They were used for the drying and storing of firewood and other fuel, and for storing fodder for the domestic animals. (Tolstoy and Dolan also noted that flat roofs were used for sunbathing and, quite openly, for lovemaking in warm weather.) In many of these houses it was customary for the family livestock—especially in winter—to be quartered on the first floor of the house and for the family to occupy the second floor. The heat from the bodies of the animals would rise and help heat the second floor. Since glass was rare, and expensive, the windows of most houses were covered with white cloth in winter to keep in the heat but allow some light to penetrate.

In Lhasa, Tolstoy and Dolan visited the Tsarong family, one of the three wealthiest families in Tibet. They lived in an elegant house that was quite different from most of the simple dwellings of Phari (PLATE 16). There was real glass in the windows—and there were a lot of windows. Although there was never any need to cover the windows here with fabric to preserve heat, fabric nevertheless was used as a part of the architecture, as it is in all Tibetan buildings. The Tsarong house had two rows of elegantly pleated awnings, with intricate colored designs in the fabric. Like all Tibetan houses, the Tsarong house was painted white. The window frames, whose tra-

20

ditional shape mirrors the basic form of the building, are painted black. All Tibetans are enthusiastic gardeners, and rows of potted plants were common to every Tibetan house. The Tsarong house was as opulent in plants as it was in glass windowpanes.

Although it is an architectural import, the chorten is one of the most familiar buildings in the Tibetan landscape. It comes in all sizes and degrees of sophistication in detail and execution, but the familiar silhouette, that of the ancient Indian stupa, remains constant. The original Indian stupas upon which the chorten is based were large, hemispheric domes with openings at the top. As a mark of respect for the holy relics contained within them, Indian kings would place their ceremonial wooden umbrellas (potent symbols of rank) over the roof openings. It was considered a major crime to disturb a royal umbrella, so this gesture also discouraged vandalism and looting. Gradually, so the story goes, as more kings placed their umbrellas one on top of the other over the stupa, the conical rings they formed became an integral part of the architectural shape. By the time the chortens were built in Tibet, the convention was established. There were usually thirteen rings, representing the thirteen stages of advancement toward Buddhahood. The entire structure, including the square base, represents the five elements: earth, water, fire, air, and space. The top of the chorten is crowned with sun and half-moon forms. The sun represents wisdom; the moon, compassion. The sun and moon forms are said to unite at the moment of achieving enlightenment. Enlightenment is synonymous with becoming a Buddha.

The gateway to Lhasa is a large chorten built over a thousand years ago. It is called the Pargo Kaling and contains the relics of the Buddha Mindukpa (PLATE 17). It retains some of the original hemispheric shape and the conical top is gilded.

The Great Chorten of Palkhor Choide Monastery at Gyantse is one of the most beautiful buildings in Tibet (PLATE 18). It was built in the fifteenth century. It contains an important series of painted frescoes in its interior, but it is richly painted and detailed on the outside as well. The painted eyes are said to represent the eyes of the Buddha looking in all directions in his concern for mankind.

The chorten at Rating is much simpler and much more primi-

21

tive than the elegant Great Chorten of Palkhor Choide. It is also more typical of Tibet's chortens (PLATE 19). Pilgrims to Rating Monastery considered it a valuable religious practice to walk around the chorten, going clockwise with their right shoulders toward the building.

Not all Tibetan architecture is religious. The Tibetans were once a nation of warriors. The Gyantse Jong, the commanding citadel of the city of Gyantse, is considered by many people to be the most impressive of the Tibetan fortresses (PLATE 20). Like the best Tibetan architecture, it seems to grow out of the hill it crowns. The total structure of hill and citadel is called the "Dragon's Back." In fact, the whole city of Gyantse is beautifully wedded to the land. The flat roofs of the houses reflect the contours of the plain.

No discussion of Tibetan architecture would be complete without mentioning the unique architectural contribution of the nomads, who comprised about half of the country's population. The nomads were referred to as the "people of the black tents." Their tents were woven from the black belly hair of yaks and usually measured about thirty feet square and six to seven feet high at the center. Pitched-roofed with a flattened area on the top and movable side flaps, they resemble Bedouin tents far more than they do the rounded yurts of the Mongols. In fact, the Tibetan nomads have always been very proud of the unique design of their tents. Although Tolstoy and Dolan did not make a photographic study of this most basic Tibetan dwelling, they saw evidence of "tent architecture" everywhere they went. Ceremonial tents were set up to receive visitors on open ground; tents were used in the parks for the spring festival; and the tent shape was ultimately reflected in the cloth enclosures of pavilions (e.g., Plate 22).

The Potala is one of the greatest masterpieces of world architecture (PLATE 21). It began as a fortress in the seventh century and was completed by the Great Fifth Dalai Lama in the seventeenth century. The Fifth Dalai Lama actually died before his plan for the completion of the building was quite realized. His minister managed to keep the fact of his death hidden for seven years until the building was finished.

No traveler who has recorded his first view of the Potala has been left unmoved. One traveler wrote: "It was January 15, 1946, when we set out on our last march. From Tolung we came into the broad valley of Kuichu. We turned a corner and saw, gleaming in the distance, the golden roofs of the Potala—the most famous landmark of Lhasa. This moment compensated us for much. We felt inclined to go down on our knees like the pilgrims and touch the ground with our foreheads."[6]

Another traveler recorded this impression: "As we advanced, the Potala grew larger and larger. Now we could discern the elegant outlines of its many golden roofs. They glittered in the blue sky, sparks seeming to spring from their upturned corners, as if the whole castle, the glory of Thibet, had been crowned with flames."[7]

The Potala was the Dalai Lama's winter palace and the seat of his government. In the summer, however, he lived in the Norbulingka, which means "Jewel Park." There are many pavilions, lakes, and gardens in the Norbulingka, all surrounded by a high wall. When Tolstoy visited there, he took a picture of the Lukhang, the Temple of the Serpent Demi-Gods (PLATE 22). This pavilion was said to be the Dalai Lama's favorite. In the doorway you can see a cloth covering for winter.

The major religious building of Lhasa was called the Jo-kang, situated in the center of the city. It was built by one of the ancient kings of Tibet, Srong-tsen-Gampo, in the seventh century. It was here that the major ceremonies of the winter prayer festival were held. It is said that the king's Chinese wife had a dream establishing the place where the edifice should rise. Many goats had to carry landfill for a very long time before a building site was created. On the top of the Jo-kang are four golden chapels (PLATE 23). They honor the patron saint of Tibet, Avalokitesvara; the Buddha; Maitreya, the Buddha to come; and the builder-king, Srong-tsen-Gampo.

As Tolstoy and Dolan left Lhasa and traveled northeast, they began to see a more rustic style of Tibetan architecture. On April 19, 1943, they passed a Bonpo cloister called Trachen Gompa (PLATE 24). This was an outpost of Tibet's ancient Bön sect, the country's indigenous religion. The shamanistic cult adopted the basic tenets of

Buddhism when it arrived in Tibet but continued some of the old magical practices as well. There are prayer flags on the pole in front of the cloister. Tibetans believe that the prayers they write on these flags are repeated by the wind—all nature entering into the celebration of Tibetan religion. One of the unusual practices of the Bön sect is that—unlike traditional Buddhists—they rather willfully carry on all their religious practices counterclockwise.

In May, when the expedition stayed in Jyekundo, Brooke Dolan photographed the Jyeku Gompa, one of Tibet's great monasteries (PLATE 25). The major temple roof is in the foreground. It was painted blue with red and white stripes. The Sakya sect that built the temple was reflecting its devotion to the deity Dorje Phagmo when it used this color scheme. The god was said to have three faces—the middle face, blue, and the flanking faces, white and red. The cells of the monks ascend the hill beyond the temple. This was a typical Tibetan practice. Often whole villages were built on hillsides, since the fertile terrain of the valleys had to be preserved for agriculture whenever possible.

With this combination of practical concern and religious intensity, the Tibetans created an architecture that blends with the landscape in a way not often found among other cultures. They saw their world as a whole, and their aim was to keep it organic and harmonious. The great twentieth-century architect Frank Lloyd Wright saw this special passion in Tibetan architecture, and it became part of his own credo. A photograph of the Potala was the only picture of a building other than his own in Wright's famous studio in Oak Park, Illinois. A student of Wright's recalls, "I well remember the large, aged photograph of the Potala in Lhasa which hung in Mr. Wright's study . . . I feel certain that the photograph of this remarkable building had a profound influence on Mr. Wright's work. . . ."[8]

The Art of Tibet

The Tibetan philosophy of art was part of the fabric of national life and all of it was religious art, expressing the living reality of Bud-

dhism as it was realized in the lives of the people. Although the art of Tibet was highly sophisticated, it was essentially contained or expressed in two forms: gilded bronze sculpture and paintings called *tankas*. *Tanka* is the Tibetan word for "banner." When the paintings were finished they were traditionally mounted on silk brocade panels—or banners. There was a pole or batten at the top and the bottom of the *tanka*. When the painting was not hanging, it could be rolled and stored away—scroll-fashion. A certain number of *tankas* had significance at specific seasons of the year and were taken out just for those seasons. *Tankas* were also used by itinerant lamas to sanctify the tents in which they held discussions of Buddhist doctrine.

Most Tibetan art is anonymous. Like much else in Tibetan life, this custom of anonymity was grounded in religious belief. Buddhism has a strong concept of the lessening of the individual ego. The Buddhist attitude toward a work of art is that when it is successfully completed, it has an existence of its own and an inherent power to help the viewer come to spiritual realization. It ceases to be the property of the artist when it leaves his worktable or easel. There have been, however, some artists in Tibetan history whose work is identifiable as theirs because of its special excellence and recognizable style of execution.

During the military conquests of the ancient Tibetan warrior kings—conquests that extended into western China, central Asia, Nepal, and eastern Afghanistan—artists from the subjugated areas came to Tibet and were influenced by Tibetan styles. At the same time, they influenced Tibetan art with expressions of their national styles.

Early in their travels, Tolstoy and Dolan made a side trip to see the pre-thirteenth-century temple of I-Wang. Here there were stucco sculptures of both the Buddha (PLATE 26) and of Bodhisattvas. (Bodhisattvas are beings who have reached enlightenment but instead of entering Nirvana re-embody in order to help others gain their spiritual state; in Tibetan Buddhism it was believed that anyone could approach a Bodhisattva and ask for help.) The sculpture of the Buddha at I-Wang has the soft folds of silk *katas* draped over its hands. It is known that artists from Khotan, a subjugated area of

25

western China, had come to Tibet in the days of Tibetan expansionism, from the seventh to ninth centuries (PLATE 27).

The garments of the Bodhisattvas at I-Wang are definitely in the Khotanese style and the folds in the garments have what is known as the "water-ripple effect." When the Buddha was alive in the fourth century B.C. he expressly forbade artists to make images of him. An artist was said to have seen the Buddha sitting by the Ganges in Benares and was deeply moved. He couldn't resist drawing the Buddha's image in some way and so he rationalized that if he drew the reflection of the Buddha as it appeared in the rippling waters of the Ganges, he would not be breaking the injunction against making images.

Just as actual cloth is integrated into Tibetan architecture, so it enters into art. The use of cloth in Tibetan art does not stop with the mounting of paintings on silk brocade to make *tankas*. The metal surfaces of bronze and other sculpture also are softened in special ways with cloth. The striking seventeenth-century bronze image in Lhasa's Drepung Monastery is devotedly dressed in costly clothing of silk brocade (PLATE 28). It was customary at the New Year for wealthy families to donate these ceremonial garments.

The juxtaposition of cloth and metal is seen in a different way in the Dalai Lama's private chapel in the Potala. There is an eight-foot silver image of the Bodhisattva Avalokitesvara (PLATE 29). The Dalai Lama is believed to be an incarnation of this Bodhisattva. The baroque quality of the great silver image is both tempered and enhanced by the traditional *katas*, draped and placed in front of it as offerings. The image was lit by a silver butter lamp, an ornately carved vessel resembling a large chalice that was filled with semi-liquid yak butter and equipped with a floating wick. Lamps like this were the only illumination for Tibetan temples.

The silver image, made for the Thirteenth Dalai Lama of metal given by the Buddhists of Mongolia, is shown with multiple heads and arms. This was a common expression in Buddhist art. The Bodhisattva Avalokitesvara was known as the Compassionate Lord who looked down on the suffering of humanity. Legend has it that as he looked down, his compassion was so great that his body broke

into many pieces. The fragmented deity was said to have been reassembled by the Amitaba Buddha, but with eleven heads and a thousand arms—all the better to help the suffering masses of humanity.

Although all Tibetan art is religious, not all of it is *in* temples and holy places—some of it is literally *on* them. The ornamentation on many buildings in Tibet goes far beyond the category of decorative architectural detail. Some of it is fine sculpture in itself. The gilded bronze sculpture on the roofs of the four golden chapels of Lhasa's Jo-kang was typical of the best of this work (PLATE 30). The roofs were outlined with hundreds of small bronze effigies of deities, and even the waterspouts were in the form of beautifully carved animal heads called *makras*.

The religious life of the Tibetans often transformed natural objects and even the landscape into works of art. The piles of *mani* stones left near monasteries and holy places became a part of the landscape, certainly. But in some places they took on a more involved, almost sculptural character. Ilya Tolstoy was especially struck by the *mani* stones he found at the monastery of Kema Gompa (PLATE 31). No foreigners, before the arrival of Dolan and Tolstoy, had ever been to Kema Gompa. But many Tibetan pilgrims had been there before them. Tolstoy estimated the number of *mani* stones in the millions. They were often whitewashed so the carvings on the stone would stand out in relief. The prayers are called mantras and are assigned to religious aspirants by their spiritual teachers—in the case of Tibetans, by lamas. Many stones among the great collection at Kema Gompa were inscribed with the most famous of mantras—Om-Mani-Padme-Hum. This is often translated as "the jewel in the lotus." The words of the mantras when correctly chanted form a musical sound. And they purportedly can alter metabolic functions and states of mind. When collected in the form of stones, the prayers created a holy sculpture in the Tibetan language.

The Tibetan sensitivity to the special character of cloth did not stop with their use of it as a complement to architecture and sculpture. Sometimes they made beautiful and original ceremonial costumes from cloth. In these costumes various fabrics were used, often

in intricate combinations, with great emphasis placed on the juxta-position of different textures and rich colors. Once, Tolstoy and Do-lan saw the traditional Black Hat Dance. In it the monk dancers wore elaborate costumes of Chinese brocades appliquéd with tradi-tional Tibetan designs (PLATE 32). The black-hat headdress was a sculptural construction in itself. The body of the hat was felt wrapped in black velvet. Atop the hat was a papier-mâché construc-tion featuring two snakes guarding a precious jewel. The monk who wore the costume became a living work of art as he moved through the ritual telling of an ancient story.

The Tibetan flag was alive with symbolic design and intricate combinations of brilliant color (PLATE 33). Two snow lions hold the traditional wheel of Buddhism. There is a white triangle to repre-sent a snow mountain and above that a rising sun design with twelve stripes of red and blue, both colors rich with symbolic meaning for Tibetans. The flag has a yellow border which repre-sents the ruling order of Gelukpa monks—the order of the Dalai Lama himself. He is also a titular leader of the country's three other monastic orders.

And there are the butter sculptures—large constructions some-times reaching three stories in height—that were carried on the fifteenth day of the feast of Monlam (PLATE 34). Actually the com-plex sculptures were not made entirely of butter. They were con-structed on frames of leather and wood. The decorations and images made of barley-flour-and-butter dough were applied to the frame-work and then painted. These phantasmagoric constructions took months to make and they were destroyed on the day after the festi-val. The symbolism behind this act was based on the Buddhist be-lief that all things, even those we most cherish, have only a temporary existence in this world.

It is almost impossible to imagine the scene Tolstoy and Dolan witnessed on the fifteenth day of the feast of Monlam. It was a ceremony of lights. The street that encircled the great temple, the Jo-kang, was lit, even in the dead of night, with thousands of small lamps—lamps filled with yak butter. The sculptures moved around and around the Jo-kang, bobbing and weaving with the

movements of the monks carrying them. The people crowded through the streets, following the fantastic sculptures, all through the night. And at a window high up in the Jo-kang, the young Dalai Lama watched. He could not join the crowd because it would have been improper for anyone to stand on a higher level than he stood.

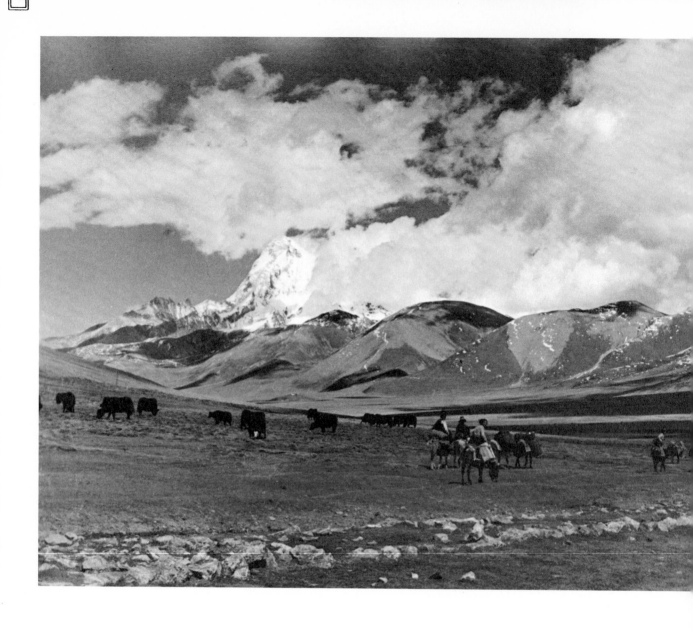

PLATE 3. *Wild yaks grazing on the plain. Chomo Lari is obscured by clouds.*

PLATE 4. *Chomo Lari reflected in the mirrorlike surface of Rham Tso.*

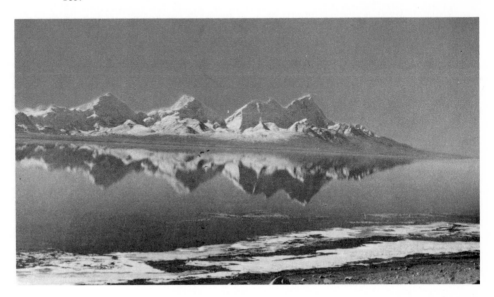

PLATE 6. *Sheep grazing on the plain outside Gyantse, one of the country's wool centers.*

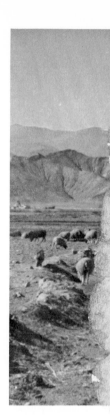

PLATE 5. *The reliquary chortens of Siling Gompa, one of the first of Tibet's ancient monasteries that the travelers visited.*

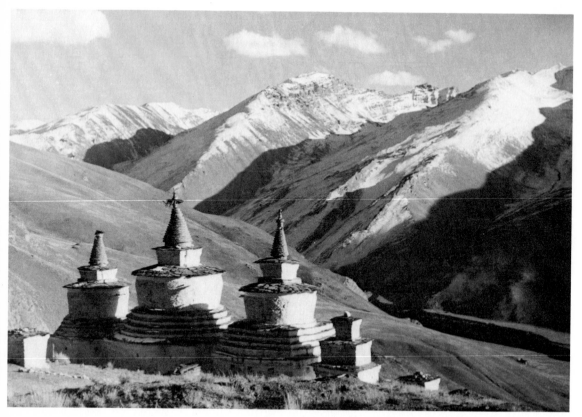

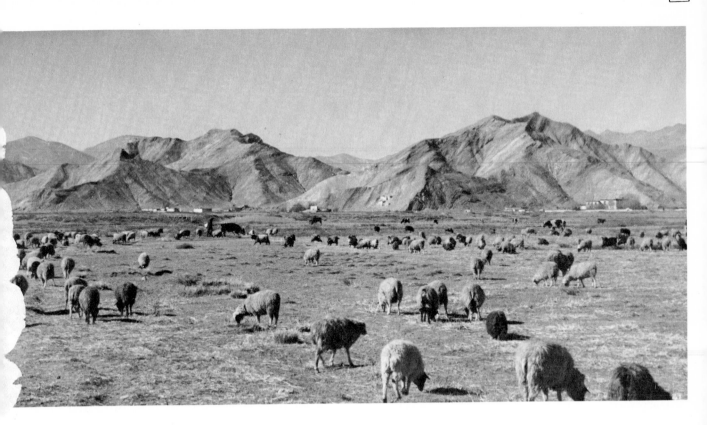

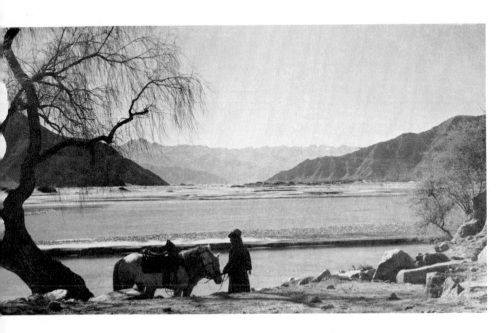

PLATE 7. *The expedition was ferried across the Tsangpo River near this beautiful place.*

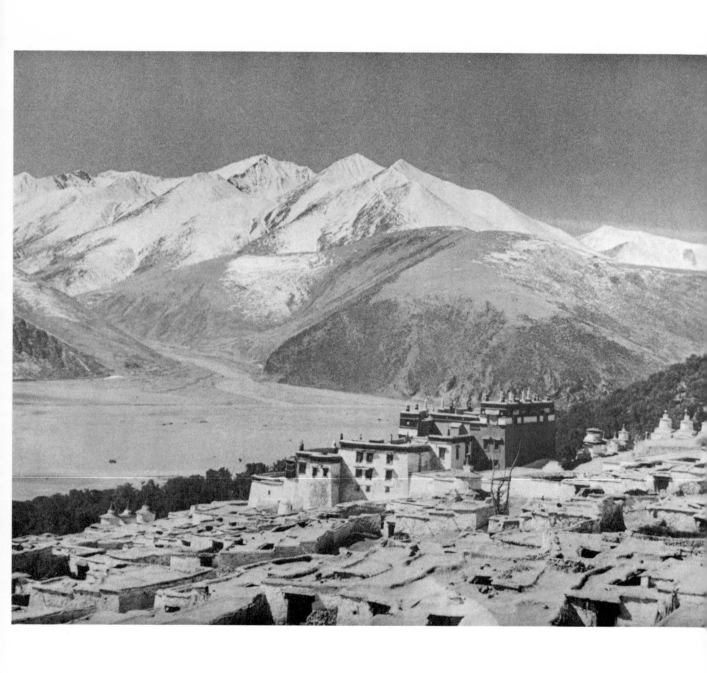

PLATE 8. *The monastery of Rating was one of the most famous and respected religious establishments in Tibet. The palace of the Rating Regent, one of the country's influential leaders, rises above the monastery complex.*

PLATE 9. *Barren hills as seen from the top of the Kangla Pass, which is over fifteen thousand feet high.*

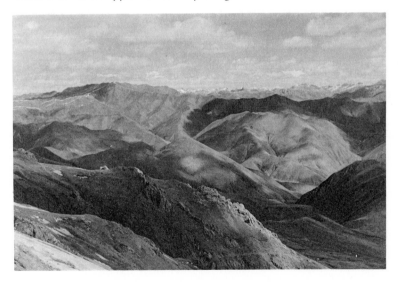

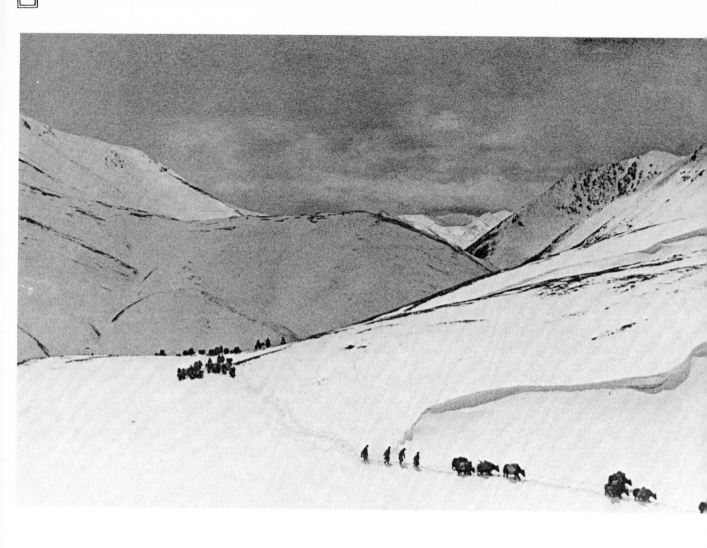

PLATE 10. *The party struggled through the Tsangne La pass under conditions that had served over the centuries as a natural obstacle to travel in Tibet.*

PLATE 11. *The expedition carried the American flag while going through the Melo La.*

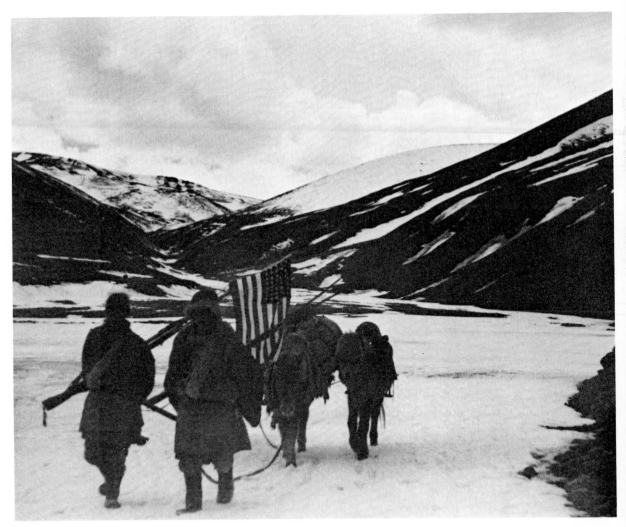

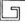

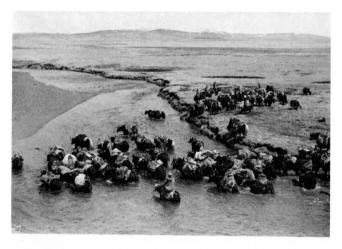

PLATE 12. *The expedition forded the Dri-Chu River as it passed through the vast Karma-Tang (Plain of Stars).*

PLATE 13. **Mani** *stones, with prayers inscribed on them, near the chorten of Dsogchen Gompa.*

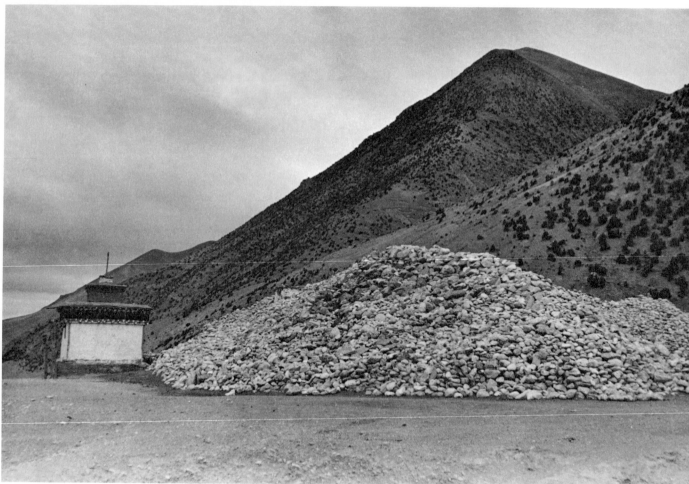

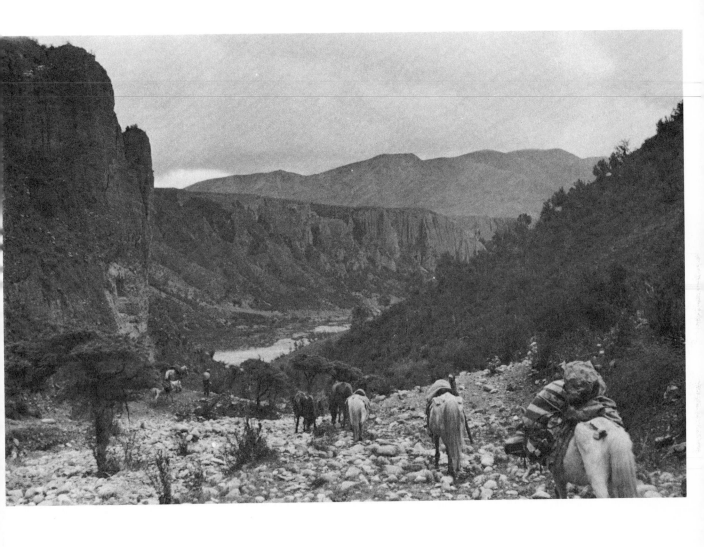

PLATE 14. *The high valley of the Ta-Ho-Pa—an isolated and secure place where there were many rare species of plants and birds.*

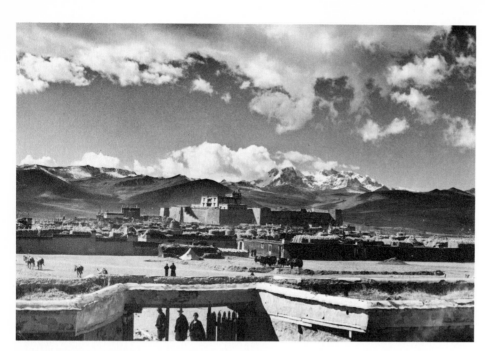

PLATE 15. *Phari, dominated by its massive fortress, was typical of the Tibetan style of walled town.*

PLATE 16. *The house of the wealthy Tsarong family was not an ordinary Tibetan house, because of its size and glass windows. The architecture, however, was classically Tibetan, as was the use of awnings and the display of potted plants.*

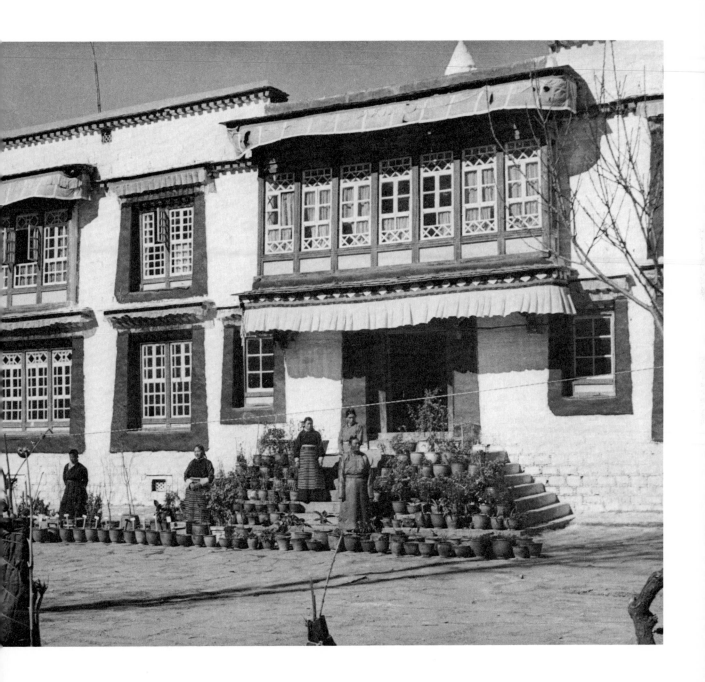

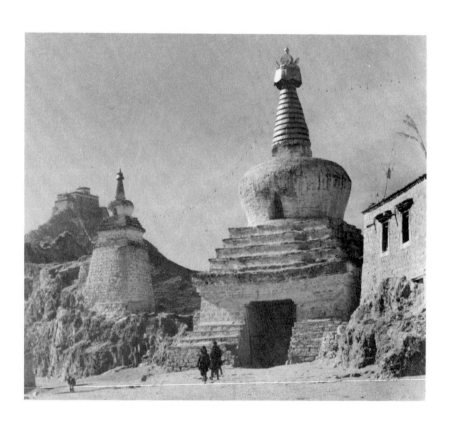

PLATE 17. *The large chorten that formed the main gate of Lhasa, seen here from inside the city, contained the holy relics of the Buddha Mindukpa.*

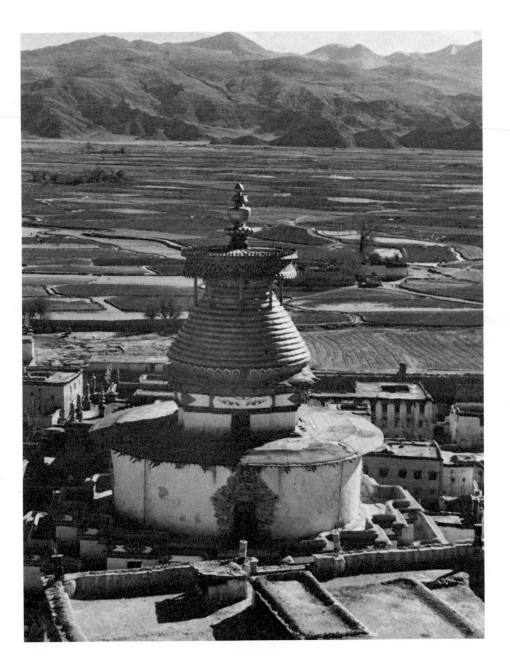

PLATE 18. *The chorten of Palkhor Choide in Gyantse is considered one of the great achievements of Tibetan architecture. The eyes are painted on all four sides, and represent those of the Buddha.*

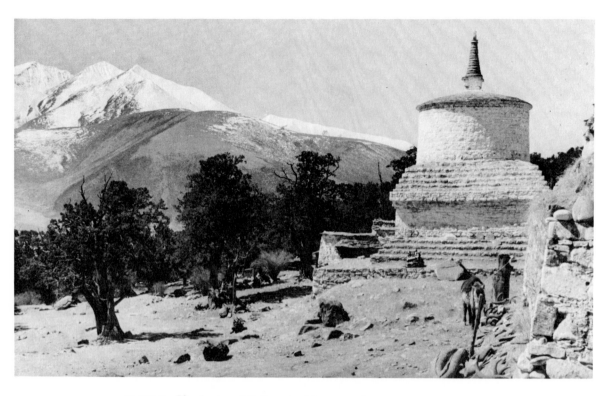

PLATE 19. *The chorten at Rating stood in a sacred grove of trees outside the monastery walls.*

PLATE 20. *The Gyantse Jong, Gyantse's hilltop citadel, is preserved from the days when the Tibetans were a warrior people.*

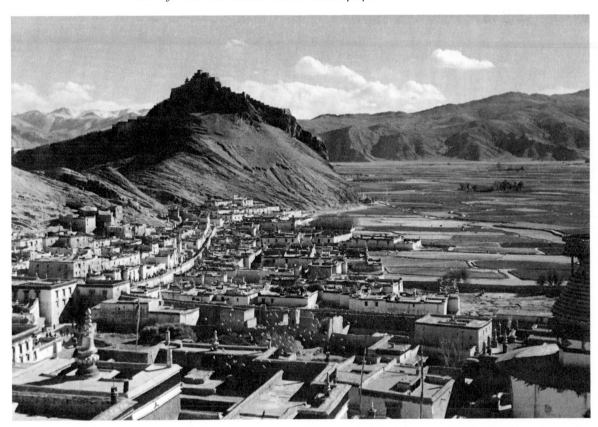

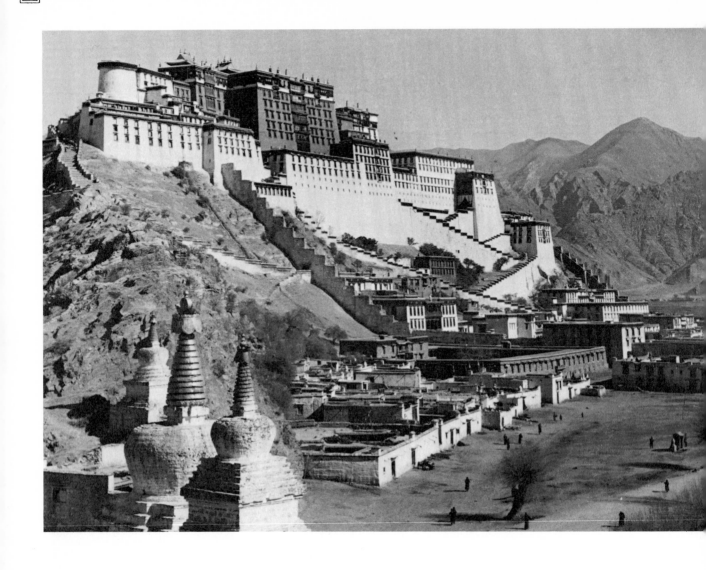

PLATE 21. *The Potala, the winter palace of the Dalai Lama and the seat of his government, is one of the great masterpieces of world architecture. Inside were large chortens containing the embalmed bodies of former Dalai Lamas and the collected treasures of the government in Tibet.*

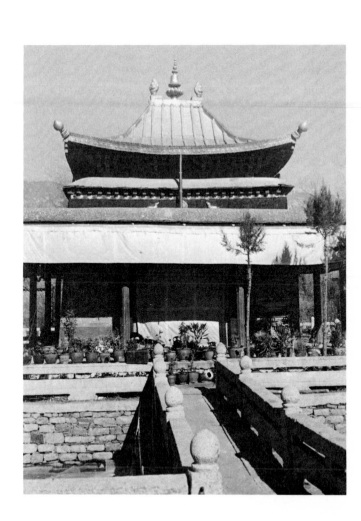

PLATE 22. *The Lukhang pavilion—Temple of the Serpent Demi-Gods, mythical creatures believed to guard precious jewels—is in the Norbulingka, the summer palace of the Dalai Lama.*

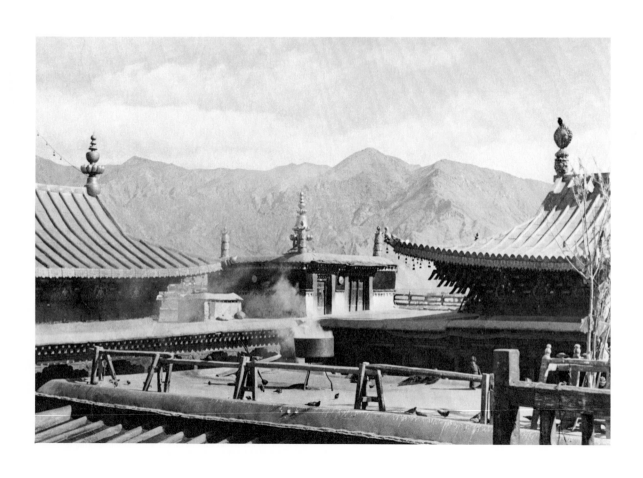

PLATE 23. *Rooftop shrines crown the Jo-kang, the most important temple in Tibet. The large urn contains burning incense.*

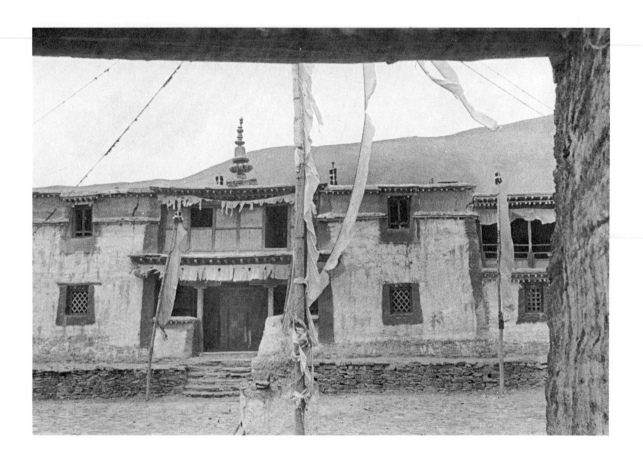

PLATE 24. *At the Bonpo cloister of Trachen Gompa, the prayer flags, blown by the wind, sound the holy words written on them.*

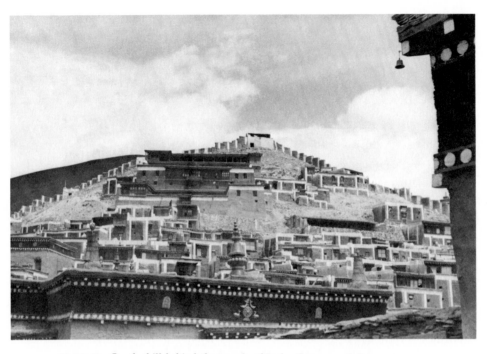

PLATE 25. *On the hill behind the temple of Jyeku Gompa, a Sakya monastery, were the cells of the monks.*

PLATE 26. *The serene image of the Buddha Sakya-muni in the temple of I-Wang has katas (silk greeting scarves) of devotees draped over its hands.*

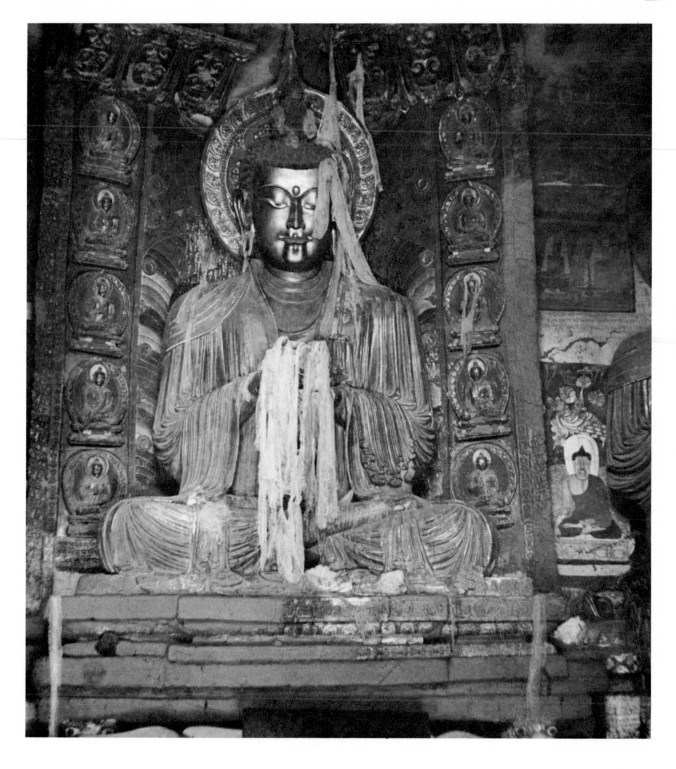

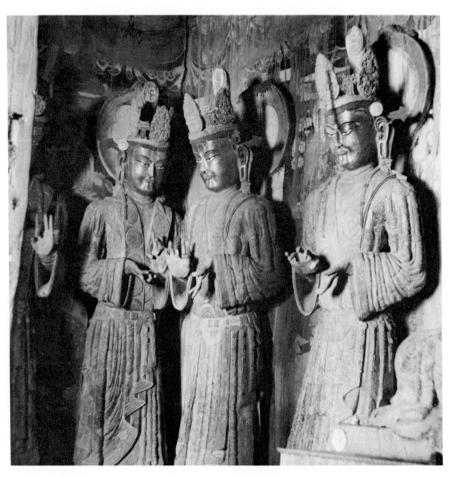

PLATE 27. *Images of celestial Bodhisattvas at I-Wang, their softly flowing robes reflecting the Khotanese style of western China.*

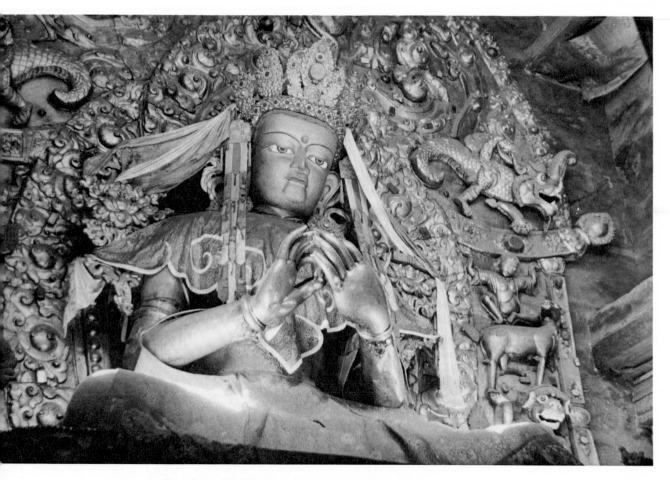

PLATE 28. *One of the gilded bronzes of Drepung Monastery in Lhasa, a
seventeenth-century image of Manjusri, the Lord of Wisdom. He is dressed
in rich brocades. His hands are in the "teaching" position.*

PLATE 29. *The silver image of Tibet's patron deity, the Bodhisattva Avalokitesvara, is flanked by four Chinese porcelain vases. The outermost pair depict events in the life of Christ and were probably gifts of Jesuit missionaries.*

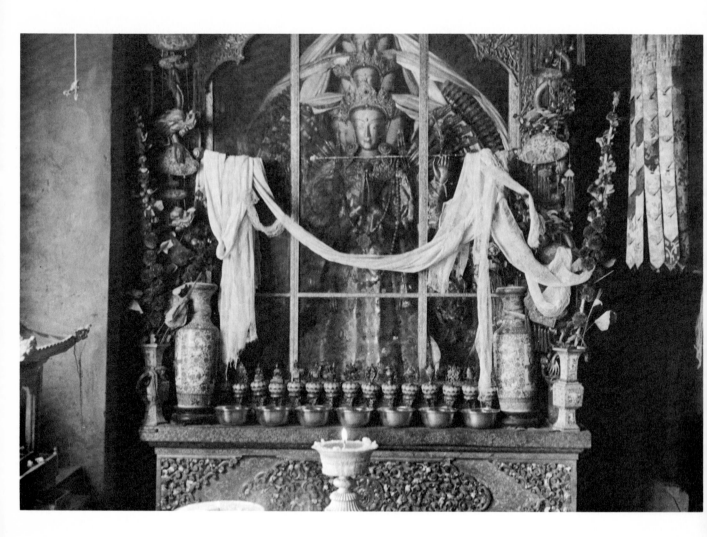

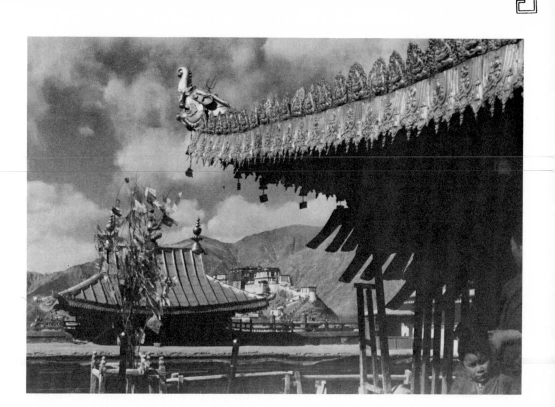

PLATE 30. *The rooftop shrines of the Jo-kang were decorated with the finest of bronze sculpture. The waterspouts on the eaves, called* makras, *were cast in the form of animal heads.*

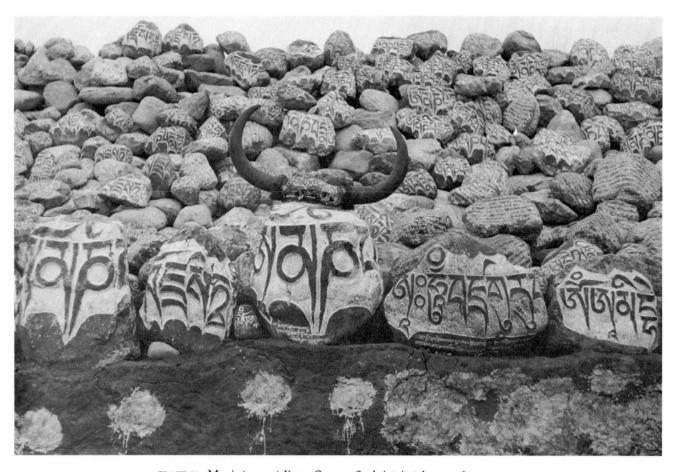

PLATE 31. **Mani** *stones at Kema Gompa. Such intricately carved stones,
many of them whitewashed to put the carving in relief, become a
monumental sculptural form.*

PLATE 32. *The Tibetans were masters of the art of appliqué. This elaborate
costume with headdress is worn by a monk dancer in the traditional Black
Hat Dance.*

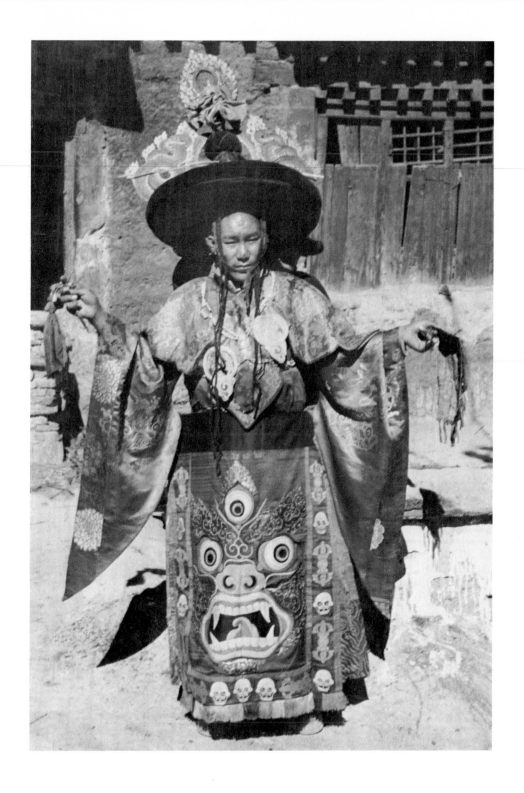

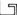

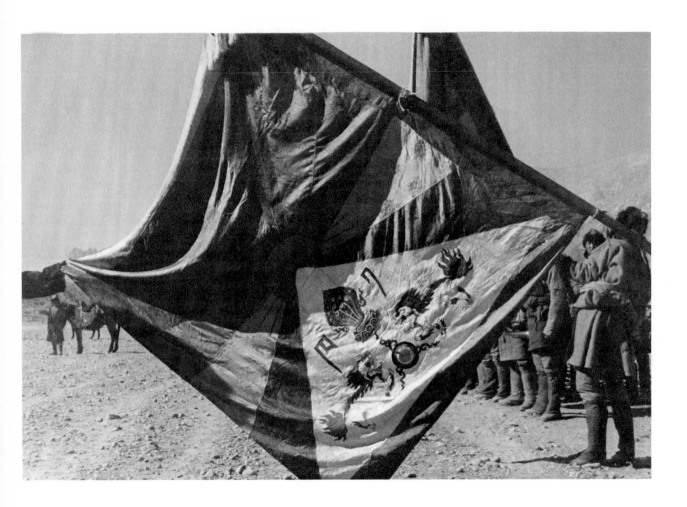

PLATE 33. *The Tibetan flag is symbolically significant. The twelve stripes of red and blue represent the twelve nomadic tribes from which the Tibetans are said to have descended. They also represent the red god Chamsing and the blue god Maksorma.*

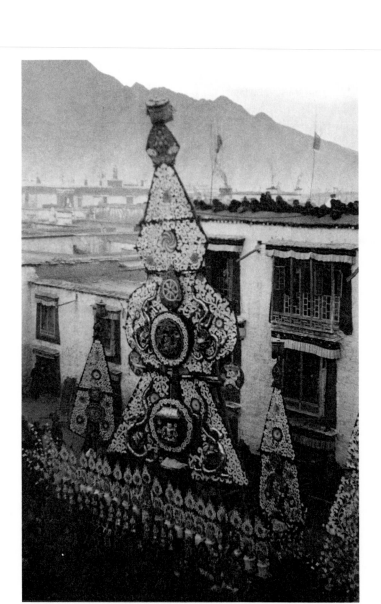

PLATE 34. *Giant, intricately decorated "butter sculptures" stand in the Barkor outside the Jo-kang on the fifteenth day of the Monlam (New Year's) festival, when they were paraded through the city.*

PORTRAITS OF THE
PEOPLE OF TIBET

The most fascinating subjects Brooke Dolan and Ilya Tolstoy found for their cameras were the people of Tibet themselves. Except for a few government officials and nobles, it is unlikely that many of the subjects were even familiar with what cameras were meant to do. But all of the people presented themselves to the camera directly and with great dignity.

The Tibetans whom Tolstoy and Dolan met and photographed were people living in a thoroughly medieval society. The gap between their world and the world of the West in World War II was vast. They did not possess many of the advantages brought by modern technology. But on the other hand, they weren't engaged in fighting a great and destructive war. And their society, highly structured and integrated as it was and centered completely on religion, brought the Tibetans a special kind of peace. They possessed—from great abbot to a nomad living in the ancient Tibetan way—a profound sense of personal identity. Throughout the centuries, the travelers who managed to reach Tibet always registered surprisingly similar reactions to the Tibetan people. They were not viewed patronizingly as "simple happy natives"; they were usually found to be a highly civilized people who were also kind, hospitable, and amazingly open—regardless of rank or position.

Because of the nature of their mission, every level of Tibetan life was open to Dolan and Tolstoy. Their striking photographic portraits literally trace the Tibetan world from top to bottom—from the child-ruler on his throne to the nomadic peoples of the remote border country.

The Fourteenth Dalai Lama, who received Dolan and Tolstoy when they came to his palace in Lhasa, was at the apex of the pyramid of Tibetan society. Although older members of his court performed many of his governmental and religious duties in his name because of his age, all of Tibetan life was at least symbolically focused on the little boy in the Potala.

The seven-year-old Dalai Lama whom Tolstoy and Dolan met already had great dignity and presence (PLATE 35). He wore the traditional hat of the Gelukpa order's incarnations, and he was robed in silk brocade trimmed with otter fur imported from Russia. A cloth of white silk was draped over his knees to protect his costly regalia during audiences when the faithful might touch their bowed heads to his body as they made obeisance to him.

The Dalai Lama was not born to great wealth and position in the European sense. Lhamo Dondrub, as he was originally named, was born in 1935 to a Tibetan peasant family who farmed in a small town called Takster in the Chinese-controlled province of Amdo. But in the Tibetan way of looking at things, the apparently simple child who was born in Takster was, in fact, the living incarnation of the great Bodhisattva Avalokitesvara, who always chose to incarnate as the person who would lead the dominant Gelukpa sect. In the seventeenth century, the Great Fifth Dalai Lama became Tibet's political as well as religious leader when he declared himself the living incarnation of Avalokitesvara. In Tibetan belief, a being with the rank of Bodhisattva could choose quite deliberately to be reborn in a specific place and at a specific time. Knowing this, these beings leave indications before their actual earthly deaths as to where they will reincarnate. By his own command made before his death, the body of the Thirteenth Dalai Lama was put on his throne in the Norbulingka Palace. Gradually the dead Dalai Lama's head was observed to turn eastward, indicating that he would be reborn to the east of Lhasa. Also, a star-shaped fungus grew on a pillar to the east of the dead man's throne. When the high lamas met to plan their search for the new Dalai Lama, they gathered further information. The State Oracle had seen a vision of a village where there was a monastery with a particular kind of green tiled roof. The country's

64

regent saw a vision of a house with unusual gutter spouts. These and other clues finally set the path of the official search party of lamas.

The lamas who were sent to Takster to search out their new ruler went in disguise as traveling merchants. Jigme Norbu, one of the Dalai Lama's brothers, has written an account of the amazing examination of his three-year-old brother Lhamo Dondrub by the disguised lamas, including a lama called Kyetsang Rimpoche: "That evening he [Kyetsang Rimpoche] and his companions played for a long time with Lhamo Dondrub and were greatly impressed by him. The monks had a number of things with them that had belonged to the Thirteenth Dalai Lama, and the normal procedure was to bring them quite casually to the notice of such children of whom it was thought that they might conceivably be the long-sought-for incarnation. No sooner did Lhamo Dondrub catch sight of the rosary of the dead Thirteenth Dalai Lama in the possession of Kyetsang Rimpoche than he addressed him indignantly, declaring the rosary was his; and he refused to let himself be persuaded, and continued to insist that the rosary was, in fact, his. . . . But not only that, the child told the disguised Kyetsang Rimpoche to his face that he was a lama from Lhasa. And the visitors could hardly believe their ears when the child addressed them in Lhasa dialect. . . . My brother Lhamo Dondrub was now subjected to a very thorough examination. In addition to the rosary, the walking stick and the damaru [drum] which had belonged to the Thirteenth Dalai Lama, the delegation also had with them his silver pencil, his spectacles and his eating bowl, together with very clever imitations of them. When Kyetsang Rimpoche now received little Lhamo Dondrub he wore the real rosary around his neck, and held the imitation in his hands in prayer. But the child did not hesitate. He ran to Kyetsang Rimpoche and tried to take the rosary from his neck by force, once again insisting that the rosary was his. By this time, he was allowed to have it. The oral examination of the child was also completely satisfactory. And so at the age of three the current Dalai Lama was found."[9]

It had been predicted centuries before the Fourteenth Dalai Lama came to Lhasa that the Thirteenth Dalai Lama would be the

last ruler of Tibet. The Fourteenth Dalai Lama, was, in fact, forced into exile at twenty-four, a few months after he had passed his examinations for the *geshé* degree (the Tibetan equivalent of a doctorate). A *geshé* degree indicated mastery of Buddhist theology and of the ancient art of theological and philosophical debate.

The abbots of the great monasteries of Tibet were powerful figures in the political and religious life of Tibet, ranking just below the Dalai Lama. They, like their ruler, usually had attained a *geshé* degree. While he was staying in the city of Gyantse, Brooke Dolan met and photographed one of Tibet's most distinguished monastics, Kempo Ngha Wang Tashi, the abbot of Pacho Gompa (PLATE 36).

Tibet's hereditary aristocracy, which ranked just below the religious hierarchy, was strongly service-oriented. Aristocratic families were required to provide at least one male for government service at little or no salary. Three ranking officials sat for a formal photographic portrait by Ilya Tolstoy (PLATE 37). They were in full ceremonial dress for the feast of Monlam, one of the state occasions when the aristocratic government officials were required to dress with great traditional splendor. The official on the left in his magnificent Chinese brocade robe and a black fox-fur hat (an indication that he was a Ko-sa, that is, above the fourth rank of Tibetan officialdom) was Changwuba. The ranking gentleman at the right was Ringkhang, a general in the Tibetan army, whose elaborate robes date in style from the time of the Mongol invasions in the reign of the Fifth Dalai Lama. All three men wore in their left ears a turquoise earring called *su gi*. The *su gi* was worn only by officials.

Just as every aristocratic family in Tibet had an obligation to give one son to government service, so all Tibetan families, regardless of rank, were expected, if they had more than one son, to send a boy to a monastery to be trained as a monk. This pattern of family obligations to a larger national family or state was common to Europe in the Middle Ages too.

Tolstoy and Dolan saw a particularly relaxed and boyish-looking group of novices at the great monastery of Siling Gompa, near Gyantse (PLATE 38). The basis of the boys' education was the Tibetan language and Buddhist religious doctrine.

66

The travelers became acquainted with one of the Dalai Lama's brothers, Gyalo Thondup (PLATE 39). Because of his special position at court he was carefully dressed as befitted the brother of a ruler. They saw him in his correct winter dress with a classical Tibetan winter hat—its silk brocaded crown and large fur flaps to protect the ears and face from high winds. His *chuba*, the name for the robe worn by Tibetans, was made of Chinese silk brocade. Dolan and Tolstoy were undoubtedly struck by the ancient swastika design in the *chuba* worn by Gyalo Thondup. Although the design symbolized the heart of Buddha and the center of the universe for Tibetans, even educated Westerners must have winced on seeing the swastika in 1942—a year in which the motif was taking on an increasingly grimmer meaning in Europe.

Because of their special mission, Dolan and Tolstoy were invited to many social as well as religious functions. At a luncheon given at the British mission in Lhasa they met a whole assembly of fourth-rank government officials, including Jigme Taring, a strikingly handsome young aristocrat (PLATE 40). He wore the ceremonial headdress of a fourth-rank official. His hair was braided with a red silk ribbon. In the center of the front braid he wore a brooch of turquoise and gold, an ornament that could be worn only by officials of his rank. Jigme Taring is now living in exile in India, where he is in charge of education for the children of Tibetan refugees.

The New Year's celebrations and all the necessary preliminary preparations that led up to them gave Brooke Dolan and Ilya Tolstoy an unusual opportunity to see ranking Tibetans in full splendor. On visiting the Phunkhang Palace, the official residence of the powerful Phunkhang family, just before the beginning of the New Year's celebrations, they saw the son of the household, Phunkhang Se (in effect, "Phunkhang, Jr."), his wife Kuku, and his sister Kay dressed in splendid clothes for the great events (PLATE 41). The women wore elaborate headdresses decorated with seed pearls and coral. Attached to these headdresses were giant earrings of gold and turquoise and coral. Phunkhang Se's father was a *Shapé*, a ranking governmental official.

When Ilya saw the robes of the Phunkhang family he was over-

whelmed by their beauty and their value. Brooke gives a good description of the two women, Kuku and Kay, in his journal: "At 3 o'clock Kuku Phunkang [sic] and her unmarried sister-in-law Kay Phunkang came in to tea. Kuku is the daughter of our good friend the Maharajah of Sikkim and was reared in the sophisticated atmosphere of Gangtok, learning to speak English fluently and to enjoy meeting highly educated people. She was brought here by a mariage de convénance six years ago and is obviously buried alive. Kay is a pretty spirited looking girl who speaks no English. Kuku means to take her down the road to Gangtok next spring for a six month's space. Both girls were dressed alike in lovely soft dark green gowns with traditional horizontally striped aprons gay in color. At the throat they wore great charm boxes of dark red gold studded with turquoise and suspended about their necks with chains of large seed pearls, coral, and onyx, each costing a fortune."[10] As Dolan and Tolstoy already knew, all Tibetans wore charm boxes, called *gao* in Tibetan. They contained prayers that were written on a paper and inserted in the box, which was then sealed. *Gao* boxes were worn for a variety of spiritual reasons.

Brooke's remarks about Kuku reflect his growing awareness of problems with the educational system in old Tibet. Very few Tibetans were sent abroad for Western education. Jigme Taring and his wife were among the few Tibetans that Tolstoy and Dolan met who had been given an opportunity for broadened intellectual horizons.

Dolan and Tolstoy met Surkhang Dzasa, Tibet's distinguished foreign minister, and his young son (PLATE 42). Surkhang's face showed signs of a severe case of smallpox. The Tibetans had little interest in Western medicine, and smallpox remained a scourge that knew no class boundaries.

Tolstoy and Dolan were very aware of the uniqueness of their opportunity to see Tibet, and thus they avoided photographing only aristocrats, government officials, or court functionaries. Sometimes they would walk into the courtyard of a simple house and take pictures of children (PLATE 43). Or they would be walking on a dusty road and come across a religious pilgrim, on his way to a holy shrine, a monastery, or even to the city of cities, shrine of shrines, Lhasa (PLATE 44).

A pilgrim might be on the road for a long time. He usually carried his possessions on his back. His pilgrim's staff might well have a sharpened end so it could double as a spear to ward off wild dogs or other dangerous animals he might encounter on the road. He would also carry his own prayer wheel with him. A prayer wheel is always a cylindrical metal case. It is hollow, with an opening at either end. Prayers are written on a piece of paper and are wound around a bamboo or wooden rod, which is then inserted into the cylinder. The rod is kept in place with a carved shell washer placed around the rod at the top of the cylinder. The devotee, a religious person, then turns the wheel with a rotating hand gesture. A pilgrim with a long necklace of shell washers was undoubtedly a truly zealous Buddhist, since after hundreds of turnings, the shell washers on the spindles of the prayer wheels wore out and would then be added to a necklace around the neck—"an outward and visible sign" of great fervor.

Tolstoy and Dolan also learned about the world of Tibet's nomadic peoples. The nomads, who lived primarily in northern Tibet in difficult conditions, led the most traditional and ancient life-style of all. They were undoubtedly the original Tibetans. The mountain land originally had been populated by nomads, and they still represented nearly half the country's population. And although the life they lived following their herds of cattle, sheep, and yaks was a hard, primitive, and simple one, it was lived with much traditional Tibetan—or perhaps nomadic—dignity. The nomads most commonly were called *aBrog Pa* ("high-pasturage ones"). They moved their herds at least three times a year, pasturing in the *drong* ("deep valleys") in the winter, and going up to higher elevations in the summer. They lived in groups ranging from five or six families up to eighty. These were actually tent groups, with one family to a tent. In the northeastern section of Amdo, however, there might be as many as a thousand tents at some gatherings or at the fall trading of wool and Chinese tea and grain.

During the latter part of March 1943, on their journey from Lhasa to the northeast, where they planned to enter China, Dolan and Tolstoy passed a nomad camp. Here they met an elderly man dressed in a traditional *chuba* (PLATE 45). But his *chuba* was made of

69

sheepskin for warmth and durability—not of the fine brocades seen in Lhasa. The *chuba* is a wonderfully adaptable garment; made of wool, it was waterproof. The preferred material for the girdle worn with it was raw silk, but often the nomads had to be content with less. The *chuba* itself usually was made of about eight sheepskins. The elderly nomad's most valuable possession, aside from his *chuba*, was the flint case he wore hanging from his belt. This case was made of leather and was decorated with small stones and metal disks. Inside there was a flintstone and a wad of raw cotton. After a spark was struck from the stone, the cotton, if carefully shielded from the wind and blown on gently, would catch fire and, in turn, help its user start a campfire. It was cold in the tents of the nomads in early spring and difficult to start fires at elevations of over fifteen thousand feet.

Not all nomads were peaceful herdsmen. In April, near Lake Koko Nor, Brooke and Ilya met some of Tibet's warrior nomads who sometimes turned to banditry on the northern caravan routes to China. These people were called the Goloks. They met a Golok warrior who looked brave enough to terrorize all the Chinese border country (PLATE 46). He was standing outside his black yak-wool tent. He wore a small hat that was kept on his head in even the highest mountain winds by his braided hair, which was tied across the hat. These braids also could be tied across the man's eyes to shield them from the sun and the dangerous dazzle of snow blindness. He wore a massive *gao* box around his neck. He was bare-chested in the chilly spring air, and his indispensable *chuba* was knotted, by its sleeves, around his waist.

This Golok warrior's *chuba* was made of a special felt cloth, from northeastern Tibet. The felt was prepared by laying out woolen fibers, wetting them, and rolling them into flat sheets of cloth. The problem was to keep the edges of the felt cloth from curling up in the process. Drukpa nomads of this region had a song they sang as they prepared felt cloth from wool:

> *Ah ling-ling ling*
> *Tey ling-ling ling*

Nay goom-goom goom
Detsi dongi thoko sho
Thoko mena thoda sho.

This nomad song translates in English like this:

May not the edges turn up
May this felt be as strong as the dark-brown-
 spotted forehead of the wild yak.
If this felt cannot be as strong as the forehead
 skin of the wild yak—may this be similar.

This is a world where time was told by the rising and setting of
the sun, and where the seasons of the people's lives were counted in
the seeding of the land and in the harvesting of crops, in the move-
ment of the herds from the valleys to the high country and back
again.

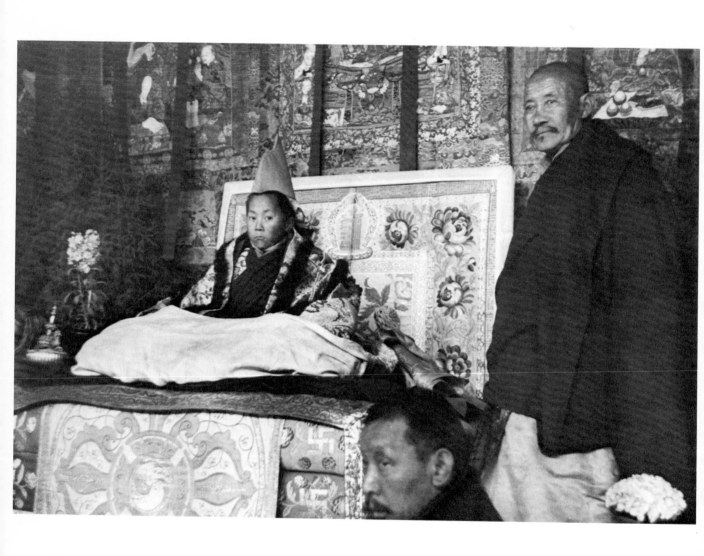

PLATE 35. *The Dalai Lama was a very serious small boy of seven when Tolstoy and Dolan were received by him. He is seated in the "lotus" posture on his throne.*

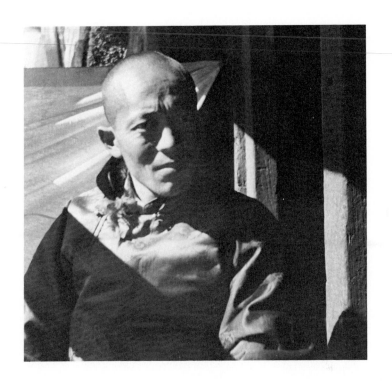

PLATE 36. *Kempo Ngha Wang Tashi, the abbot of Pacho Gompa. Although the abbot of a great monastery might have considerable political power, he also had to be a person of extraordinary spiritual development.*

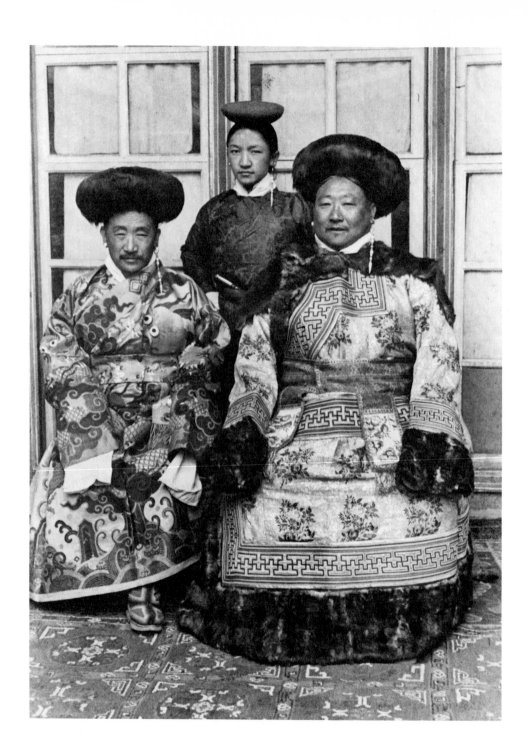

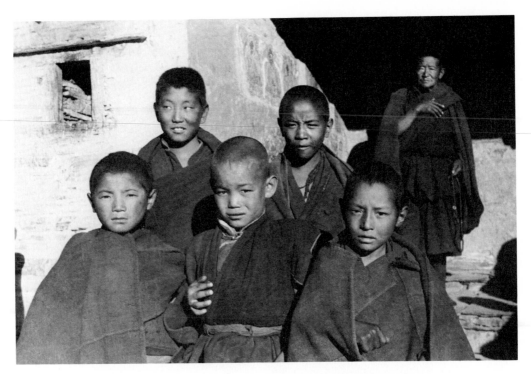

PLATE 38. *Young novices, aware of having their picture taken, and their stern monk teacher in the background. They would study the Tibetan language, a form of Sanskrit, and Buddhist doctrine for many years before their education was complete.*

PLATE 37. *Aristocratic officials dressed in their finest ceremonial clothes for the Monlam festival—clothing dictated by custom and rank. The overlong sleeves were another indication of rank.*

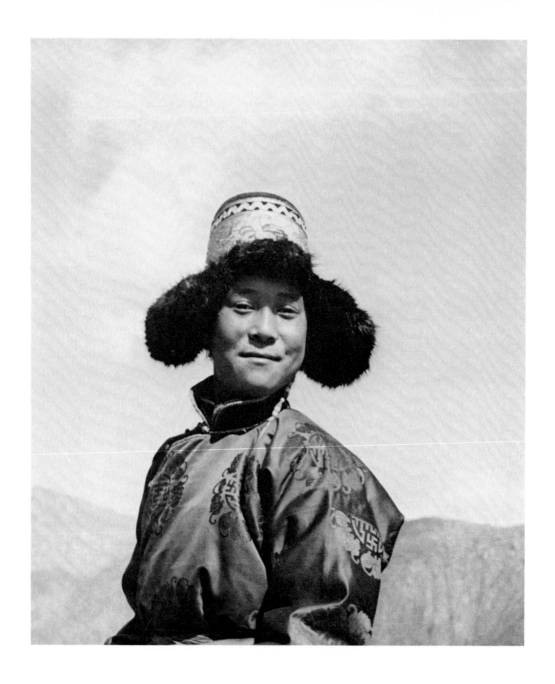

PLATE 39. *Gyalo Thondup, an older brother of the Dalai Lama, dressed elegantly for winter.*

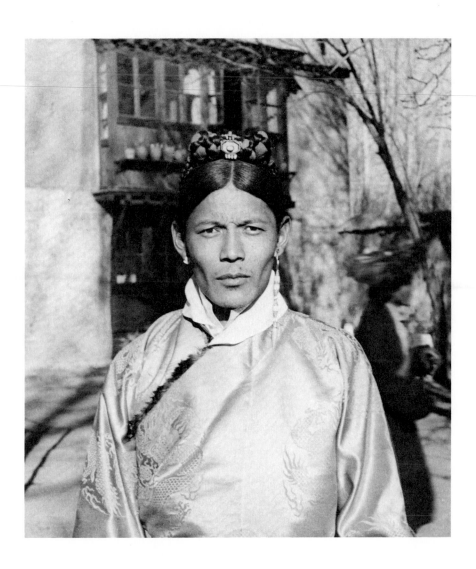

PLATE 40. *Jigme Taring, a fourth-rank official who was one of the treasurers at the Monlam festival in charge of distributing money to the monks. Later he was an officer in the Tibetan army.*

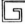

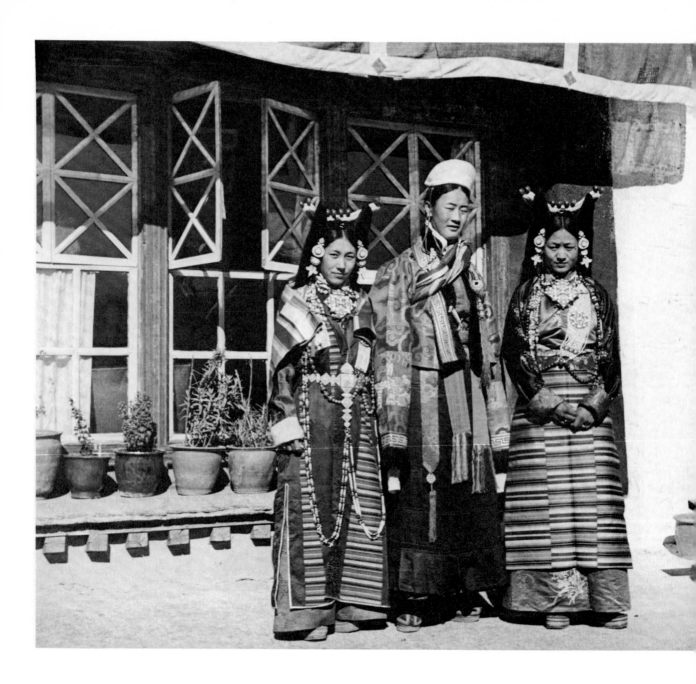

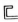

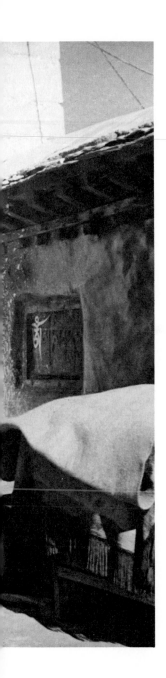

PLATE 41. *The heir of the Phunkhang family, Phunkhang Se, flanked by his wife Kuku and his sister Kay outside the Phunkhang Palace in Lhasa. This family was one of the most powerful in Tibet.*

PLATE 42. *Surkhang Dzasa, shown here with his young son, was foreign minister of Tibet when Tolstoy and Dolan were there. Dzasa was an honorific title of Mongolian origin granted only to high-ranking government officials.*

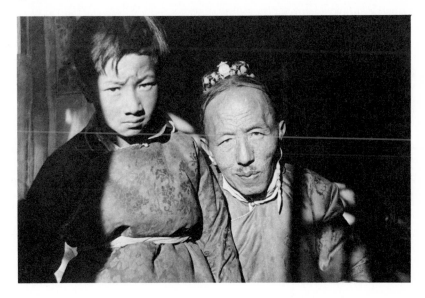

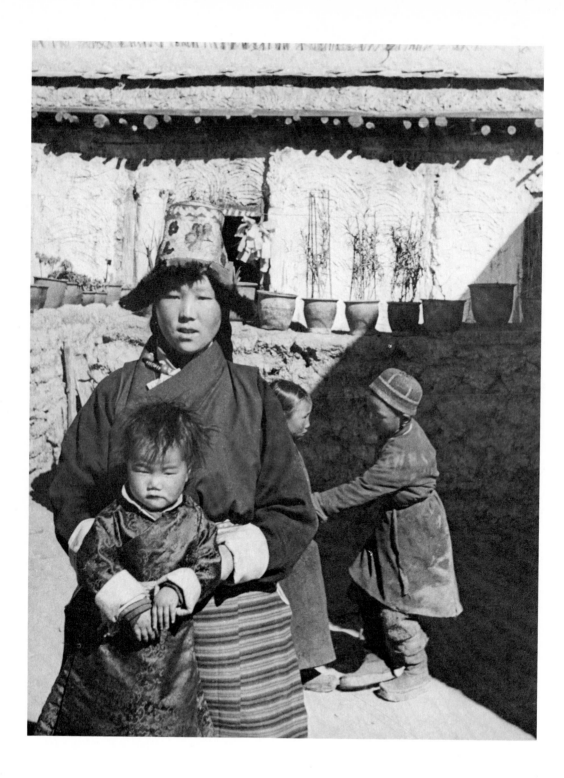

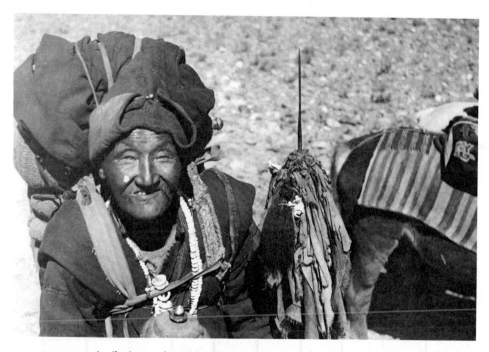

PLATE 44. *A pilgrim on the road to Gyantse. He carries a prayer wheel (left) and is armed with a spiked staff (right) for protection.*

PLATE 43. *A mother and her children in the courtyard of their house in Lhasa.*

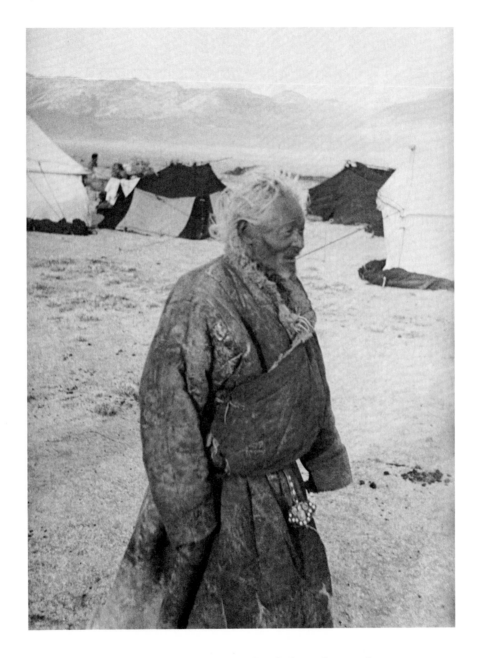

PLATE 45. *An elderly nomad in his sheepskin* chuba *at the nomad encampment called Lalung Karmo. The expedition's tents are in the background.*

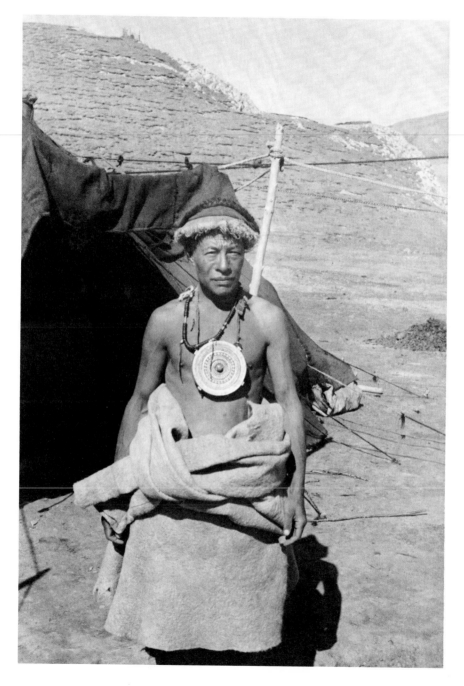

PLATE 46. *A member of the Golok tribe stands outside a traditional nomad tent of black yak wool.*

THE WAY OF LIFE

The way of life in Tibet was unique. It must have been an incredible, revealing moment when Tolstoy and Dolan heard a jingling of bells and turned to see a small wiry man trotting along the trail, carrying a spearheaded staff with bells on it (to let people know he was coming); this was an official government mail carrier taking a written message to someone in the next town (PLATE 47). There were many such mail carriers; in fact, each man was spelled by another after he had run about four and a half miles. There was even "special-delivery" mail—important government documents—that might be carried by relays of horsemen. The mail carrier's lance, with a spear point, served to keep off wild animals or bandits.

The clothes of the Tibetans were determined by tradition and by social class. The clothes of the nomads usually were made of sheepskin or sometimes finer yak hair woven into cloth. The clothes of farmers, tradesmen, and monks were made of a cloth woven from the wool of sheep. The clothes of the nobility were made of fine Indian and Chinese silks and brocades, brought in by caravan traders. But the aristocratic ladies of Lhasa, when Tolstoy and Dolan arrived there, used Helena Rubinstein cosmetics and favored "Evening in Paris" perfume imported from Calcutta. Traders also sold the less affluent women of Lhasa inexpensive powdered rouge from China. Although Tibet was isolated by its geography, it still had been on busy trade routes for centuries. By 1942, however, Tibet's isolation had more to do with the monastic government's desire to preserve their religion intact than it did with the perilous state of the moun-

tain passes. Still, the Tibetans were ingenious about introducing small touches of the world outside. Sunglasses, providing a wonderful relief from the glare on snow-peaked mountains and the clear, bright sun, were worn on the streets of Lhasa by fashionable people—but they could not be worn in the presence of the young Dalai Lama, nor could any other kind of eyeglass. It was considered an irreligious act to wear anything that might be construed as changing or altering "reality."

Transportation

Travel in Tibet was difficult but not impossible. Caravans from India and China visited Lhasa and other Tibetan cities regularly. Often the pack animals were mules or horses or yaks. Sometimes, however, a caravan of camels would enter the giant chorten that served as the main gate to Lhasa—a scene that looks straight out of *The Arabian Nights* (PLATE 48).

Before reaching Lhasa, travelers had to cross the Tsangpo River. They customarily were ferried across in coracles (PLATE 49). The hull of the boat was made of a willow-branch framework with raw, uncured yak skins stretched over it. Tolstoy and Dolan discovered they had to keep their feet on the willow framework lest their boots puncture the thin yak skin. The great advantage of the coracles was their weight. They were so light that their owners could make a portage easily with the little boats on their backs, looking a bit like giant snails.

To transport animals and heavy equipment or supplies across rivers and lakes required sturdier vessels. The usual heavy-duty ferry was a flat-bottomed wooden barge about thirty feet long (PLATE 50). Brooke Dolan described the expedition's crossing on one of these sturdy but primitive ferries: "Fifteen or sixteen . . . ponies and mules are made to jump aboard through a low breach in the deck rail and if a few boxes are broken so much the worse for the owner. The animals are arranged in a herring-bone pattern which best utilizes the deck space. Two men forward handle heavy oars and one

man aft a long stern sweep."[11] Disembarking from a Tibetan ferry was a rough-and-ready business. Passengers and animals often had to wade ashore.

Ponies, mules, horses, and domesticated yaks were of critical importance to Tibetans. They were virtually the only means of land transportation for rich and poor alike. The Thirteenth Dalai Lama was given cars as gifts and they were used for a short period of time for official excursions on the flatter roads around Lhasa. But the Tibetans had no idea how to repair them and so, ultimately, they were stored away as curiosities. The serious business of Tibet was dependent on pack animals trained to the rugged mountain trails. Wealthy families owned large stables of both work and saddle animals, and employed stablemen and grooms (PLATE 51).

Early travelers to Tibet had gained—and passed on—the false impression that Tibetans never used wheeled vehicles because they were impractical on mountain trails. However, there actually were some wheeled carts that were used on the flat plain around Lhasa (PLATE 52). They were probably copied from British military vehicles that came into Tibet with the Younghusband expedition of 1903–4. This was a military expedition launched from British India. As a result of this inroad, the British were granted the right to establish a military garrison at Gyantse and a trade mission in Lhasa. Tolstoy and Dolan stayed at the British mission while they were in Lhasa.

Tolstoy and Dolan became accustomed to the hazards of travel in pack trains. Since they wished to see as much of Tibet as possible, they spent many hours on the trail. The leg of the journey that took them from Lhasa to the Chinese border was the most arduous for them—partly because of the weather, but even more because of the hazards of traveling on pack animals through an almost insanely difficult terrain.

After leaving Lhasa, Tolstoy and Dolan followed the Sog Chu Valley toward Rating. Their caravan had to cross the Sog Chu River on a high suspension bridge of ancient and precarious design (PLATE 54). The bridge floor was fashioned of logs bound together by rope. There were no handrails. There were ropes overhead on either side of the bridge, rather appropriately hung with prayer flags. As soon as a man or a horse stepped onto the bridge, it began to sway vio-

lently. The Tibetans were used to swinging bridges and had developed a sort of dance step used while crossing them in which they moved to counterbalance the shifting of the bridge and stayed upright. Many Westerners were reduced to crawling over on their hands and knees. The pack animals were led across with a guide fore and aft.

As the party traveled farther to the northeast, there were many other hazards—even trouble in the flatlands. Tolstoy reported: "Tussocks of fairly solid surface were interspersed with bog holes, which trap unwary pack animals. Here one of the ponies has wandered off the turf and is floundering in a swamp pit."[12] It took two of the nomad guides to extricate him (PLATE 53). Bandits posed even more of a threat. As they progressed toward Amdo and Kham, the whole expedition had to be armed, including the guides, who carried flintlock rifles and swords. Nomad bandits preyed on the caravans passing through the rugged, remote country.

Trade

Tibetans shopped in the age-old way. They went to a central market in town to buy what they needed and to sell.

Gyantse, the city that was the center of the Tibetan wool trade, had an especially busy and elaborate market (PLATE 55). The lodestone in Gyantse was the giant chorten and the centrally located Palkhor Choide Monastery complex. The market was held within the monastery walls—in fact, the spaces for the merchants' stalls were rented from the lamas. Outside the monastery walls there was a special area where traders from other cities and farmers from the countryside could leave their horses and other pack animals while they displayed their wares inside. The color and the noise were considerable. The horse blankets were bright with traditional Tibetan designs, and old friends called out to each other as they unloaded their animals. Above it all, the ancient wall of Gyantse—called the Dragon's Back—dominated the horizon. Gyantse was still very

much a walled city in the true medieval sense. There were watch-towers where sentries once stood watch for hostile armies.

There was nothing necessary to Tibetan life that one couldn't buy in the stalls of a market like Gyantse's (PLATE 56). For instance, there were butter churns—a necessity in the making of Tibetan tea. Tibetans traditionally brewed black tea imported from China and mixed it with yak butter, soda, and salt. They would drink as many as forty cups of this mixture every day. Also for sale were the tea itself and the pot to brew it in. The black Chinese tea the Tibetans drank was unusual in a number of ways. First of all, it didn't look like most other tea. It was pressed into hard blocks, sometimes embossed with Chinese landscapes. Pieces had to be broken off the blocks and boiled to make tea. Until very recent times, the black tea from China had been used as currency in Tibet.

If someone didn't own a yak, he could purchase yak butter, already churned. The barter or sale of yak butter was one of the main economic supports of the herding nomads. There was also cloth of all kinds in the Gyantse market: imported silks from India and China, and local woolens.

In Lhasa, shopping was even more varied. Lhasa's central market was actually a street of stalls and shops that circled the city's central temple, the Jo-kang. The market street was called the Barkor (PLATE 57). Because Lhasa was the capital, it attracted goods from beyond the boundaries of Tibet in great quantities. There were Muslim merchants in Lhasa with both indoor shops and stalls in the street who sold Indian goods—jewelry, fabrics, and cosmetics. In Lhasa, the tailors' shops were also in the Barkor. An odd note in 1942 was the appearance of an occasional Western-style fedora hat along with the traditional Tibetan headgear. One of the ironies of recent history is that it is now possible to see an occasional Tibetan hat on the streets of Western cities like London and New York, where they have recently become fashionable.

Food

Although Buddhist, Tibetans ate a diet that was based heavily on meat. The reason was practical. The Tibetans were herders and wool producers; they had little available land that was suitable for growing vegetables and fruit. Therefore, they found ways to compromise their way of life with the tenets of their faith—a faith that theoretically prohibits the taking of any life, no matter how insignificant.

The way around the Buddhist prohibition of killing animals was relatively simple. The butchers of Tibet were called *porus* and they were generally Muslims; they were also considered something of a caste unto themselves and were, in a special way, analogous to the untouchables in India. In Gyantse Tolstoy got his first look at the shop of a *poru* who proudly displayed the severed head of a yak for him (PLATE 58).

All Tibetans frowned on the killing for food of small animals—fish and birds, for instance. The reason? A fine theological point. They felt that killing large animals for food—yaks, cattle, sheep, and pigs—minimized the number of deaths needed to feed the nation. But one would have to kill great quantities of smaller animals to provide a significant food supply. And behind the Buddhist veneration for all life is the central doctrine of reincarnation and the belief that life progresses from lower animal levels toward the human level, and that the human encompasses all lower life forms in his being.

As is the custom in nomadic and agrarian cultures, food was a frequent ceremonial gift to honored visitors of the country. When Dolan and Tolstoy arrived in Lhasa, they found impressive gifts of food outside their quarters (PLATE 59). There was indeed an opulent array of meat, including skinned and butchered pigs and lambs. There was also a live ram. There were cloth bags of barley flour and of dried peas for their horses (see PLATE 60 for a picture of this feed being sold at market). And there were yak-skin bags filled with yak

butter. Even in the humblest of nomad tents, a visitor would be offered yak-buttered tea immediately upon entering, and the best of any other food available. From top to bottom of Tibetan society, food was, in fact, the correct ceremonial offering.

The real staples of the Tibetan diet were barley and barley flour, milk, butter, yogurt, and cheese—in addition to meat. The average Tibetan peasant certainly could not rely on restaurants for food when traveling—there weren't any. So travelers took along braziers to cook their food on (PLATE 61). At the fall harvest, nomad groups sent out a caravan of people to trade wool, butter, and live-stock for barley and other goods. This trading caravan was called a "stove party" because the group would be small enough to share one stove to cook on; it was usually a group of eight to ten men.

Sometimes the people who caught the Americans' curious eyes were startled at the attention they were receiving while performing the relatively simple act of cooking their supper. Other people—especially people of a more raffish sort—were unconcerned. *Porus* and the occasional mule driver they met on the road were extremely nonchalant. Both callings were at the lowest end of the Tibetan social scale. A couple Tolstoy photographed near Phari were unusually casual in front of strangers (PLATE 62).

One of the mainstays of the Tibetan diet was *tsampa*. *Tsampa* was roasted barley mixed into Tibetan yak-buttered tea, forming a paste that was then rolled into balls and eaten with the fingers. But there was *haute cuisine* in the grander circles of Lhasa, and it was almost always Chinese in style. Tolstoy and Dolan were invited to a banquet by the Kashag, an advisory body that was made up of a monk and of aristocratic laymen. Dolan described the exotic fare in his journal: "Woe to him who does not quickly learn the use of chopsticks in Tibet. The banquet was Chinese and the first dish was sharks fins, shredded, glutinous, and slippery. This 'delicacy,' expensive even in China before the war with Japan, must be of fabulous price in Tibet today. Mutton balls in soup followed and then sea slugs or perhaps vice versa. Momo, steamed dough with meat within, mushrooms, sugared bacon, shellfish, lamb and mutton variously prepared as well as other dishes. . . . There were a dozen hors d'oeuvres around the edges of the table, including dried shrimp, cold lambs tongue,

tinned pears, pineapples and peaches, cold bacon, sugarplums, dates and a translucent spaghetti of pea flour strongly spiced."[13]

Farming and the Business of Wool

For a land rumored for so long to be a sterile wasteland, Tibet was amazingly fruitful in its own special way. Essentially, the country, with its fields (limited though they were) and its herds, could both feed itself and trade with the outside world.

In effect, wool and herds were the key to everything that happened in the Tibetan economy. The Tibetans exported wool—both sheep's wool and yak wool—to many countries. The Tibetan yak was especially useful. There was literally no part of the yak the Tibetans did not know how to use or consume. Before the advent of synthetics, the white beards worn by Santa Clauses in American department stores at Christmas were made of yak tails.

No one knows how the Tibetans first learned about wool and its uses. The herding of sheep is believed to have started about ten thousand years ago in central Asia. There are records of the spinning of sheep's wool indicating that it probably started about 3500 B.C. It is certain that Tibetans were much influenced by the ancient lands of the Near East, and they may have brought back some ideas about the herding of sheep and the spinning of wool from their military conquests in the days of the warrior kings (around A.D. 600). Certainly there are many elements in traditional Tibetan dress that appear to be Turkish in origin.

Ilya Tolstoy, remembering his childhood on his grandfather's estate in Russia, had a special interest in the Tibetan wool industry and in agricultural matters in general. He took many of the expedition's photographs of Tibet's agricultural life at the Doring estate near Gyantse.

The women were customarily responsible for handling wool after shearing. The processing of wool was done by the most ancient

methods. A small girl might be entrusted with carding the wool so that the fibers all lay in the same direction (PLATE 63). The more complicated steps of processing the wool were done by women and girls working in teams—sorting it to take out impurities and spinning it into thread for weaving and, finally, weaving it on simple looms into cloth (PLATE 64). Since the Tibetans did not remove the lanolin from the wool, the cloth they wove was almost waterproof.

At the simplest level, woolen cloth might be dyed into traditional elements of design. A star pattern was a popular motif and "star dyeing" had been done for centuries. Star-shaped plaques of differing colors were literally tied into the cloth before dyeing and then the whole length of cloth was immersed in a wooden tub of dye (PLATE 65). One of the most refined uses of Tibetan wool was the weaving of magnificent rugs (PLATE 66). This was something of a cottage industry, but rugs from the small towns of Tibet were carried all over the world by traders. The striking Tibetan colors—deep blues, tans, oranges, reds—were woven into designs incorporating traditional dragon and lotus motifs. Today the tradition of rug making is carried on in the communities of Tibetan exiles around the world—notably those in India.

In 1942 when the Tolstoy-Dolan expedition arrived in Tibet, a good deal of Tibetan wool was destined for export to British-controlled India. It struck Tolstoy, as he watched Tibetan peasants having their wool weighed at a British factor's station, that there was something slightly fantastic in the notion that wool from Tibetan sheep grazing high in the world's most remote mountain country would ultimately be knitted into warm stockings for British seamen shepherding convoys of war supplies across the North Atlantic (PLATE 67). The peasants brought wool from outlying areas into centers like Gyantse where it was factored and its value was credited to the accounts of the landowners on whose estates they worked. (Any wool from the nomads' "high-pasturage" sheep already would have been sold or bartered to the peasants.) The greatest demand both outside and inside Tibet was for sheep's wool. Yak wool, which was used primarily by the nomads for making tents and some outer garments, had too harsh a quality for general use.

The Tibetans were truly independent—not in the sense that

modern nation-states are independent but in the ancient sense of a total use and control of their own environment. The only staple of the Tibetan diet that had to be imported from the outside world was tea, brought in from China.

The Tibetans even made their own paper—and several grades of it at that. Papermaking was a cottage industry, often one perfected by women. In Lhasa, Tolstoy saw a woman making paper outdoors (PLATE 68). She had first boiled a mixture including the ground roots of a shrub (daphne) and recycled shreds of paper and bits of thread. When the brew was the consistency of a thin paste, she spread it on drying frames that could be tilted at just the proper angle to the sun. When it had dried, it was peeled off the frames—and there was paper for writing letters and wrapping important packages.

Barley was the principal grain. Tibetans fed it to their herds and they dried it and roasted it to feed themselves. Because of the unusual climate of Tibet, it was possible to get a winter crop, and in drier regions farmers irrigated their fields to gain the maximum yield (PLATE 69).

Farmers often used bullocks to pull their plows, and the designs of the plows varied somewhat from province to province (PLATE 70). The nomads had their own methods of tilling the soil. Tolstoy was fascinated to see nomads plowing a spring barley field at an elevation of more than thirteen thousand feet. They used a team of yaks, of course, and a far simpler plow than the one used by peasants farming the great estates at lower elevations (PLATE 71).

Tibetan women worked in the fields with the men. The expedition passed through the barley-growing area of Ling Ma Tang in harvest time and saw the peasant women working with scythes and rakes, bringing in the harvest (PLATE 72). When the grain had been winnowed, it was stored in cloth bags.

In the richer farming areas fields were carefully divided and marked off by adobe or stone walls. Here control was often a key word. Tibet had a medieval landholding system. A great part of the farmland was owned by the monasteries or the nobility. Many peasant families worked as tenant farmers on the land, although they

might be given small plots of land for their own use. They were not serfs, however. If a peasant family could somehow manage to accumulate funds to move on to a town or city and go into trade of some kind, they were free to do so.

There were also peasants in Tibet who owned their own land and farmed for themselves. The family of the Dalai Lama were independent peasant farmers. Families like this took their harvest into the nearest trading village and bartered for what they needed. If their land was good and the harvests rich, peasant farmers might make a good living for themselves in the countryside.

The government in Lhasa was by no means blind to some of the inequities in the Tibetan system in general and the system of land ownership in particular. The Thirteenth Dalai Lama had made some reforms, and the present Dalai Lama, before going into exile, had further reforms under consideration. However, it is difficult to imagine the pattern of Tibetan life changing much from within. The system was agreed upon, and in its own special way it worked.

Family Matters

Tibetan women were partners to men in most matters. The limitations in their lives were dictated more by their social and economic class than by their gender. In a country that was so thoroughly medieval in many ways, Tibet was surprising, and, in the 1940s, unique in Asia in its attitude toward the role of women.

In Tibet, both marriage and divorce were considered personal matters. Tibetan Buddhism did not place its seal on marriage. It was contracted by the two people involved, and there was no religious ceremony performed. In fact it was thought to be unlucky if a monk was present when a couple announced their intentions. Essentially, Tibetan marriages were arranged by families—especially in the case of the aristocratic families where there was an effort to keep property and wealth within a given line. However, love matches were by no means unheard of.

Divorce, like marriage, was a decision made by the two people involved. The couple who wished to be divorced usually tried to arrive at an agreement as to the disposition of property and children. The usual custom in divorce was for girls to remain with their mothers and boys with their fathers. Divorced women could remarry easily, and it was not unusual for a woman to have several marriages if she chose to. Polygamy was fairly common, especially among the aristocracy, who used it as a means of keeping property within a family. If the wealth and property of a family devolved on a mother and her daughters, for instance, it was not unusual for a man—perhaps a relative or a family connection—to be appointed head of the family and marry all the daughters. A matriarchal family might have found it necessary to bring a man into the picture in this fashion because the law required every aristocratic family to provide a male for government service, on pain of losing their estates if they failed to do so. If at some later point a younger sister who had been pulled into a polygamous marriage in this fashion wished to marry someone else, it is likely that she would be permitted to do so, and even receive a dowry from the head of her family.

These rather fluid rules about marriages and divorce were not just the privilege of the aristocracy. However, it was less usual to find peasant couples, for instance, marrying and divorcing frequently, since the marriage partnerships made by country people were closely bound to a working relationship. Polyandry was practiced by the nomads.

Education

Tolstoy and Dolan had a good opportunity to see a lot of Tibetan children. They were everywhere, they were well treated, and, in true Oriental fashion, they participated fully in the lives of their parents. Like children everywhere, they were involved in their own games and, in many cases, in the business of going to school. Brooke Dolan was especially intrigued with a game called *chibi,* which he saw children playing in Lhasa (PLATE 73). The point of the game was to keep a feathered ball (the feathers were from vultures) in the air by kicking it with the feet.

There was education available for children of all classes who were able to take advantage of it. It wasn't, strictly speaking, a class privilege. However, illiteracy was high in Tibet. This may have been due in part to the fact that the children of tradesmen and peasant farmers worked with their families in shops or in the fields and could not often be spared for the rather rigorous, classical Tibetan education. In the cities, the children of nobles and tradesmen attended day schools and usually paid a small fee to their teachers, often in the form of a gift of food or handwoven cloth. In the country, the landowners sometimes set up schools for their own children, and the children of peasant farmers working on the land were free to join them in the classroom if their parents could spare them from the fields. There was a distinction made between schools run for children who were destined for lives in the everyday world of Tibet and children destined to be lamas in the country's vast monastic system. In the monastic schools the children invariably were taught by lamas, and the whole thrust of their education was preparation for the monastic life. The monastic school system would take aspiring young monks through levels of theological and philosophical education equivalent to graduate school in the West. Occasionally the son of a noble family would be educated out of Tibet—usually in some special skill needed by his homeland.

99

Both lay and monastic education were very rigorous. School days started at dawn, with breaks for breakfast and lunch. Lessons continued until dusk. School was held seven days a week throughout the year, except for holidays on the fifteenth and thirtieth of each month and the major festivals like the New Year celebration, which lasted three weeks, and the annual picnic festival, which lasted a week. Reading and writing were thought of as the backbone of Tibetan education because they prepared the student to read Buddhist scripture. To ensure the dedication of students, parents gave teachers the right to use physical punishment to enforce discipline, but there is no evidence of cruelty.

Tolstoy and Dolan saw students at their studies in schools of many sorts, but there was a basic pattern in the classrooms. To start the children off in their study of writing, they were given boards covered with chalk and sticks with which they scratched the characters of the Tibetan alphabet (PLATE 74). As they progressed, they were given paper on which to write. The rather complex Tibetan alphabet is a Tibetan adaptation of Sanskrit and was introduced by the early Indian scholars who came to teach Buddhism. The literary form was primarily for religious use, and there were two forms of spoken Tibetan—one formal and another for everyday use. (The spoken language is of the Indo-Burmese group.)

At one school in Lhasa, Tolstoy saw a younger brother of the Dalai Lama—Lobsang Samten—at work on his studies. The only feature distinguishing him from his other classmates was his rather elaborate silk brocade robe and his shaved head, indicating that he was to become a monk. An ever-vigilant teacher hovered in back of the children. He was called Chim Din, and since he had been a monastic official at one time in his life, he had the reputation of being a stern disciplinarian. It was observed that he established his authority at the beginning of each school day by kicking open the door of the classroom quite forcefully as he entered.

It was the custom for class to be held in open courtyards whenever weather permitted—even in the winter.

Although all forms of education in Tibet were essentially religious in intent, the monastery schools were permeated with the

spirit of Buddhism. Tolstoy visited the school of Lhasa's Sera Monastery and saw the aspiring young lamas writing outdoors in winter sunlight. Many of the students already wore monks' robes and had shaved heads (PLATE 75).

The Western travelers also visited the courtyard school of Drepung Monastery in Lhasa. Here they saw advanced students in theology being led in debate by an instructor (PLATE 76). One day these students would probably attempt the final *geshé*, or "doctoral," degree. These degrees also were based, at least in part, on the student's ability to debate on scriptural nuances in the most sacred texts of Tibetan Buddhism, the Kanjur and the Tanjur. These texts were the first Buddhist scripture brought to Tibet.

Ilya Tolstoy, walking in the Barkor at the start of the great New Year celebration, saw a crowd of Tibetan students just released from school and ready to start the big holiday (PLATE 77). They were still carrying their school examination boards on which they had written their equivalent of exams. They headed straight for the booth of a man selling prayer flags and pages from Buddhist scripture. Hanging out new prayer flags was one of the most common ways of starting the festivities.

Matters of Life and Death

There was a dark side to Tibetan life that Tolstoy and Dolan also discovered. Tibet was a medieval country in 1942–43, and the justice system was medieval in the way decisions were arrived at and punishments imposed.

An interesting point to Westerners about the Tibetan system of justice was that capital punishment had all but disappeared. And although the system was hierarchical, as were most other systems in Tibet, the Dalai Lama, the undisputed ultimate hierarch, traditionally held himself aloof from most of the meting out of justice. It was

considered unfitting that the incarnation of the Bodhisattva Avalo-kitesvara—the Lord of Mercy—should participate in criminal cases and the harsh code of punishment that was the state's response to verdicts of "guilty as charged." In most cases the prime minister assumed the Dalai Lama's executive role in the legal system. The only cases in which capital punishment could even be considered by the government in Tibet were cases of treason.[14]

The premise in Tibetan justice was indeed for the punishment to fit the crime. A thief might be sentenced to work for the people he had robbed until reparation was made. However, a frequent offender might be dealt with more harshly. And in the wild border country where the nomads lived, justice was meted out harshly to those found guilty of banditry. Among the nomads themselves, reprisal or a loose system of mediation prevailed. Through mediators, for instance, a suitable indemnification for an act of theft would be worked out by mediators (sometimes even lamas) and then agreed to by thief and victim. All nomads were on alert constantly for raiders, and, in turn, were raiders themselves. Some groups developed very bad reputations as raiders of caravans, and it was these people that the central authorities tried to bring to justice.

In Gyantse, Tolstoy saw a young man, a convicted murderer, wearing heavy leg irons joined by a rigid iron bar (PLATE 78). He probably had killed someone of high rank, for the more usual murderers were put into irons that were somewhat easier to shuffle along in. A convicted murderer would stay in irons for life. He was free to move about during the day as best he could but he had to report to Gyantse's fort at night.

Conditions were considerably harsher in the Tibetan-controlled territory of Nagchu on the Chang Tang Plain. Here there was almost constant strife between authorities and the Drukpa nomads who lived by attacking the trade caravans and were given to slaughtering the people unfortunate enough to be in the caravans they robbed. Brooke Dolan reported a hair-raising conversation he had with a government official, Changchi Kenchung, about punishments given out in Nagchu: "Murder and lesser crimes are very common in Chang, robbery less rife than in Lhasa. Every prisoner or accused re-

ceives a hearing and of every crime there are many degrees, calling
for different punishments as at home. The hearing is of course be-
fore the Changchi only: jury trial is not known. The commonest
punishment is a lashing . . . 100 lashes is not considered severe for a
misdemeanor. For thievery, armed brigandage, or murder, the penal-
ty is loss of one or both hands or legs, which are cut above the knee.
To seal the arteries the stumps are at once plunged into boiling oil,
but the Changchi complains that many culprits die after amputation
of the legs. Such death compounds a sin which may rebound upon
the justice and his minions. 'Many prisoners,' remarked the Chang-
chi, 'prefer lashing to amputation but after severe lashing delivered
on the buttocks and just below the culprit is seldom able to walk
again as the muscles and tendons are destroyed. As many as 1,000
lashes are administered and death may ensue!' "[15]

In Kham and Amdo, Chinese justice prevailed, and beheading
was the way in which death sentences were often carried out. Tol-
stoy and Dolan saw the severed head of a robber displayed as a
warning to highwaymen in this remote area (PLATE 79).

Even in Lhasa, the harshness of the ancient laws sometimes
stood out in stark contrast to the tenets of the religion. It was
against Buddhist belief to kill, and that was why the Changchi with
whom Brooke Dolan talked was dismayed when a prisoner he had
flogged had the "bad taste" to die. Tibetan custom, then, condoned
reprisal and harsh punishments short of death, even though such
actions ran counter to religious doctrine. But the Dalai Lama, dis-
cussing the tenets of his faith in 1978, was reported as saying: "Un-
less you have some internal development in the religious field, the
external environment has a great and strong influence over you. It
also depends on each individual's intellectual capacity, attitude to-
wards life, and circumstances. But usually when I talk about Bud-
dhadharma [the teachings], I refer to two important points: one is to
help others, and the other is, if you cannot help others, not to harm
them. In these two you have the essence of the teaching of Bud-
dha."[16]

Although the Tibetans did not believe, at least theoretically, in
the taking of life, they had a very open way of dealing with death.

103

When Tolstoy and Dolan were in the city of Jyekundo, they saw the road outside a dead man's house decorated with the eight precious symbols of Buddhism; these were done in lime whitewash (PLATE 80). This was the way of marking the route of the funeral procession. The events following the funeral procession were rather more direct and practical.

The Tibetans did not believe in burial, as they couldn't afford to use good land that way, and they couldn't use scarce fuel for cremation; their way was basically ecological. Bodies were cut up by special butchers and placed on mountainsides to be eaten by Tibet's ubiquitous vultures, the country's sacred bird. Some of the skeletal remains were kept for use in religious art, and the leftover bones often were ground up as fertilizer for the soil. Only the bodies of renowned saints or incarnations were entombed.

Sometimes the bones of the dead were made into musical instruments for use in religious ceremonies. Skulls might be made into drums by sawing off the top and stretching skin over the opening. Leg and arm bones might become ceremonial horns. Skulls were also made into offering cups for use at Buddhist altars. These skulls were finished with silver or gold liners, set with semiprecious stones, and topped by intricately decorated lids of precious metals. Cups or chalices of this sort are highly prized by Western art collectors. Human bones also were carved and made into ceremonial aprons worn by monks during religious observances.

Since the goal of Buddhism is to reach the state of enlightenment, or Nirvana, these objects seen in daily use in religious ceremonies had the effect of reminding the faithful of their own mortality. Buddhist doctrine says that one of the greatest obstacles to enlightenment is *attachment*, particularly to one's own body.

The Roaming People

Nomadic peoples comprised forty-eight percent of the population of Tibet. There were seven tribal groups of nomads, and most of them led peaceful lives, despite the rather flamboyant few who lived as brigands. Like many nomadic peoples, the Tibetan nomads were herdsmen who usually lived in black yak-hair tents and tended their yaks, cattle, and sheep, moving seasonally. They moved to higher pastures in the summer, and lower altitudes in winter. Depending on conditions, they might move three to eight times a year. They lived principally in the more remote, harsher areas of the country. The greatest number lived in Amdo and Kham in the northeastern part of the country, though others lived on the great plain of Chang Tang in the north, and in the wild, remote sections of the west.

Although there were certain customs and a way of life common to all the nomadic tribes of Tibet, specific peoples made adaptations to the land they inhabited. The Drukpas were valley people, low-landers by Tibetan standards. The Drungpas were also valley people, but they lived in wooded rather than open valleys. The Shingpas were only seminomadic—they were farmers, in part—and lived at altitudes up to fourteen thousand feet.

The Dugpas lived in the highest habitable altitudes in the world, on immensely high grassy plains in the north, using the ground juniper scrub for fuel. The air was thin and dry and there was very little rain or snow. The temperatures ranged from seventy or seventy-five degrees Fahrenheit in the summer to minus ten or fifteen degrees in winter. The skies were usually clear in winter. When the rare storm developed in summer, it was short, but there were likely to be hailstones.

The nomads did not worry as much about rationalizing their meat eating as the city dwellers in Lhasa did. They killed antelope, gazelles, and yaks for meat, which was the mainstay of the nomadic

diet. This they supplemented with milk, cheese, and yogurt. They were apt to drink skimmed milk, since the butterfat was removed and made into balls, which the nomads dried on the tops of their tents to make a kind of cheese, or into butter to use in making buttered tea. The nomads often sold butter to the monasteries; the monks used it not only for food but also for burning in the traditional butter lamps that lit the holy places. *Tsampa*, the mainstay of the usual Tibetan diet, and rice were special delicacies for the nomads, and they did not eat vegetables or fruit. The nomads also killed wild animals for their pelts—especially lynx, snow leopards, and foxes.

The social order among the nomads was simple. The essential unit was the tent "circle," which usually comprised five or six tents but could number as many as eighty. There was one family to a tent—and, more specifically, one adult woman to a tent. Most marriages among nomads were monogamous, although there was some polyandry—the opposite of the arrangement of the aristocratic families in Lhasa. The essential duties of the men were to tend the herds, to train the saddle and pack animals, and to fight (when necessary). The men were also the hunters of the tribe, and they killed the herd animals that were to be used as food. The women milked yaks, made the butter and cheese, and collected dung for fuel. They wove cloth in their spare time.

Some nomadic families held property—pasture or farmland—and the herds were inherited equally by sons and daughters. If there were several sons in a family, it was considered unfortunate to have to divide the family's landholdings among them. Land was precious in Tibet. It was not uncommon for a woman to officially marry the eldest son of a family but, in practice, function as wife to all his brothers. The resulting children were legally the children of the eldest brother, whoever the real father had been.

The nomads were not isolated from the rhythms and patterns of general Tibetan life. They traded with peasant farmers for grain (mostly barley), tea, cloth, and implements. The most active trading time was just after the harvest in the fall, when the nomads were making their winter camps. At regular times in festival periods, gov-

ernment officials collected taxes from the nomads. These taxes were paid by the whole tent circle, not by individual tent families. The taxes were levied in trade. Since herd animals were the nomad's chief possessions they were usually the medium of barter.

Although the nomadic life was harsh, there is no doubt that the Tibetan nomads were often better off economically then the peasants. The nomads owned their herds, and through force and evasive mobility they held onto their freedom. Their main products (butter and meat) were always in demand—by the monasteries, but also by the peasants and the aristocracy. In addition, the nomads offered transportation and escort services that were highly valued. The Tibetan nomads were by no means a humble people. Through their proud boasts and swaggering manner they showed they knew their worth—and they were alternately feared and revered by the rest of the population.

Nomadic families were just as intricately bound into the Buddhist system as other Tibetans. If a family sent a boy into a monastery to be a monk or a girl to be a nun, they would receive a tax forgiveness. The children were usually quite willing to go into monastic communities, since they knew they would have better food and clothing than they had at home—and it was a prestigious honor to be a religious in a country dominated by religion. In most nomadic tents, there was an altar throne for visiting monks, and incense was burned every day. The older people carried prayer wheels and wore *malas* ("rosaries") around their necks.

Entertainment in the camps of the nomads was simple. It could be exciting to watch and dangerous to participate in, since acrobatics were performed on horseback and often roping contests with wild yaks and sheep were held. There were cross-country horse races of about four miles on which wagers were placed. The usual stakes were cattle.

The nomads did not have calendars, but they kept track of the passage of the year in their own way. In August they watched for a certain star to appear in the sky that told them it was time to start moving toward their winter encampment. In the fall, which was harvesttime, there was a tradition of night-long parties, with danc-

ing and drinking. This was the season when marriages were arranged, because it was a time when young people were apt to meet. Although parents contracted marriages between their offspring, nomadic parents were just as apt to give in to love matches as parents in Lhasa or Gyantse were. The travelers must have been bewildered at first when they noticed that nomad girls appeared to have unusually dark complexions. This was because they used a mixture of black grease (from yak butter) to protect their skins from the high winds. Over the centuries this darkening took on the distinction of being a symbol of beauty.

There were no formal schools set up by or for the nomads, but, of course, nomadic children acquired by a very early age a great deal of practical knowledge. They were taught to recognize footprints left in the grass by raiders out to steal their herds. They learned to put their ears to the ground to hear the approach of horses. Legend has it that they could hear horses three days away. The nomads had special speech patterns, communicating by rather courtly proverbs and set phrases. They might begin a conversation with the phrase, "From my little lotus mouth there are ten thousand words—I've been to the top of the snow mountain and my hat did not blow away." This opener indicated that the speaker was an experienced person with much to say and that he or she could be relied on to tell the truth. A favorite nomad adage was "The skin of an animal is as good as the compassion of the poorest parents."

A particularly succinct proverb about herds reveals the nomads' realistic sense of humor about the domesticated animals they relied on so heavily. Any domesticated animal will mate at any time in the year, so it was incumbent upon the herders to be particularly vigilant in keeping stallions, rams, and yak bulls from females at the time when mating would produce offspring in midwinter, when conditions were unfavorable for newly born animals. "They all have four legs," said the nomads about their sexually active herds.

Living beyond the law, some nomads raided the herds of other nomads in parties of forty to fifty men. The most common technique was to run the stolen herds until they were exhausted, and far enough away so that pursuit seemed unlikely.

The nomad bandits were tough and resourceful. If they were wounded, they urinated in the open wound to sterilize it. If bleeding wouldn't stop, they cauterized the wound with their flint lighters. If they had "taken" a bullet, they knew how to extract it with their knives. They made bandages with the membranes of animals or with torn bits of their own clothing; they soaked their wounds in hot springs. When nomad outlaws were on the run and ill, they had several standard remedies. Bile from a wild bear was considered a good tonic. Goat fat was healing for chronic sores and for abrasions. If all of their remedies failed, nomads on the wrong side and right side of the law might then resort to consulting visiting lamas or oracles for cures.

The Tolstoy-Dolan expedition encountered many nomads, both in populated areas and when they moved through nomad country. Near Rating they encountered three well-dressed nomad women—a wife of a chieftain and her sister and daughter (PLATE 81). Their hair was done in multiple braids. It was traditional among the nomads to braid their hair in multiples of nine, a sacred number. The family wealth was often attached to the braids of nomadic women in the form of silver coins and turquoise and other semiprecious stones (PLATE 82).

While traveling on the great Chang Tang Plain the expedition met a nomad family encamped by themselves (PLATE 83). There was an older man, the head of the family, with his young wife and six children. The man was trying to keep the fire going in the oxygen-thin air of the Tibetan highlands. He was using a bellows made of the whole skin of a goat. An iron funnel had been tied to the neck opening.

They encountered another encampment of nomads at the nearly derelict Pogne Gompa Monastery; the children were dressed in sheepskins (PLATE 84). As they went farther into nomad country they began to recognize the special adaptations the nomads made to their ancient way of life. Some of the nomads hunted with flintlock rifles, probably gotten in barter from traders or acquired by some less legal means (PLATE 85). Certainly every tent had at least one rifle. Flintlocks were not the most stable or accurate of weapons, but the no-

madic hunters learned how to steady them. They tied two long sticks to them which could be quickly planted in the ground, and then took aim. The kick of the ancient weapon was not so bad when it was used in this way. Tolstoy and Dolan observed that nomads on their saddle yaks had long bangs that almost covered their eyes, English sheepdog fashion. This, they discovered, was an age-old safeguard against glare and snow blindness (PLATE 86).

As the party moved deeper and deeper into the wild border country on their journey toward China, they began to see the Ngolok nomads. They were tall, strong, and inveterate bandits, coming from some ancient warrior stock. Ilya Tolstoy was bemused by the fact that the Ngoloks, in addition to their reputation for banditry and ferocity, were credited with great religiosity. A party of Ngoloks near Lake Koko Nor were wearing *malas* around their necks, while carrying lethal-looking swords (PLATE 87). A story was told in Tibet of the most notorious of Ngolok chieftains who decided to visit Lhasa for a blessing from the Dalai Lama—and to offer a substantial tribute. He was indeed received with great respect because of his fame and religious devotion. Although he was a wanted criminal in Chang Tang, he was given immunity while he was in Lhasa. And he did indeed receive his ruler's blessing out of respect for his military powers and his devotional zeal.

Before they left Tibet, Tolstoy and Dolan saw an astonishing sight in the Chinese-controlled Amdo province: over a thousand Ngolok nomads—mostly women in full tribal dress—were clearing a vast area in which the Chinese were going to build an antiaircraft emplacement (PLATE 88).

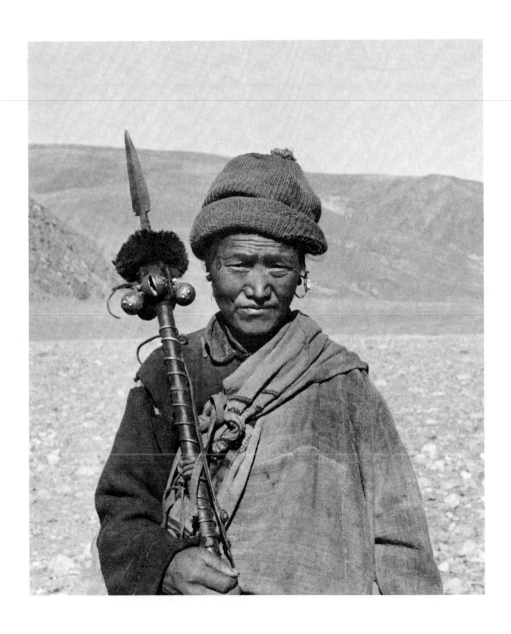

PLATE 47. *A mail carrier whom Tolstoy and Dolan met on the trail had bells on his staff to announce his approach.*

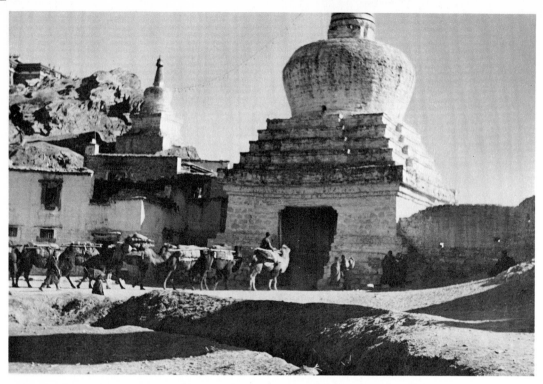

PLATE 48. *A camel caravan enters the main gate of Lhasa. Such an ancient means of transportation connected Tibet with the rest of central Asia.*

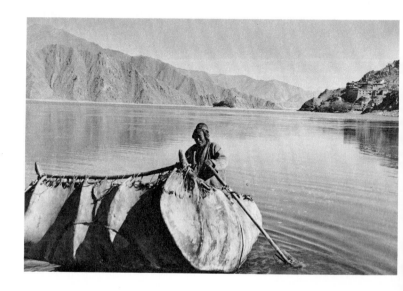

PLATE 49. *The travelers had to cross the Tsangpo River to reach Lhasa, and they were ferried in coracles like this one, a boat having a willow framework with yak skins stretched over it.*

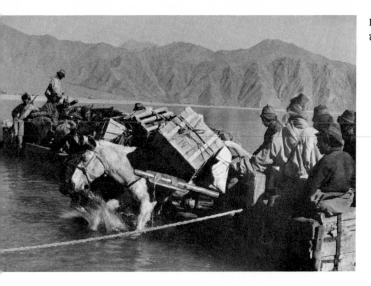

PLATE 50. *When there were pack animals to transport across water, flat-bottomed wooden barges were used.*

PLATE 51. *Fine ponies—attended by grooms—were displayed outside the Lhasa residence of their wealthy owners, the Bhondong family.*

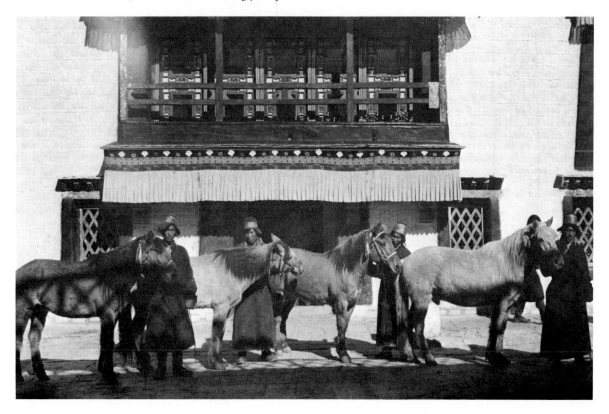

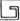

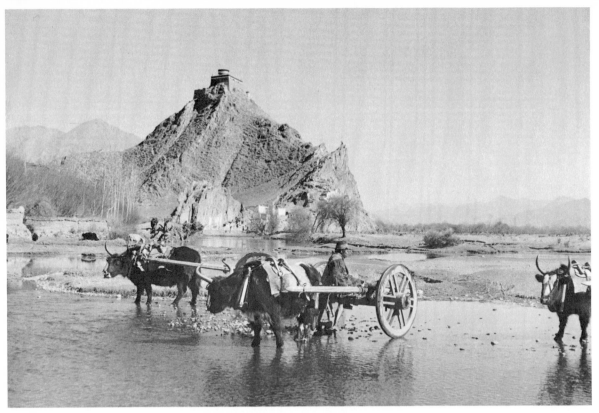

PLATE 52. *Two-wheeled carts crossing the Kyichu River with Chokpuri hill in the background. The medical college is housed in the buildings at the top.*

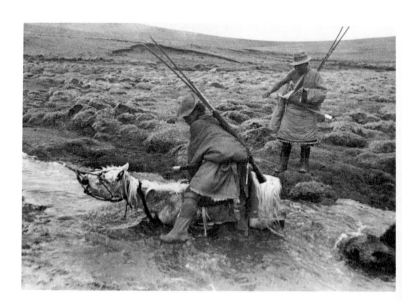

PLATE 53. *One of the expedition's sturdy pack ponies being pulled from a bog.*

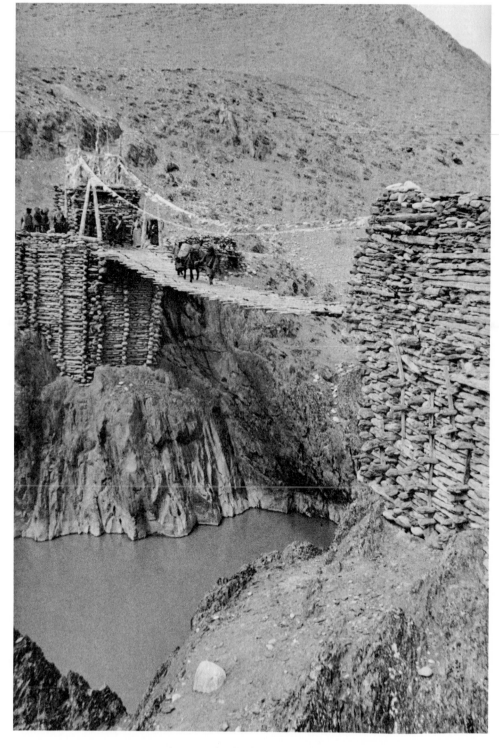

PLATE 54. *A suspension bridge over the Sog Chu River.*

PLATE 55. *The market in Gyantse was held within the city's monastery complex.
This is the area just outside the monastery walls where the pack animals were
unloaded.*

PLATE 56. *Inside the Gyantse market, goods were displayed on stone shelves that were rented from the monastery.*

PLATE 57. *The Barkor was the central bazaar of Lhasa, and it was sophisticated compared to the markets of smaller cities and towns. The ground floors of the buildings in the background were indoor shops, many of which were owned by Muslims.*

PLATE 58. *A butcher with a yak head. Butchers were* porus, *a group at the lowest level of Tibetan society; they were usually Muslim. The existence of* porus *allowed most Tibetan Buddhists to avoid killing for themselves.*

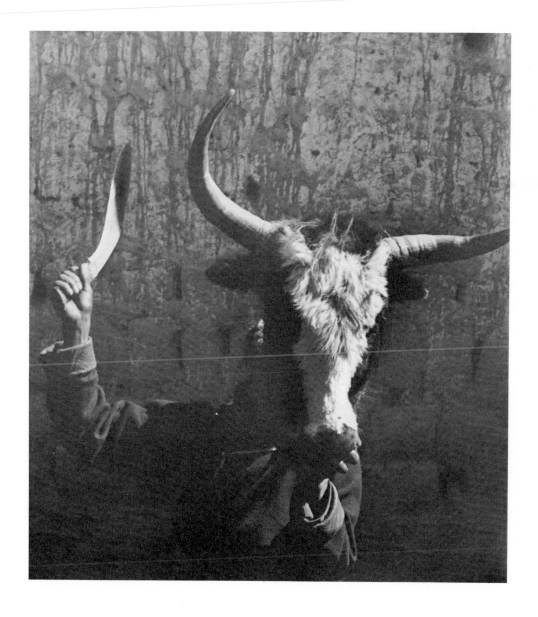

PLATE 59. *Lavish provisions were waiting outside the house Tolstoy and Dolan were to occupy when they reached Lhasa. Food was a traditional welcoming gift in Tibet.*

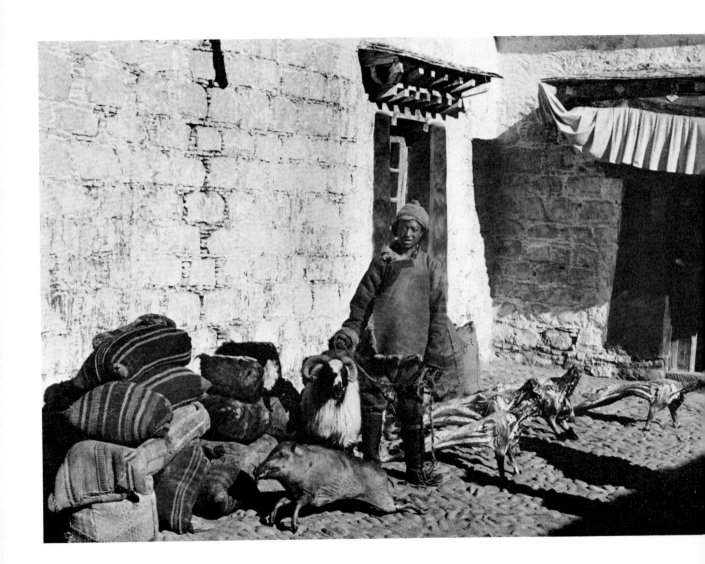

PLATE 60. *Samdup, one of the expedition's interpreters, went shopping in the Phari market wearing a Sikkimese hat. He is buying dried peas, feed for the expedition's pack ponies.*

PLATE 61. *A Tibetan peasant couple cook a meal on their own stove while waiting to cross the Tsangpo River by ferry.*

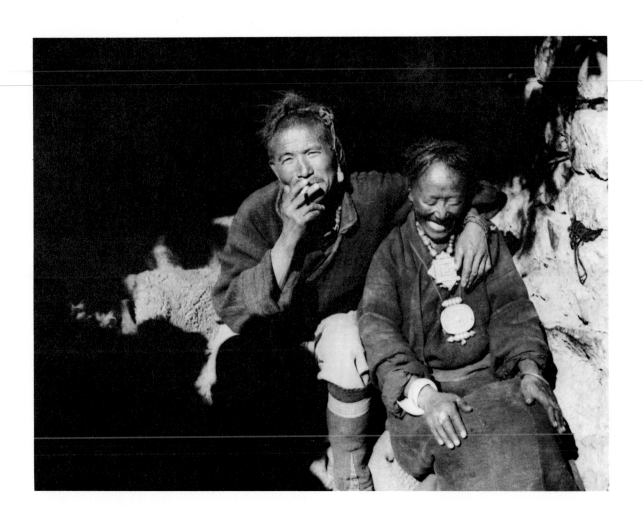

PLATE 62. *A particularly casual couple whom Tolstoy photographed on the road near Phari.*

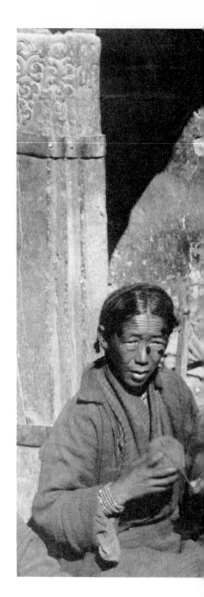

PLATE 63. *A young girl doing a crucial step in the processing of wool: carding. She is "combing" the fibers with a pair of metal-toothed cards.*

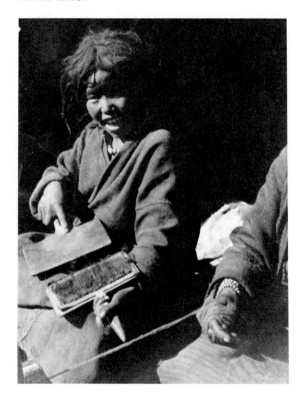

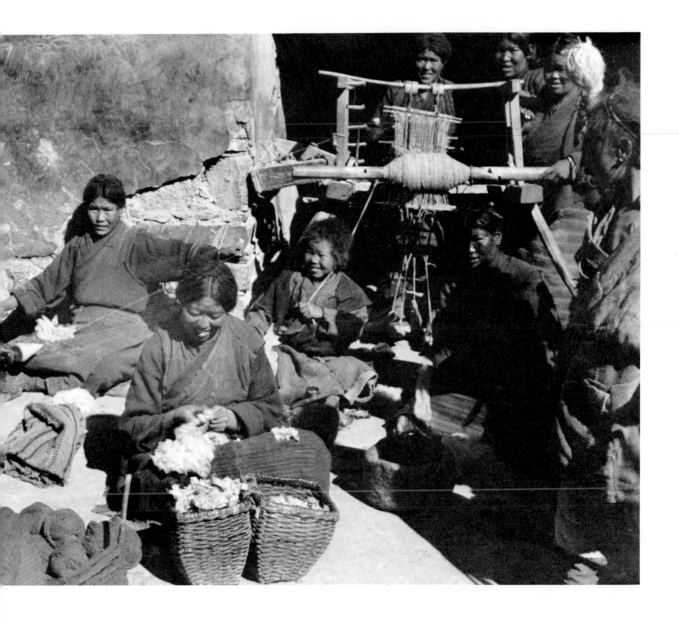

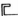

PLATE 64. *Women and girls did the work of processing sheep's wool and weaving the cloth, a major cottage industry in Tibet. The coarser yak fibers were used by the nomads to make their famous black tents.*

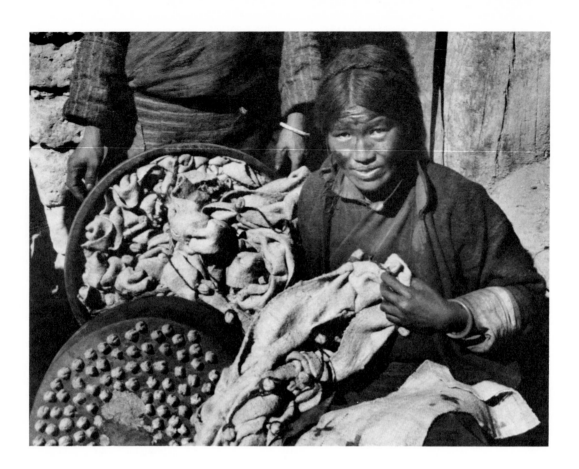

PLATE 65. *A woman preparing woolen cloth for star dyeing, a distinctive Tibetan patterning done in subtle colors. The saddle blanket seen in Plate 55 displays this classic Tibetan design.*

PLATE 66. *A Tibetan rug being woven on a hand loom. These smaller Tibetan carpets were used to cover chair seats and couches. They were not used as a floor covering.*

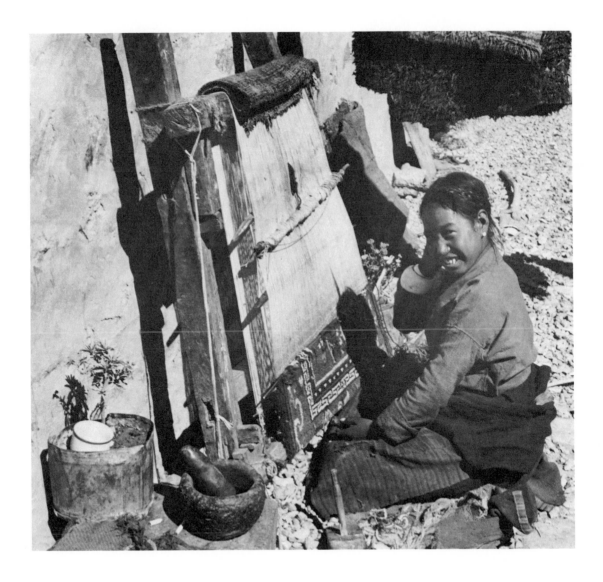

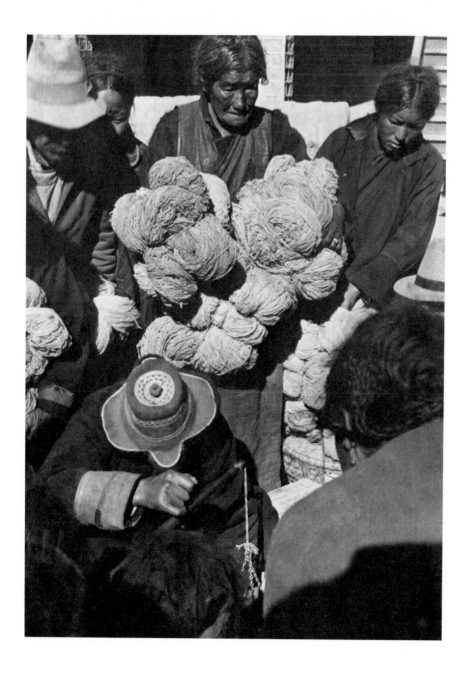

PLATE 67. *Wool brought in by Tibetan peasants being weighed at a British factor's station. Eventually, the wool would be transported into British India by pack animals.*

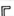

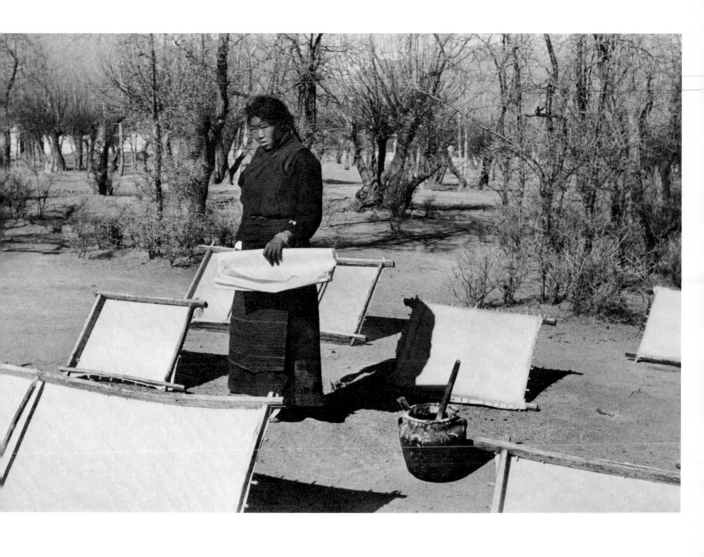

PLATE 68. *Paper was also handmade. A gelatinous paste was applied to cloth stretched over frames and then dried in the sun.*

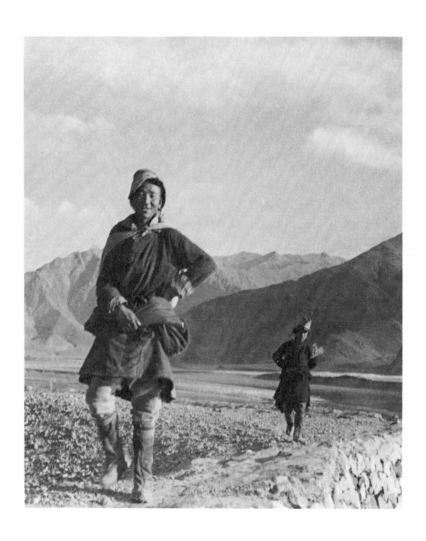

PLATE 69. *Peasant farmers walking along the edge of a field near Lhasa.*

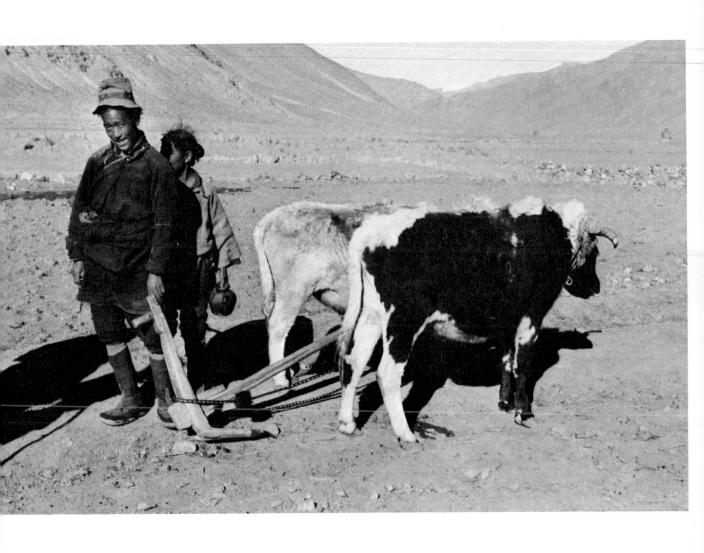

PLATE 70. *A farmer plowing his land with an ancient plow and a team of bullocks. The boy standing behind him has brought a pot of tea out to the fields.*

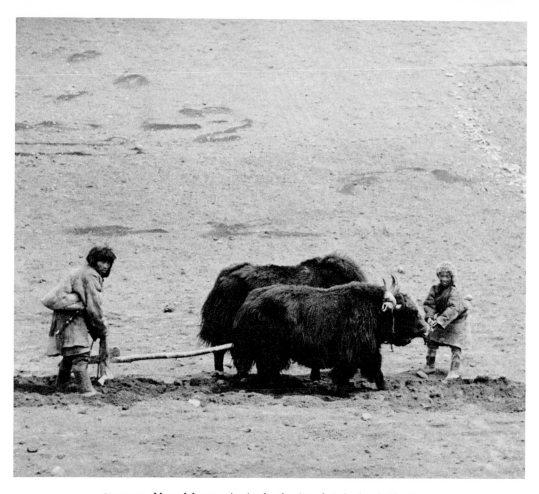

PLATE 71. *Nomad farmers in Amdo plowing their barley field with a yak team.*

PLATE 72. *A peasant woman helping to bring in the barley harvest. She wears a traditional Tibetan apron made of three bands of striped woolen fabric sewn together. Aristocratic women wore aprons of the same design but made of silk.*

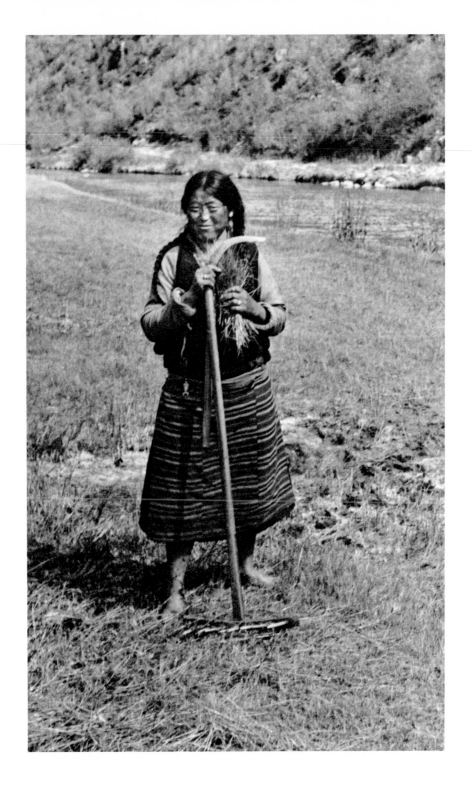

PLATE 73. *Two children playing* chibi, *a game whose point was to keep a small feathered ball in the air. The bare branches of the trees in the background clearly show the Tibetan style of pruning.*

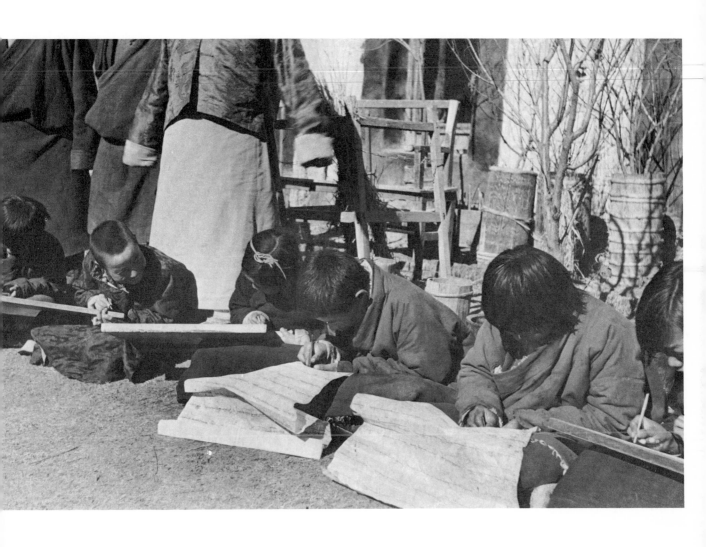

PLATE 74. *Tibetan children work hard at mastering the complex Tibetan alphabet. The well-dressed boy at left is Lobsang Samten, a younger brother of the Dalai Lama.*

PLATE 75. *It was an honor to study at a great institution
like the Sera Monastery in Lhasa. The two boys on the
left are novices* (getsels).

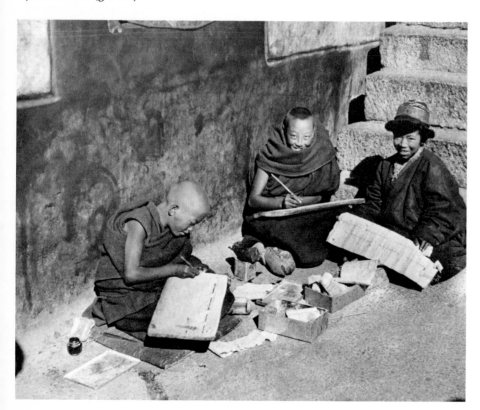

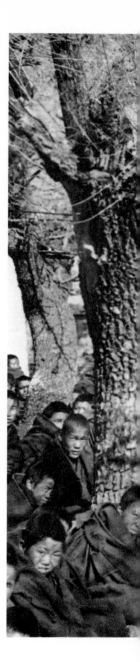

PLATE 76. *A class in the courtyard of the Deyang College, at Drepung Monastery. The senior monk is conducting theological debates, an important part of advanced education in Tibet.*

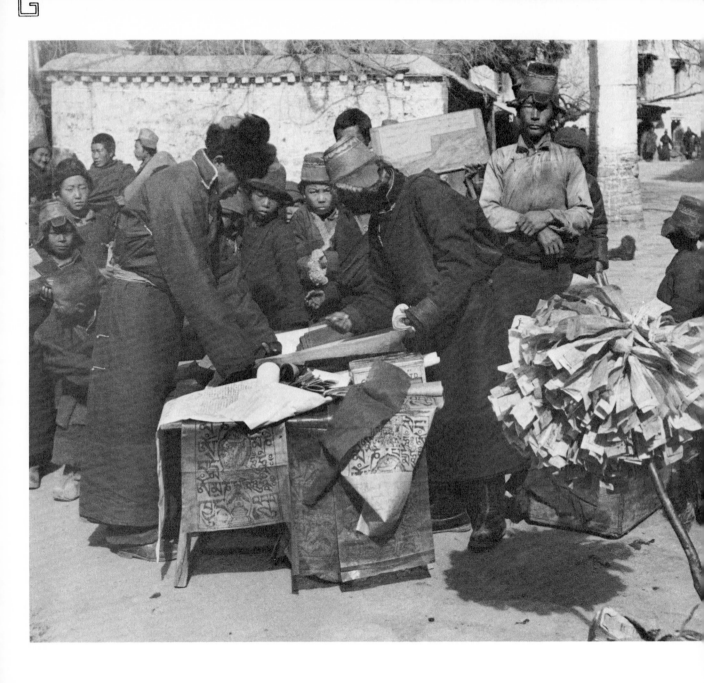

PLATE 77. *Young students with their examination boards, gathered around a vendor of prayer flags and pages of Buddhist scripture.*

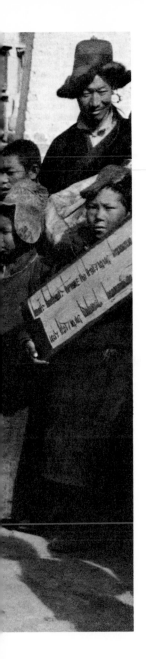

PLATE 78. *Medieval justice reigned in twentieth-century Tibet. This young man is a murderer. Although the death penalty was almost unheard of in Tibet, this man would remain fettered for the rest of his life.*

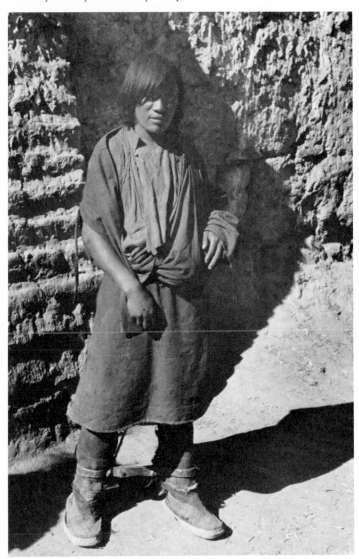

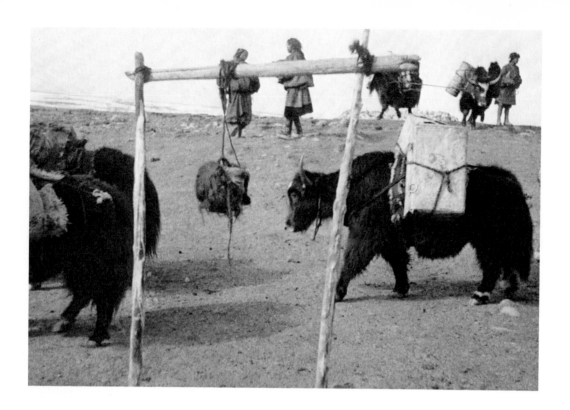

PLATE 79. *In eastern Kham and Amdo, the Chinese system of justice more often prevailed. The severed head of a bandit was displayed as a warning to others near the Sharadho nomad encampment. Brooke Dolan reported in his diary that the head had been there for four months.*

PLATE 80. *A family member of this house in Jyekundo had died. The designs in the road (the eight precious Buddhist symbols) mark the route of his funeral procession.*

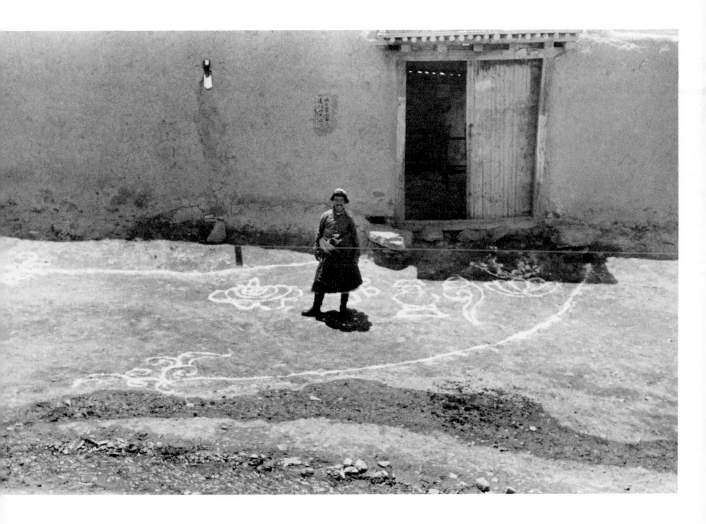

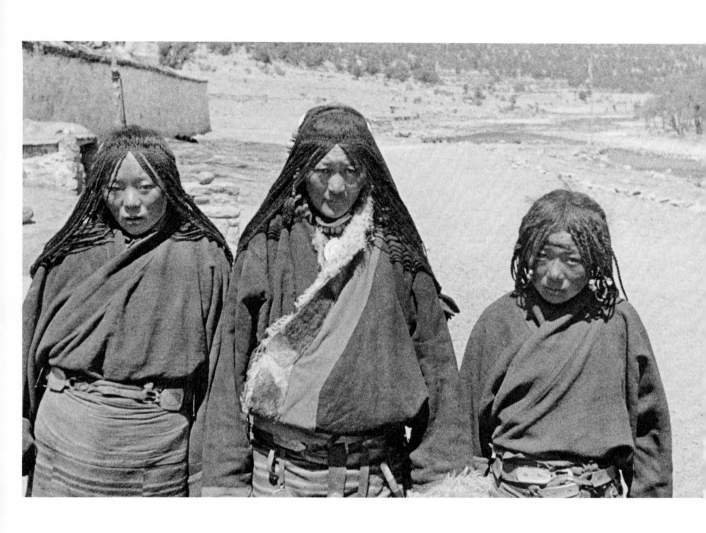

PLATE 81. *The Khampa woman in the middle, photographed near Rating, is the wife of a chieftain. She is flanked by her sister (left) and her daughter. Their hair is intricately braided in 108 strands, a religiously significant number.*

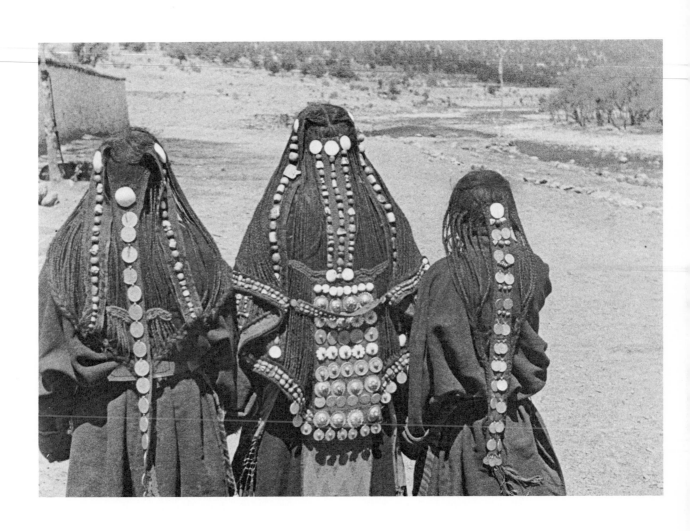

PLATE 82. *From behind, one gets a better idea of how well placed they are in their tribe. Their wealth is braided into their hair in the form of silver coins, turquoise, and other semiprecious stones.*

PLATE 83. *A nomad family on the vast expanses of the Chang Tang in northeastern Tibet. The head of the family (left) was sixty-five, and he had a young wife and six children.*

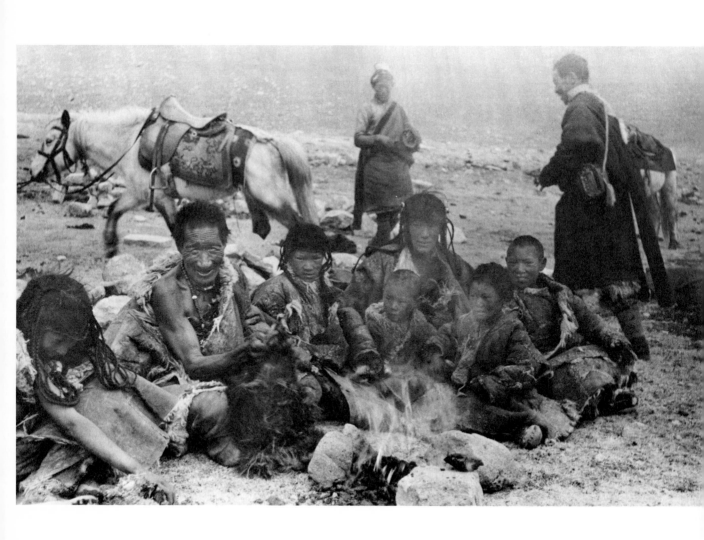

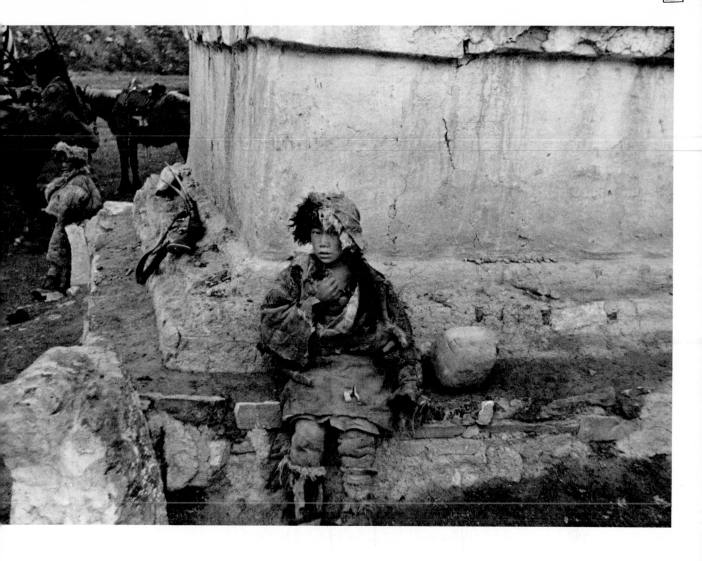

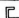

PLATE 84. *Tolstoy and Dolan came across another nomad encampment at the venerable but almost abandoned Kargu monastery, Pogne Gompa. The boy is sitting on the base of the monastery's chorten, dressed in his* chuba *and a sheepskin hat.*

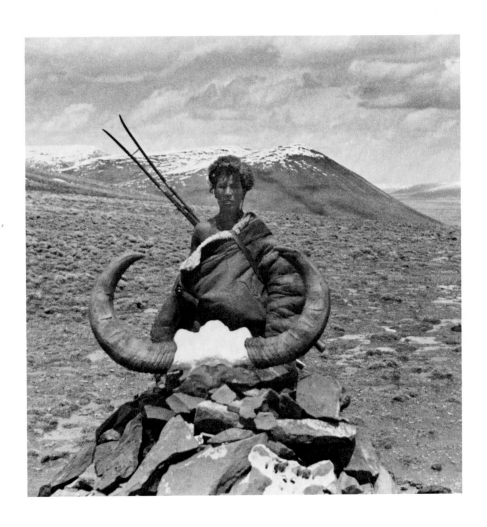

PLATE 85. *A young nomad posing between the horns of a wild yak.*
His flintlock is slung across his back.

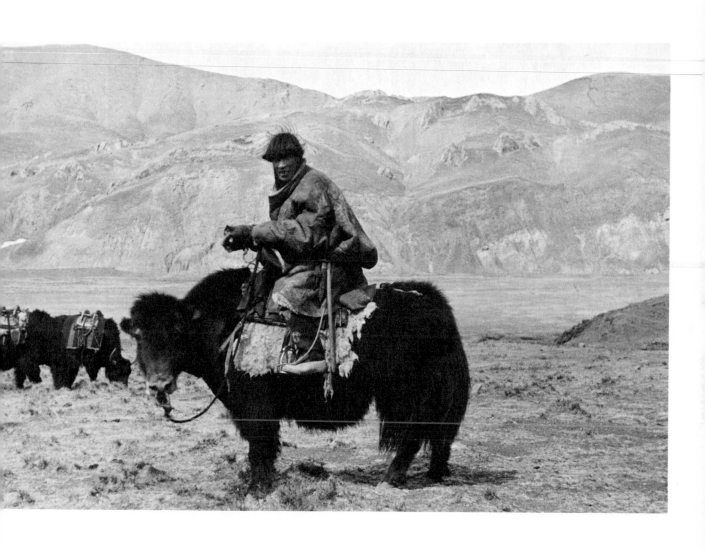

PLATE 86. *A nomad caravaneer sitting on his yak, equipped with a saddle blanket of sheepskin.*

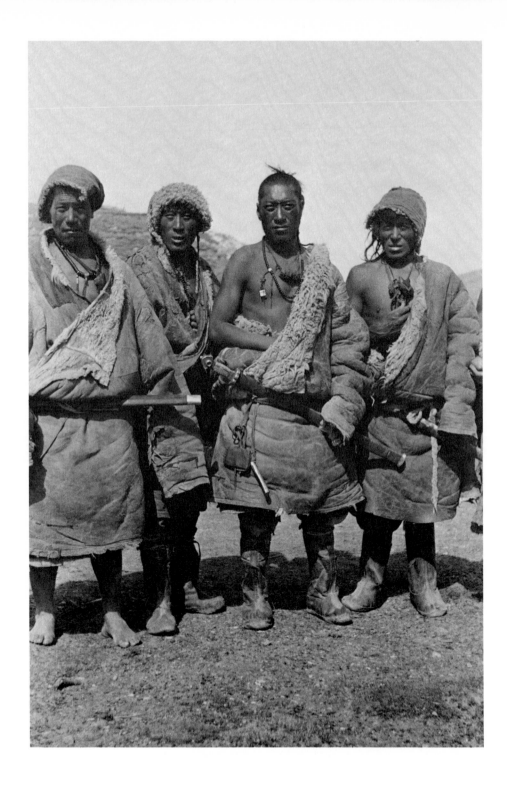

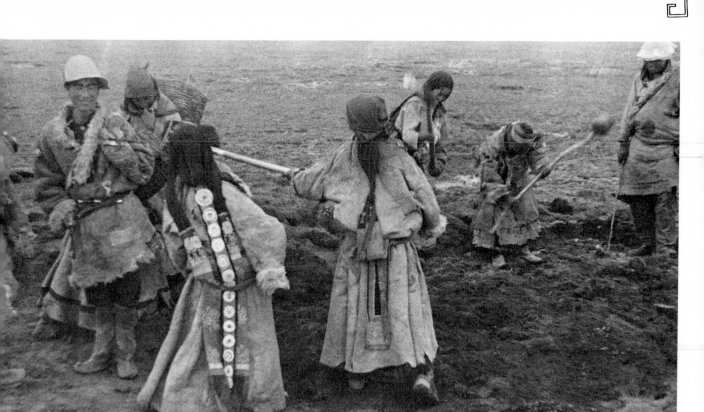

PLATE 88. *In Chinese-controlled territory, Tolstoy and Dolan found Ngolok nomads working as laborers, clearing the way for the construction of a Chinese military emplacement. At the left, a nomad woman wearing an elaborate Ngolok hairstyle.*

PLATE 87. *Ngolok nomads were notorious for organized banditry. These men are wearing malas (rosaries) around their necks. The act of telling the beads is called tan-c'e, which literally means "to purr like a cat."*

THE FESTIVALS

To Dolan and Tolstoy the astounding thing about Tibet was the degree to which the traditional festivals and commemorations of the year caught the full attention of the people and involved them all. Partly this was because Tibet was still a religiously centered culture and the festivals had a religious connotation. But it was also apparent that a busy schedule of events was important because the festivals were a form of entertainment and education in a land where almost no other public diversion was possible. Because only a small percentage of people were literate, reading wasn't a frequent home activity, although the people did have a repertoire of folk tales they were fond of recounting, many of which were quite ribald. And in cities like Lhasa there was a certain amount of diversion to be gained from listening to the news, which was sung in rhyme in the street. But the official festivals of the Buddhist year were the real events that people anticipated.

Festivals of one kind or another were held every month in Tibet, so the Tolstoy-Dolan expedition saw a good sampling of them as they passed through the country. The year began with the festival of the New Year, the great prayer festival, which was the longest and most elaborate. It was followed by Buddha's birthday. This was the day on which Tibetans were totally consistent with the tenets of their faith, and would allow no killing of animals—either by *poru* butchers or by hunters. Then there was the late-spring picnic festival when the people went into the fields, or to the parks if they lived in cities, and camped out for a week. Lhasa was deserted during this

153

festival. A month later, everyone made a religious pilgrimage to the nearest monastery. Because it was summer and the land was fruitful, it was the custom for women to abandon their fine jewelry and adorn themselves with green beans and red berries.

Further into the summer, on the seventh day of the next month, was a great event in the social and religious life of Lhasa. Everyone went to the Norbulingka palace in traditional Tibetan costume. Because it was an official residence of the Dalai Lama, there could be no smoking, drinking, or gambling. But there were other pleasures to divert the attention. For a week there were presentations of traditional Tibetan operas and plays, many of them seen only during this one festival.

The next month's festival was one of the happiest of the year. It was a kite-flying festival. When a kite mounted especially high, the string sometimes would be cut. In Tibetan belief, as in the beliefs of other peoples, the kite represented a prayer mounting to heaven. There were also contests of a rather warlike nature for the men and boys. Powdered glass would be glued to the kite strings and contestants would duel to see whose string would be cut, the kite soaring off into the sky.

In the ninth month of the year, there was another holy festival on the twenty-second day. On this day the Buddha was said to descend from the Tushita heaven on a flight of stairs or ramp. It was the custom, once more, to make a pilgrimage to a monastery to commemorate the event. In the tenth month, the preparations for the New Year actually began. It was the custom for everyone who could to whitewash their house on the fifteenth day—not painstakingly, but by throwing buckets of whitewash at the walls, a jubilant, celebratory act. It was also a custom to give money to anyone who begged for it.

On the fifteenth day of the next month, there was an elaborate celebration in honor of the Indian goddess Kali. In Tibet she showed her more benevolent side—she was the goddess of lovers. An image of her was taken from Lhasa's great Jo-kang Temple and carried into the Barkor, which circled the building, in solemn procession. At the end of the procession through the Barkor, an image of her symbolic

lover was brought out to meet her. This happy day was for gift giving, and it was traditional to give money to friends and to children. After the Kali festival, it was customary for everyone to put away their summer clothes and wear winter clothing; the reverse was done in the late spring, no matter what the seasonal temperatures were.

In the Tibetan calendar the eleventh month of the year usually fell in December of the Western calendar. During the eleventh month the death of Tsong-kha-pa was commemorated. He was the founder of the Gelukpa order of monks, the yellow-hat sect headed by the Dalai Lama. The feast was called the Ganden Namcho because Tsong-kha-pa had founded the Ganden Monastery in Lhasa, the third largest monastery in the country. Ganden Namcho was a festival of lights. In Lhasa the effect was magical. At dusk thousands of butter lamps were lit. Even the hillsides surrounding the city were lit by lamps brought by monks from the small monasteries in the area. The elder brother of the Dalai Lama, Jigme Norbu, who had studied at the monastery of Kumbum near Lake Koko Nor, describes the Ganden Namcho ceremony there: "In his honor his followers light thousands of lamps, and during the feast Kumbum was turned into a sea of light. The snow-covered temple and the other monastic buildings shone brightly in the light of innumerable butter-lamps and candles, whose flickering made the ice crystals give back a golden light. . . . It would be difficult to imagine a more beautiful and dramatic picture than that offered by the endless procession of red-garbed monks each holding a flaring resin torch."[17]

When Brooke Dolan and Ilya Tolstoy visited the wool city of Gyantse in November of 1942, they had a taste of Tibet's classical theater, the plays that were customarily performed by monks as part of religious festivals. They were lucky enough to see the famous Cham dances, so called because the historic and symbolic events they represent are symbolized in a highly choreographic manner.

The Cham dances were performed to the accompaniment of music played by monk musicians. The dances were meant to be enjoyed as entertainment, but they also presented religious messages and a bit of Tibetan history as well. The monk performers were

dressed in rich costumes of embroidered and appliquéd silk brocade. If a monk was playing the part of a god or some other unearthly creature, he wore a fantastic painted mask. All the gods in the Tibetan tradition fall into one of two categories, benign or horrific. They symbolize the extremes of human emotion. Buddhism teaches that meditation can often lead to enlightenment. Emotional extremes of any kind are believed to tie one to earthly concerns. Meditation on the extremes is thought to weaken their grasp on a person. Religious people generally understand the nature of the benign gods and the emotions they represent, but the doings of the horrific gods (called Dharmapalas) representing fear, death, lust, and anger, for instance, are more difficult—but they make for good theater. There were many horrific deities in the Cham dances.

Tolstoy and Dolan saw the Black Hat Dance. It tells the story of one of Tibet's ancient kings, Lang Darma, who lived in the ninth century. Lang Darma ruled after Tibet's warrior kings, who had conquered many distant lands and established the Buddhist religion in Tibet. Because Lang Darma favored the old ways of Tibet's ancient Bön religion and wanted to reestablish it, he destroyed many Buddhist monasteries and temples. There is a legend that a devout Buddhist monk of Lang Darma's day named Lhalung disguised himself by wearing a black-and-white reversible robe with the black side out and rode a white horse colored black with charcoal. He tied his horse to a tree by the river and approached the tyrant Lang Darma. Finding him unprotected, the disguised monk knelt in obeisance and when he got up shot Lang Darma with an arrow which he had concealed in his robe; in the general confusion that followed, he reversed his robe as he raced for his horse, and when he mounted, he was in white. Then he rode his horse into the river, and it too became white. But the searchers, looking for the man who had shot the king, sought a man in a black cloak, riding a black horse. Lhalung, after he made his escape, retreated to a cave, where he meditated. A villager who lived near Lhalung's cave suspected the meditating monk was the murderer of Lang Darma; when the monk was meditating he felt his heart, which was beating rapidly. But the villager kept quiet because he, too, was a Buddhist. After the reign

of Lang Darma, Tibet broke up into petty chiefdoms; the prestige of the monarchy was gone. The country remained fragmented in this way for four hundred years. This story is in many ways typical of the tales that were woven into the fabric of the Cham dances.

Tolstoy and Dolan saw the Black Hat Dance and other Cham dances at the monastery of Palkhor Choide Gompa in the center of Gyantse. The monk musicians began the ceremonial music (PLATE 89). They were wearing the classic crested yellow hats of the Gelukpa order and they played the long, telescopic horns of Tibet, horns so long they had to be supported on wooden stands. They were designed to sound long, clear notes that would echo from one mountain to another. The dancers began to move through their stylized patterns, the brilliant colors of their costumes standing out boldly against the ritually whitewashed walls of the monastery (PLATE 90).

There was some comic relief in the Cham dances. This was provided by two masked dancers who kept the audience amused in the intervals between the dances (PLATE 91). The masks these dancers wore caricatured the look of original Indian pandits (Ācāryas) who had brought Buddhism to Tibet. They had prominent hooked noses, typical, to the amused Tibetan eye, of the Indians, and they wore Nepalese-style *gao* boxes around their necks and Indian headdresses. They carried Tibetan horns called *kang gling*, which were made of copper and decorated with silver. The wandering Indian pandits, in the early days of the religion in Tibet, had blown horns like these to ask for food. In the Indian Buddhist tradition, monks are supposed to beg for their daily meals; the Tibetans virtually had eliminated this practice. The two humorous pandits always had incense burners hanging from their horns, which smoked throughout the performance.

The visitors also saw the Yama Dance (PLATE 92). The masks worn by the dancers were far from amusing. *Yama* was the traditional Sanskrit word for the lord of death—*shinje* is the Tibetan word. The dancers were masked and costumed to represent the lords of the cemetery—*citipati* in Sanskrit, *Shing yong* in Tibetan. The dancers resembled fearsome-looking skeletons. The bones of the skull seemed

157

to protrude from the mask and the mask had a crown of skulls too (PLATE 94). Masks like these were meant to be frightening in order to help the Buddhist meditator focus on and deal with his fears.

The visitors also saw a dancer representing one of the most popular figures in Buddhist mythology, the snow lion (PLATE 93). The snow lion appeared on the Tibetan flag. The stylized snow-lion figure was familiar in all of northern Indian Buddhist art. When the Buddha gave his first sermon in the Deer Park in India, his words were said to have the power of a lion roaring. The Tibetan snow-lion dancer carried a sword, and his papier-mâché mask, painted with brilliant colors, had a marvelously ferocious expression.

There were other animal-headed deities in the dances too. The deer dancer had an exceptionally beautiful robe and a pendant carved of human bone hung on a string of bone beads around his neck (PLATE 95). The deer mask itself was a combination of the slightly fearsome and the very fanciful.

After the performance, the Western visitors saw the monks removing their heavy masks—and with a good deal of obvious relief (PLATE 96). They wore knitted or felt caps to protect their shaven heads from irritation. The masks were both heavy and very hot to wear during the extremely vigorous dances.

Tolstoy and Dolan were in Lhasa for all of the Monlam festival, the greatest festival of the Tibetan year. Lhasa was the focal point of the celebration for the whole country. The city's population usually doubled during this holiday, with visitors from all over Tibet flocking to the capital. The festivities began, actually, with the Guthor festival, which came two days before New Year's day itself (called Loshar). The entire Monlam festival in all its parts lasted for more than three weeks. The Tolstoy-Dolan expedition had arrived in Tibet in the year of the Water Horse (1942 on the Western calendar). On Loshar (February 5, 1943) they saw the Tibetans usher in the year of the Water Sheep.

The official festivities of the New Year began in the Namgyal courtyard of the Potala, on Guthor. Several pageant plays were performed, as well as Cham dances. The theme of all the Monlam festivities was, in part, historical. The Tibetans were celebrating the

installation of the Great Fifth Dalai Lama as both spiritual and temporal ruler of the country. After the assassination of Lang Darma, which Tolstoy and Dolan had seen represented in the Cham dances at Gyantse, there was no central authority in Tibet. In 1247 the Sakya sect of monks came to power, and their founder Sakya Pandita was put on the Tibetan throne by Prince Godan, the Mongol ruler who was the grandson of Genghis Khan. The Tibetans were respected religious leaders among the Mongols and they were able to maintain an independent identity as a country with Mongol military support. This situation continued until 1642, when, at Shigatse, the Great Fifth Dalai Lama was proclaimed absolute ruler of Tibet.

The momentous event has been described by a Tibetan historian in this way: ". . . the Dalai Lama was led in state to Shigatse and placed on a throne in the audience hall of the palace. On two thrones a little lower than his sat Gushri Khan and Sonam Chospel. The Khan then offered the Dalai Lama the Mendel Tensum, which is a symbolic offering, consisting of a gold image of the Buddha, a book of scriptures, and a small chorten (stupa), representing the body, the speech, and the mind of the Buddha, respectively. The Mongol Khan then declared that he conferred on the Dalai Lama supreme authority over all Tibet from Tachienlu in the east up to the Ladakh border in the west."[18] The Tibetans then became the spiritual leaders of the Mongols while they still remained militarily dependent on them.

But there was more to the Monlam festival than a series of historical pageants and religious observances. The people celebrated in their own homes in simple and meaningful ways. Before Loshar itself, it was the custom to whitewash the house and put on new or clean clothing. It was also customary to pay off old debts. On the night before Loshar, parents put out new clothes near the pillows of their sleeping children. On the day before New Year's day, Tibetan women baked and cooked for any guests that might come. Cookies of all sorts were traditional for the beginning of the New Year celebrations. They were given to visiting friends and eaten by the family, too.

On New Year's eve, it was a family custom to have the house-

hold sit down together for dinner, masters and servants alike. A soup was served made of meat, cheese, and vegetables—and it had dumplings in it. Strange tokens or objects were hidden in the dumplings to reveal the character of the person receiving them. A pea found in the middle of a dumpling represented the qualities of frugality or stinginess. A piece of paper found in the dumpling indicated that the finder was a person who could be blown about by the wind—like paper—with no opinion of his own. Salt indicated that the recipient was not outgoing but knew his own worth, and a twisted piece of string indicated a gossip. Everyone was expected to drink nine bowls of the heavy soup—for good luck. In the course of the evening's celebration, two dough figures representing a man and a woman were paraded through the house and, when they had made the complete tour of the rooms, were thrown out the window. They represented the passing year's bad luck. The whole gathering applauded and cheered as they went out the window. At three o'clock in the morning of New Year's day (Loshar itself), the entire household would get out of bed and go to the family chapel or shrine for prayers, the elders leading, followed by the children. They then ate a bowl of wheat porridge for good luck. If they were a Lhasa family or visiting friends or relations in Lhasa for the holidays, they would go to the Jo-kang. Thousands of people dressed in their new clothes converged on the great temple in the small hours of the morning. When they returned home they set off firecrackers.

It was in the Namgyal Courtyard of the Potala that Tolstoy and Dolan saw the reenactment of the battles that established the Great Fifth Dalai Lama on his throne. It was indeed history come alive, for the performers in the pageant wore the uniforms and clothing of the period. They saw three men dressed as officers of the old Tibetan army (PLATE 97). They were shopkeepers or farmers in real life, but their families held the hereditary right to play these historical parts each year, and the costumes were passed down from generation to generation. They would wear them for the entire Monlam festival and they would then be put away for another year. These men were among about twenty such who were called "one-month officials" because of the hereditary parts they played.

160

Actually, the historical pageants and dances presented an even broader sweep of Tibetan history than the single event of the establishment of the Great Fifth Dalai Lama on the throne in the seventeenth century. For instance, there were almost five hundred people who portrayed Tibetan infantrymen of the seventh to ninth centuries, the days of the great warrior kings. They carried weapons ranging from ancient battle-axes to flintlock rifles and wore, in many cases, chain mail and traditional Tibetan army boots (PLATES 98 AND 99).

Tolstoy was particularly impressed with the shields carried by the mock infantrymen. They were made of very tightly woven bamboo, which would have been impenetrable to most arrows and spears, and they were decorated with feathers (PLATE 100). In the course of the pageant, when a retreat was staged, the symbolic infantrymen wore shields on their backs—and the feather designs, looking like faces, thereby created an illusion of advance (PLATE 101). When this part of the pageant was performed, the visitors noted, the audience laughed uproariously, some people shouting out, "Where did you hit me?" The Tibetans were no longer very warlike and they were apt to find the warlike goings-on of their ancestors funny rather than awe-inspiring. This attitude certainly spoke ill for the Tibetans being able to defend themselves in the modern world of armies and power politics. An even greater irony was added to the scene by the fact that although most of the performers who played the historic soldiers were civilians, the bowmen were real soldiers from the Lhasa garrison.

Brooke Dolan was fascinated with the military pageant at the Potala too. In his journals he describes a scene: "Two parallel files of bowmen have advanced to the center of the courtyard and are under the direction of a captain who stands at their head midway between the two files, as the great lama tubes of silver projecting from under a long tent on the east side of the court bray ponderously. The bowmen sway and stamp. . . . A spokesman for one file recounts the victories of his 'army' and taunts the leader of the opposing column. The latter replies that the bows of his brave soldiers were made for men and not for women. Unable to endure more the men of one file withdraw a pace or two and fit dummy arrows to their bows, while

the opposing file drops to the floor of the court, each man presenting his shield to the volley which is discharged at a sharp command. To satisfy the honor of both parties the roles are then reversed."[19]

Before the performance of the military pageant and historical plays, Cham dances were presented by monks. This portion of the celebration was symbolically presided over by Ho-Shan, the Chinese god of wealth, who was believed to be the patron of the Buddha's first sixteen disciples. The role of Ho-Shan was played by a monk in a bigger-than-life-size mask of the god's head (PLATE 102). He entered the courtyard to the accompaniment of music, bowed to the little Dalai Lama who was watching from a window high in the Potala, and took his seat on a throne of honor in the audience. The large-headed god traditionally was flanked by two short figures on either side of his throne who represented children.

The official celebrations were not the only ones in Lhasa during Monlam. There were wandering troupes of Khampa performers there too—dancers, singers, and acrobats from the province of Kham. They performed in the streets to their own music played on traditional instruments such as the *da-myen*, the Tibetan guitar (PLATE 103). When the men danced, they often did tumbling routines (PLATE 104). The audiences that gathered around were especially fond of their humorous acrobatics that involved mock accidents—one man pretending to fall from the shoulders of another. Then the women performed a dance, accompanied by drums, which began slowly and built up to a frenetic pace (PLATE 105).

Khampa troupes like this led almost nomadic lives, wandering throughout Tibet—and even beyond. The particular troupe that Tolstoy and Dolan saw during Monlam in Lhasa had just come from performances in India.

On February 6, 1943, which was the second day of Monlam, all the officials of the Tibetan government were expected to appear at an audience before the Dalai Lama in the Potala. They were dressed in ceremonial robes styled after court dress from the time of the Great Fifth Dalai Lama. They would present *katas* and other ceremonial gifts to their child-ruler. The exchange of gifts was an important ceremonial practice at the court of the Dalai Lama at many

162

points of the year. Tolstoy and Dolan had presented the ruler with gifts from President Roosevelt at an earlier audience with him—an autographed portrait of the President, a gold chronograph watch, silver models of sailing ships, and crystal vases. When they left Lhasa, the ruler sent gifts to the President in carefully wrapped boxes decorated with live flowers—gold coins and precious religious art, including *tankas*. Tolstoy and Dolan had confided to court officials that Roosevelt was an ardent stamp collector and might appreciate receiving Tibetan stamps, a rarity in the West. The Tibetans turned down the request, however, feeling that any gift made of paper was not suitable for the head of a great country.

At the Dalai Lama's Monlam audience, some of the officials were dressed in exceptionally valuable costumes. These were actually owned by the state and were passed out by a treasurer in the Potala for the occasion. The silk of their robes was the costliest of ancient silk brocade. They wore immense gold *gao* boxes set with semiprecious stones and necklaces of coral and amber. Long strings of turquoise beads were suspended from their ceremonial earrings. Around their waists they wore cloth bags filled with giant pearls (PLATE 106). When they prostrated themselves before their ruler, they spilled the contents of the bags at his feet, reflecting the ancient custom of giving costly gifts to conquering kings.

When all the gifts had been presented and all the prostrations made, the Dalai Lama blessed the assemblage individually and as a whole. Then monks would stage debates on sacred doctrine, and these, rather significantly, were followed by ancient sword dances. Toward the end of the audience, food was served, and both Tolstoy and Dolan were shocked by the melee of people who scrambled over the floor to reach the meat and bread.

It is estimated that about twenty thousand monks were among the hordes of visitors to Lhasa during Monlam. The government traditionally housed them in public buildings. They were then provided with money and food by the government. This was raised by donations from the wealthy earmarked for the purpose. It was customary for the wealthy to sell some of their jewelry for this purpose and to donate the proceeds to the state treasury. The treasury would

then offer the funds in loans at ten to twelve percent interest to anyone who needed them, and in this way have more than adequate income to provide for the visiting monks.

During the closing days of Monlam, archery and shooting contests and wrestling matches were held on the Trapchi Plain, just outside of Lhasa. This part of the celebration was called Yarsol. Before the contests began, it was customary for all of the participants to file in front of the Jo-kang in their historical costumes. Ilya Tolstoy was struck by the charm of seeing a mounted cavalry troop dressed in seventeenth-century Mongolian uniforms pass in review (PLATE 107). When they reached the front of the great temple, they presented *katas* to the city magistrates and publicly proclaimed their fealty to their ruler.

It was the custom to ask two prominent men to impersonate Mongolian generals at the time of Gusri Khan and, in effect, be hosts for the festival. This was a great honor but it was also an enormous expense. The two men had to pay all the costs of food and drink for the guests, of costumes for the participants, and of tents for the spectators. Two government officials of the fourth rank were chosen the year Tolstoy and Dolan went to the Yarsol. They did indeed wear the costly brocaded robes of ancient Mongolian generals and black fox-fur hats (PLATE 108). They rode to the playing fields on beautifully saddled and caparisoned ponies (PLATE 109).

One of the great expenses of the "generals" was to provide the assemblage with Tibetan beer called *chang*; it was brewed from barley. The women who served the beer to the spectators were called "*chang* girls," and it was the responsibility of the two "generals" to see that the girls were clothed in the finest silk robes and adorned with the costliest of jewels (PLATE 110).

In the early morning of the big day, the servants of the Lhasa aristocracy had an archery contest that was judged by a ranking government official (PLATE 111). Later, the more serious contest of the day would begin. Horsemen in ancient Mongolian cavalry uniforms would compete by shooting at targets with bows and rifles, while riding at full gallop. Their entrance onto the field was glorious to see in itself (PLATE 112). They carried their standards in their

hands, had quivers of arrows tied to their waists, and wore fantastic helmets topped with peacock feathers. There were also more conventional archery contests, and these contestants, too, were dressed in ancient Mongolian uniforms (PLATE 113).

The pageantry ended with a giant procession of monks, who carried their giant *torlma* (butter sculptures) to be burned in front of the Potala. There would be new ones the next year and, as far as they knew then, every year until the end of time.

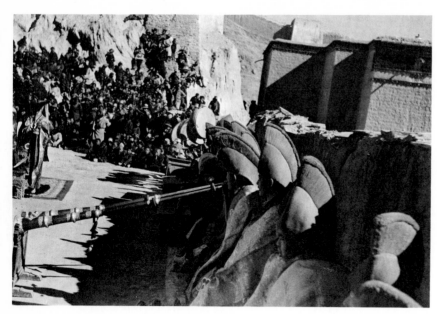

PLATE 89. *Long, ceremonial horns announced the beginning of the Black Hat Dance, which was to be performed at Gyantse's Palkhor Choide.*

PLATE 90. *The Black Hat Dance gathers momentum as the brightly costumed monks begin to move through the ritual choreography, which tells the ancient story of Lang Darma, the enemy of Buddhism. In this dance, he was often stabbed orgiastically in a cathartic act expressing the people's hatred of tyranny.*

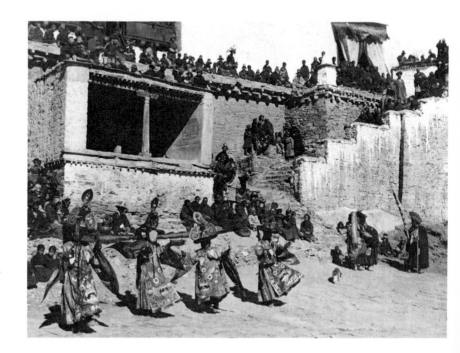

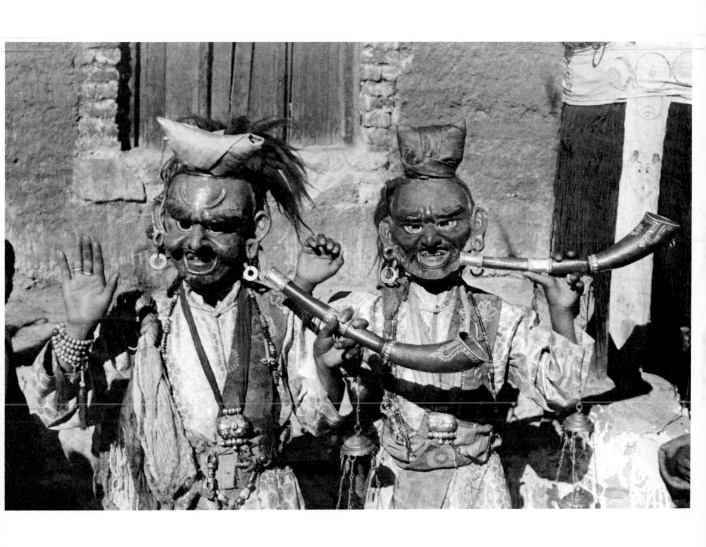

PLATE 91. *These two performers were the comic relief in the long ritual Cham dances. They are masked caricatures of the Indian pandits who first brought Buddhism to Tibet.*

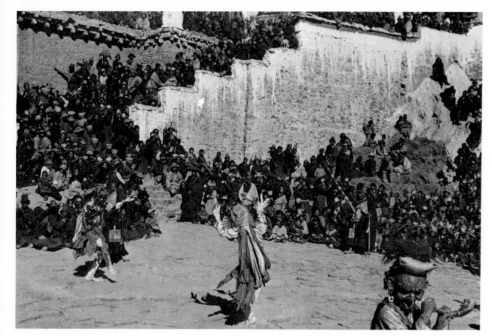

PLATE 92. *The Yama Dance is performed at Gyantse. The dancers are costumed to represent the skeletal Lords of the Cemetery—the assistants to Yama, acting as the Judge of Hell.*

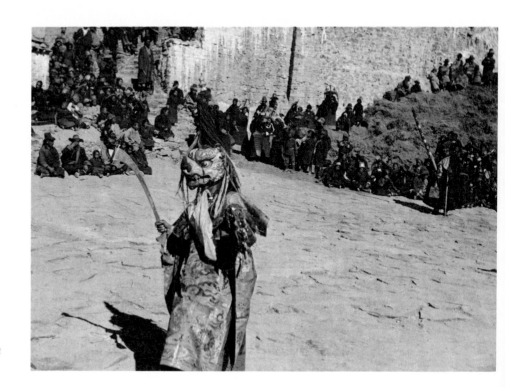

PLATE 93. *One of the most popular figures in Buddhist mythology, the Snow Lion, also appeared in the Cham dances.*

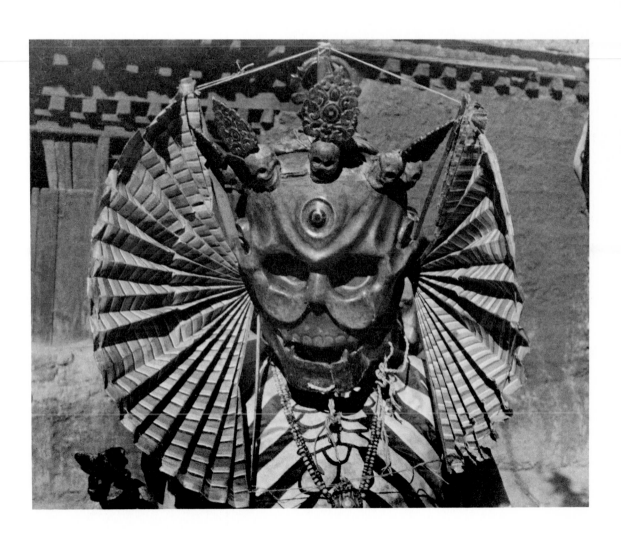

PLATE 94. *The mask of a Lord of the Cemetery is crowned with skulls and in the center of the forehead is the third eye of meditation.*

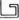

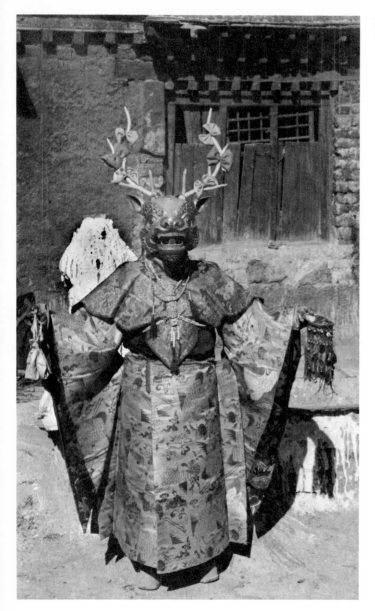

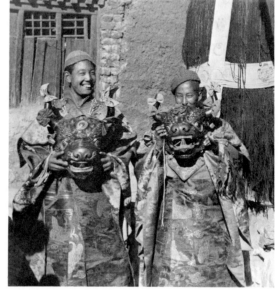

PLATE 95. *A stag-headed dancer, recalling ancient Bön (animist) concepts, performs in the Yama dance.*

PLATE 96. *Monk performers after removing their heavy deer masks. They wear knitted caps to protect their heads from the rough interior of the masks.*

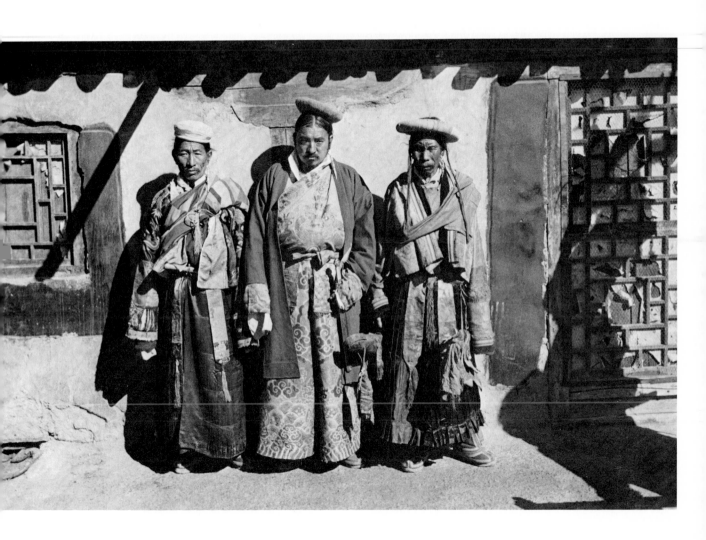

PLATE 97. *"One-month officials," as the Tibetans called these men, portrayed army officers from the country's warrior past in the Monlam celebrations. They inherited the costumes and the right to wear them. The man on the right led the traditional battle songs.*

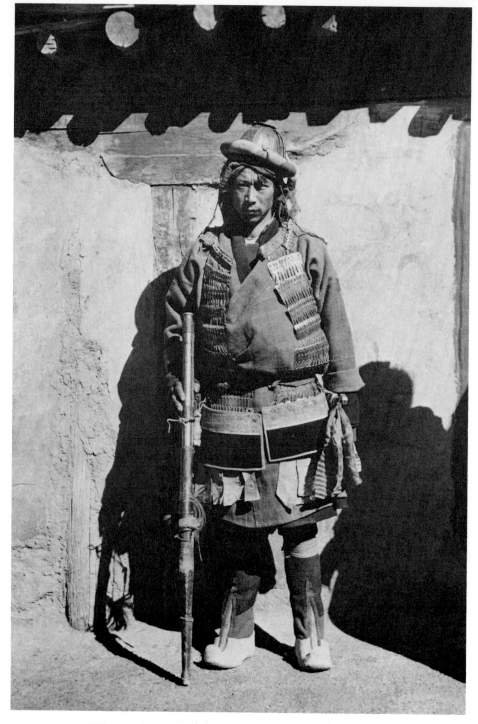

PLATE 98. *This Yarsol festival performer has a coat of mail, a flintlock rifle, and traditional Tibetan boots. The Yarsol pageant reenacted military struggles of the seventeenth century.*

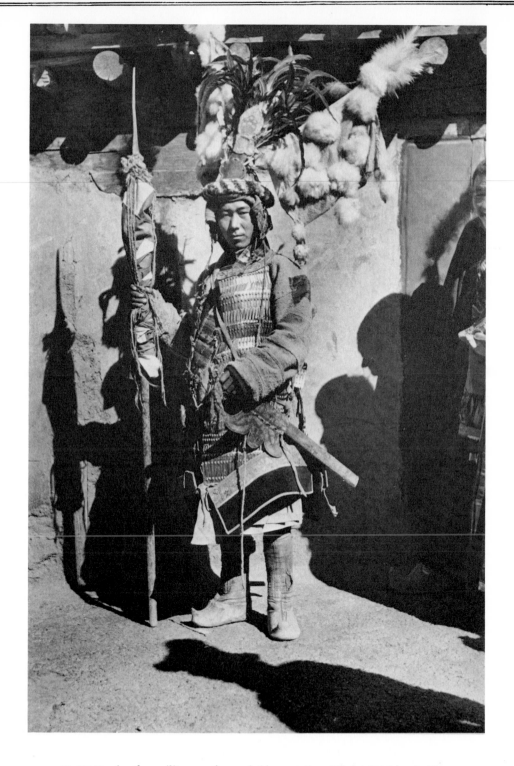

PLATE 99. *Another military performer holds an antique Tibetan battle-ax in his left hand.*

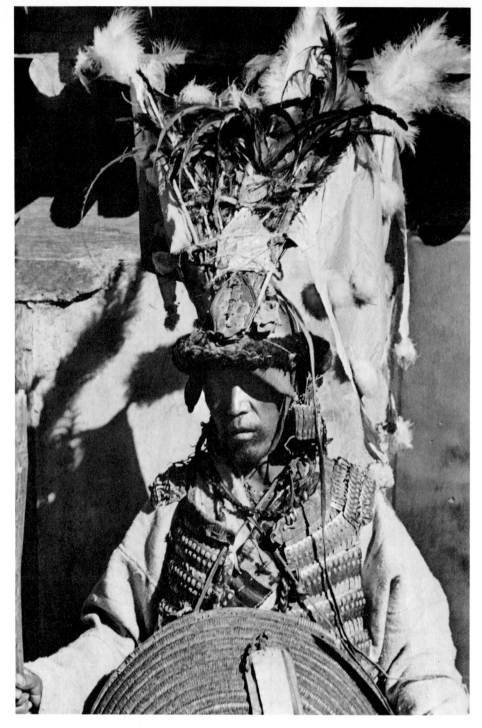

PLATE 100. *A Yarsol soldier, an infantryman, wears a vulture-feather headdress and carries an almost impenetrable shield of tightly woven bamboo.*

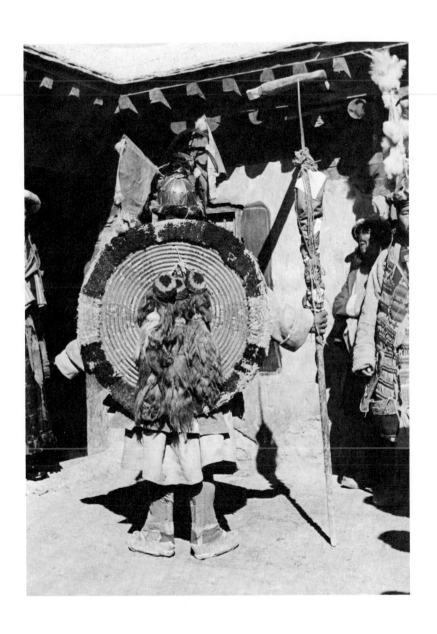

PLATE 101. *A shield worn on a soldier's back helped to confuse the enemy if the Tibetans were forced to retreat.*

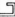

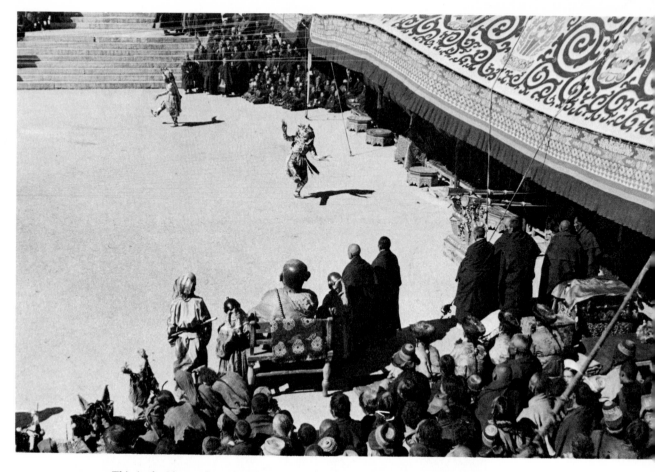

PLATE 102. *This is the Namgyal courtyard of the Potala, where Cham dances were always presented in honor of the approaching New Year. The enthroned figure with his back to the camera is a bigger-than-life-size masked representation of the Chinese god Ho-Shan (protector of the young), who presided over the dances.*

PLATE 103. *Khampa performers also came to Lhasa during Monlam. They were wandering players who sang, danced, and did acrobatics; they came from the province of Kham—hence their name.*

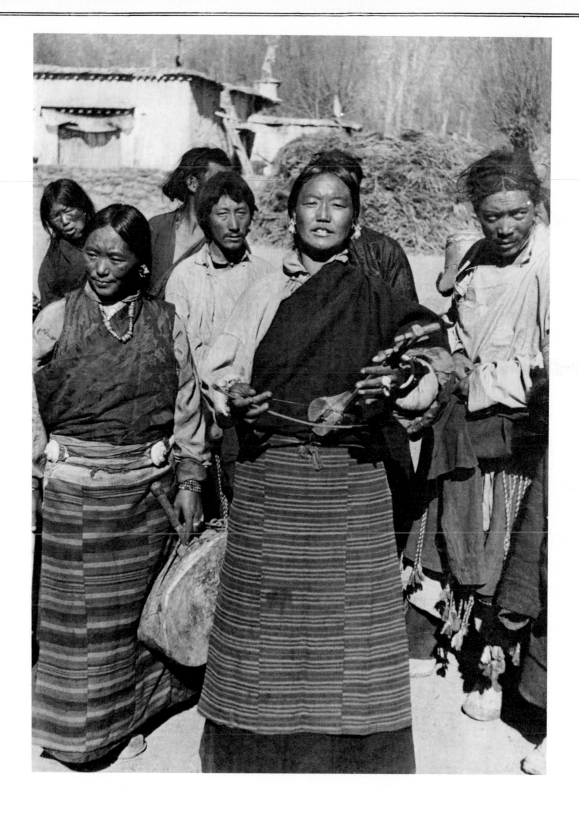

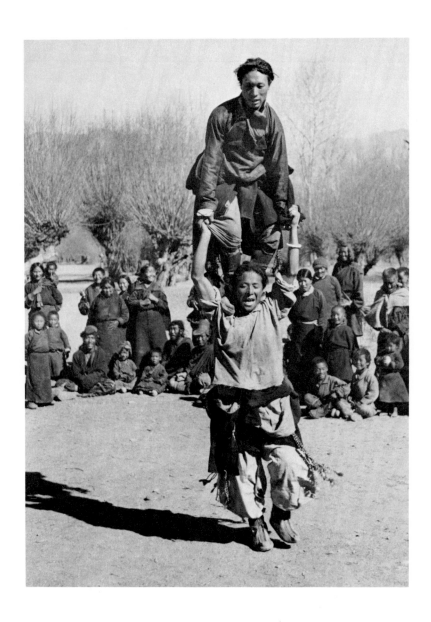

PLATE 104. *Khampa acrobatics generally were performed by the men in the company and were integrated into the total performance of dance and music.*

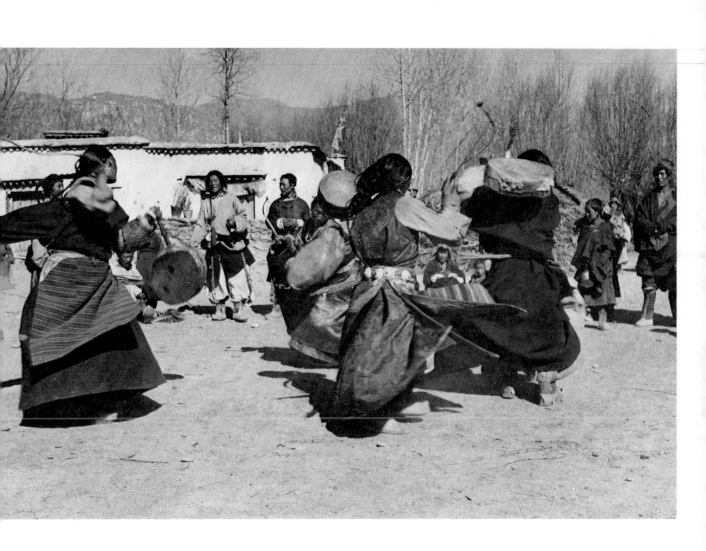

PLATE 105. *The dance of the Khampa women could become wild and abandoned.*

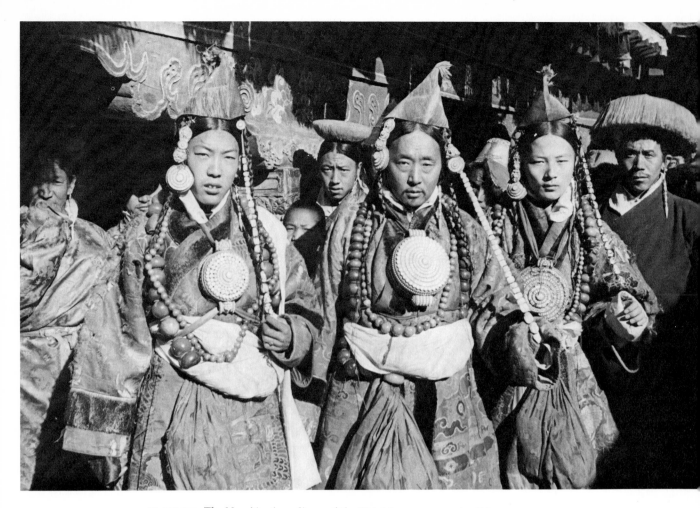

PLATE 106. *The New Year's audience of the Dalai Lama was a splendid affair. Important state officials wore antique costumes of great beauty for the occasion.*

PLATE 107. *A mock cavalry troop in seventeenth-century uniforms passes in review at the Jo-Kang, prior to the Yarsol pageant. The awning in front of the temple bears the traditional Buddhist symbol of the Wheel of Dharma.*

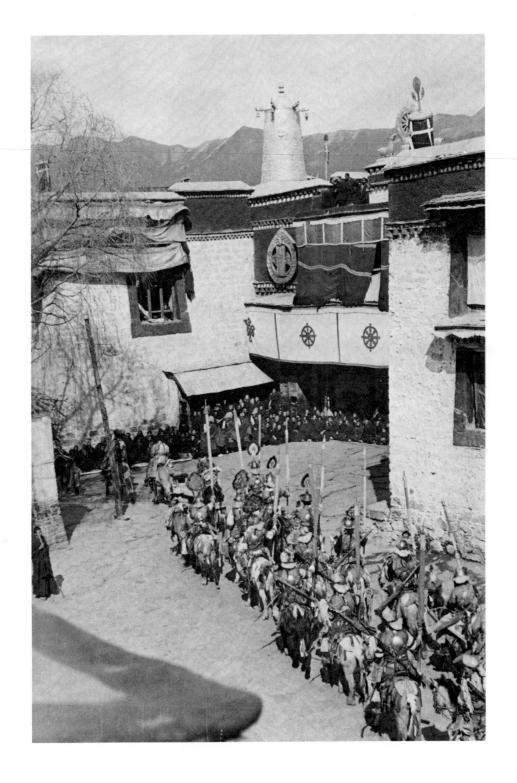

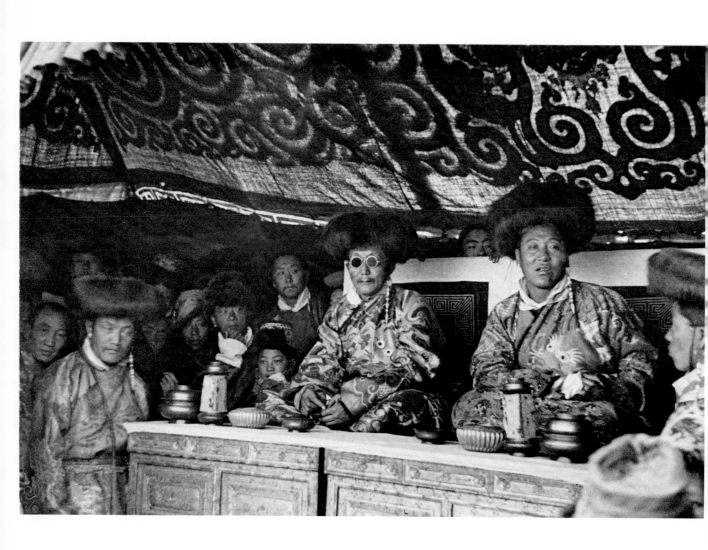

PLATE 108. *Two ranking government officials donned ceremonial robes—replicas of those worn by seventeenth-century Mongolian generals—to preside over Yarsol.*

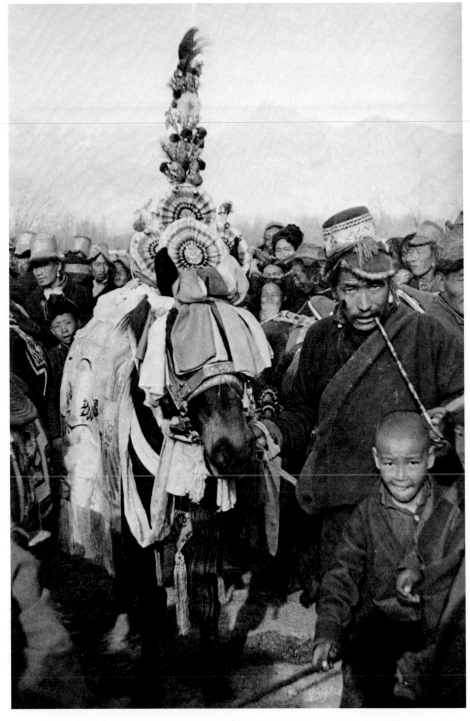

PLATE 109. *Each of the Yarsol "generals" rode out on an elaborately bedecked pony. The pageant and games were held outside Lhasa, on the Trapchi Plain.*

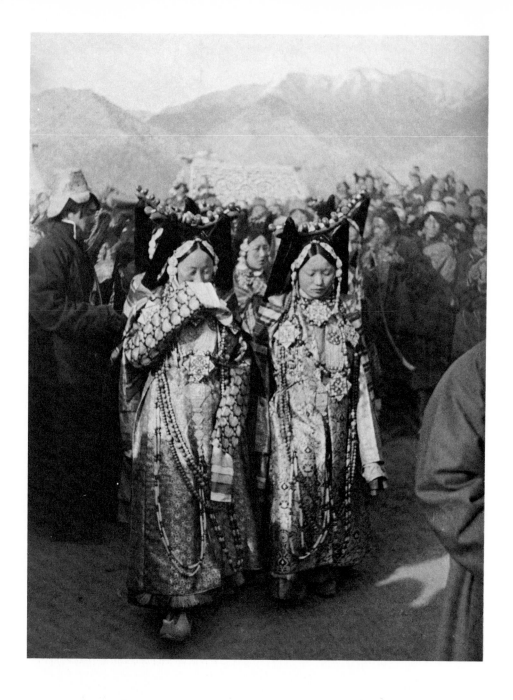

PLATE 110. *These magnificently dressed young women are the "chang girls."
They were chosen by the Yarsol "generals" to serve* chang *(barley beer) to
the spectators at the games.*

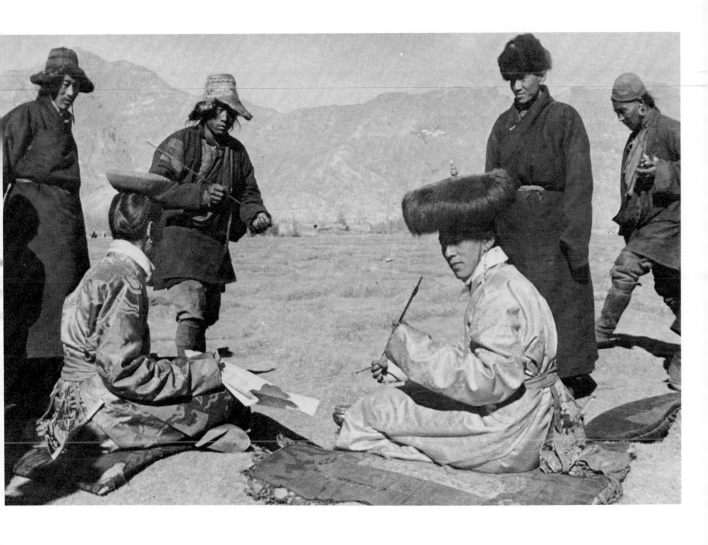

PLATE 111. *A high-ranking government official in a black fox-fur hat judges an early-morning archery contest held for the servants of the Lhasa aristocracy.*

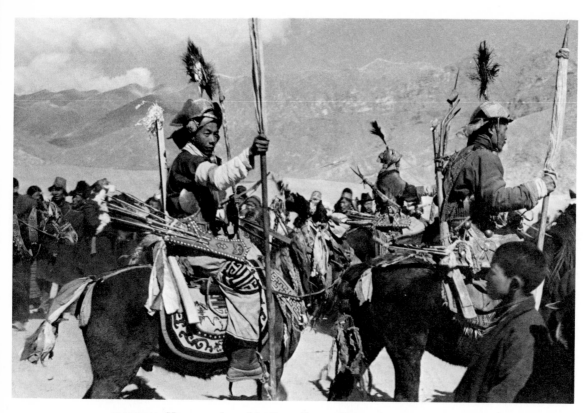

PLATE 112. *Horsemen dressed in the uniforms of Mongolian cavalry ride out to the Trapchi Plain. They will participate in contests of skill on horseback—including shooting at targets while riding at full gallop.*

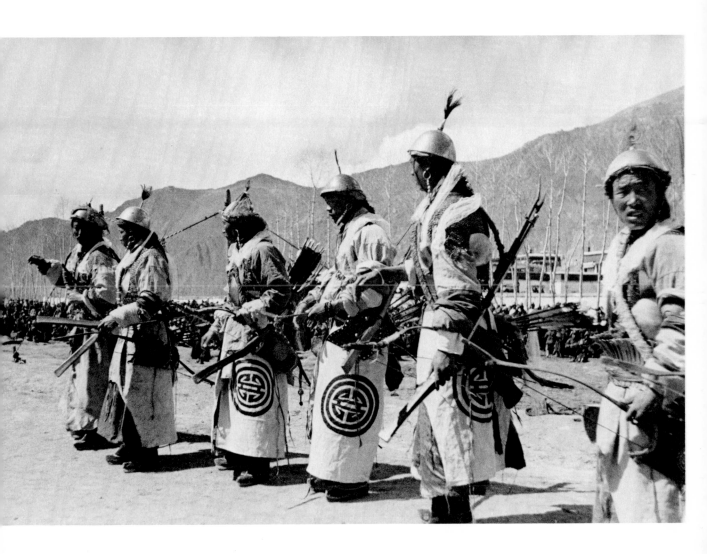

RELIGION

The Buddhist way is based on the life and teachings of the Indian prince Gautama Siddhartha (563–483 B.C.), who gave up position and wealth to become a sage. He lived as an itinerant teacher, and it is said that he reached, during his life, enlightenment or Buddhahood. The word *buddha* means the enlightened or awakened one. Like the Hindus, the Buddhists believe in reincarnation, or that each living being will recapitulate the cycle of life-death-rebirth until he or she reaches either union with the Godhead, as in Hinduism, or the state of enlightenment, as in Buddhism. The idea of reincarnation is not unique to the East. Plato had a similar concept and even some early Christian sects entertained the idea. Leo Tolstoy was among those Western intellectuals who became fascinated with the doctrine in the early years of the twentieth century. But he saw it from a master storyteller's point of view: "How interesting it would be to write the experiences in this life of a man who killed himself in his previous life: how he now stumbles against the very demands which had offered themselves before, until he arrives at the realization that he must fulfill those demands. . . . The deeds of the preceding life give direction to the present life."[20]

Buddhism was introduced into Tibet from India by the teacher Padmasambhava during the reign of King Tri-stong-det-sum in the eighth century A.D. Although Tibet had practiced the shamanistic Bön religion prior to that, Buddhism was by no means an unknown quantity when the teachings of Padmasambhava arrived. King Srong-tsen-Gampo, the predecessor of Tri-stong-det-sum, had two

wives, a Nepalese princess and a Chinese princess—both of whom were Buddhists. They already had established some of the basic concepts of Buddhism in Tibet. The ground was prepared when the great teacher came from India, followed by wandering pandits who spread the doctrine far and wide. Padmasambhava also introduced a written form of the Tibetan language derived from Sanskrit, the ancient and sacred language of religious India.

The Buddhism that was introduced into Tibet came chiefly from the great university of Nalanda, as it had evolved in the Indian Pala Dynasty. This was, essentially, the northern Mahayana Buddhism of the Vajrayana school. It was based on the tantric meditative discipline that was in favor in Bengal in the eighth century.

The heart of Tibetan Buddhism on a popular level can be better understood, perhaps, by a story Dolan was told in Lhasa: "He says that to Tibetans a good heart is everything, counterbalancing the wiliest sort of life, and without it good works avail not at all. As an illustration he told a story very popular with the Lhasa folk. A certain villager had lived all his life by slaughtering animals for the market and was deeply moved one day by the intelligence of a goat which somehow pushed his knife out of sight as he was about to butcher it. Overcome with pity for the goat, and with disgust for his long years of taking life, he forthwith threw himself from the cliff by a monastery above Sera and was transported straight to paradise. In a nearby cell in the rock, a hermit of great reputation for self-denial and piety, who had witnessed this drama and its miraculous ending, bethought himself that his own reward should at least be equal to that of a foul-living butcher and resolved to follow his example. But he was dashed to pieces at the foot of the cliff and found his way to hell—not paradise."[21]

The Western travelers began to see the ways in which Buddhism had revolutionized Tibet as they discovered vestiges of the old, pre-Buddhist Tibet in their travels. They were, of course, especially struck by the military pageantry at the end of the Monlam festival and they were also struck at the total removal of the Tibetans of 1942–43 from their own warrior past. The military games at the end of Monlam were considered amusement only, far from re-

192

ality for the contemporary—i.e., post–eighth century—Tibetans. The American travelers also saw vestiges of the Tibetan past in holdovers, among the nomads and elsewhere, of the old Bön magical practices. But these were only oddities and truly vestigial. Buddhism had converted all of Tibet, and with the institution of the office of Dalai Lama as both religious and temporal leader, the country was in all senses of the word a theocracy.

In the Tibet Tolstoy and Dolan visited, it was estimated that between ten and twenty percent of the male population became monks.

The expedition became aware of the religious world of Tibet early on. After they left Gyantse, Tolstoy and Dolan visited Samding on Lake Yamdrok, the monastery of the only woman incarnation in Tibet, Dorje Phagmo, the "Diamond Sow." During the first Mongol invasions of Tibet, so an old story goes, the abbess of the monastery, seeing the approaching Mongol soldiers and fearing pillage and the rape of her nuns, changed herself into a large sow and the nuns into piglets. When the Mongol troops entered the monastery complex and found only pigs, they were amazed. Then the abbess changed herself and her nuns back into human form. The Mongols were so overwhelmed by the miracle that they were converted to Buddhism on the spot.

Brooke Dolan recorded their approach to the monastery in his journal: "We ascended by stone steps each fifteen inches high to the first level of the temple. . . . We asked many questions relating to the history of this historic shrine but few were answered satisfactorily. Typical question: 'How many hundred years ago was the monastery built?' Inevitable answer: 'Many hundred years ago.' However we knew that the abbess, Dorje Phagmo, was a woman of learning, of Geshé rank, and presently we would have an audience with her. One last question: 'How old is the venerable abbess?' Answer: 'Six years old.' "[22]

In the temple they saw magnificent old chortens on the inner altars, silver-plated in some cases and inlaid with gold and semiprecious stones—turquoise, coral, amber, onyx, and opals. Above the main doorway of the monastery they saw a spirit trap, made from

193

colored wool yarn stretched across sticks (PLATE 114). The trap was supposed to ensnare evil spirits attempting to enter the holy place. They are also referred to as "sky traps." The history of these magic charms probably dates back to the old Bön religion of pre-Buddhist days. The North American Indians wove similar devices.

As the travelers neared Lhasa, they saw the road called the Linghor, which circled the entire city, including the Potala on the Marpuri (the Red Hill). It was more than five miles long, and every religious pilgrim to the city was expected to circumambulate the complete route—it was one of the greatest devotional practices in Tibetan Buddhism. And it wasn't a devotion restricted to visitors from the far reaches of the country. Some of the devout citizens of Lhasa made the ritual walk every day, usually in the morning when it was cool. Even before dawn, the Linghor was usually very crowded. The pilgrims often stopped at the foot of the Chokpuri, where the rock was carved with prayers and holy images (PLATE 115).

If a pilgrim to Lhasa had traveled a long way and conceivably might never make the circuit of the Linghor again in his life or, at best, not many times, it was the custom to do the pilgrimage on the Linghor by prostration (PLATE 116). This is a Tibetan practice in which the body is lowered to a totally flat position, face down, to indicate humility and devotion to a higher being. In this circumambulation, the easier way was to follow the road and measure progress by the length of one's body. This method took about three days. Pilgrims often wore mittens to protect their hands, and knee pads. The most serious devotees, however, made things more difficult for themselves by always prostrating in the direction of the Potala, which was to the right of the road. This meant that the progress was measured by the body's width. Doing it this way, the very devout spent five days circling Lhasa.

The grand or dramatic religious gesture was not limited to pilgrims and devotees on the Linghor. Drama was part and parcel of the ritual life of Tibetans. On the nineteenth day of the Monlam festival, the travelers saw a truly awe-inspiring succession of ceremonies. The ritual involved the monks of the three largest Gelukpa monasteries in Lhasa—Drepung, Sera, and Ganden. There were thir-

194

ty thousand monks involved. The essential ceremony was called Torgyap and involved the ceremonial burning, in front of the Potala, of the *torlma*, the giant butter sculptures.

First, a long procession of monks in Gelukpa hats descended the steps of the Potala, each carrying a drum (PLATE 117). There was music at every phase of the ceremony. When the vast procession reached the Doring Memorial Column, the historic monument in front of the Potala, a giant brushwood fire was built and the glorious *torlma* that had been labored over and painted so carefully were thrown into the fire (PLATE 118). This ritual act represented the dissolution of all negative qualities accumulated during the year just past—including war, famine, illness, and the negative mental and physical qualities of all the Tibetan people. Because the *torlma* that is burned was indeed a work of art that had involved great labor and artistic skill, the burning of the image represents the impermanence of all physical things, including precious works of art and the inevitable transmutation of all physical things from a material form to an invisible formlessness.

One of the most venerable figures in Tibet, the State Oracle of Nechung, was present at the Torgyap ceremony every year. Before the burning of the *torlma*, the oracle went into a trance, taking on the form, in Tibetan belief, of Yamantaka, the conqueror of death—one of the Dharmapala deities. At this moment and in this form, the Tibetans believed, the oracle could predict specific events of the year to come.

During their three-month stay in Lhasa, Tolstoy and Dolan were able to visit the three major monasteries in the Lhasa area. Drepung was the largest monastery in Tibet and, in fact, the largest monastery in the world at that time. There were eight thousand monks housed there. Drepung was nicknamed the "rice heap" because at a distance its countless small monastic cells looked like so many tiny grains of rice. There were many separate colleges or schools within the Drepung complex. The visitors were taken aback when they noticed that some of the monk officials seemed to have abnormally wide shoulders (PLATE 119). They learned that the broad-shouldered monks had duties that involved keeping order among

195

the vast legions of monks, and that these broad shoulders were the result of shoulder pads traditionally worn to give them a powerful and commanding look. Because of its size and wealth, Drepung played a major role in many aspects of Tibetan life. The administrative head of Drepung, a man with unusually broad shoulders, had an aide who carried his mace of office and called out his name and titles every fifty yards as the administrator made his progress through the monastery (PLATE 120). The mace was made of wood covered with a thin skin of silver. It was decorated with brass representations of the eight precious symbols of Buddhism.

The Lhasa monasteries were very influential in the Tibetan government. In fact, some of the monks were government officials. Within the monastery structure itself there were many levels of occupation. On the administrative level, there were monks who were responsible for running their monastery's landholdings in the Lhasa area. On a more humble level, there were some monks who were specifically charged with doing the housework—cooking and cleaning—of the vast establishments.

All three of Lhasa's major monasteries were Gelukpa establishments. The Gelukpa monks had a strong tradition of scholarship. When Tsong-kha-pa established the order, he did so with the specific intention of reforming monastic practices and reasserting scholarly standards. The Gelukpa monks studied the original Indian texts and scripture of their religion and learned to recite them by rote. This allowed them to quote appropriately and perhaps endlessly when they came to participate in the long debates by which they qualified, ultimately, for their *geshé* degree. The sacred teachings were in two major books, the Kanjur and the Tanjur. They also studied the "Perfection of Wisdom," the Buddhist "Doctrine of the Middle Way," the "Treasury of Philosophical Notions," and binding rules of "Monastic Discipline." The rules the monks lived by were called the Vinaya. These rules had been introduced gradually by the Buddha as he had to deal with complaints of lay people about the conduct of monks. Since the greatest number of monks entered the monasteries when they were quite young and unformed intellectually and spiritually, some of them later chose to pursue

196

lives as monks outside the walls of the monastery. This was permissible as long as they were able to keep their monastic vow of celibacy. If a Gelukpa monk could not maintain that vow, he did have to separate himself from the community formally.

Many of the rites Tolstoy and Dolan were able to watch took place in Lhasa's great central temple, the Jo-kang. Thousands of monks were there for the various rites and ceremonies of Monlam. Tolstoy and Dolan discovered that sacred food and drink were served in the venerable temple, as part of the ritual and sometimes out of necessity in the long ceremonies. With such vast masses of people involved, monastic proctors policed the monks in their various activities at the Jo-kang. Everything about the monks' ritual meals at the Jo-kang had been brought to a science over the centuries. The monks ate sitting on the floor, in long lines demarcated by white sand spread in front of each row of monks—to catch any tea or soup they might spill (PLATE 121). Each monk had his own wooden bowl, which was his constant companion. When it was not in use, it was tucked away in the folds of his robes. During Monlam, there were monks everywhere in the Jo-kang, even on the second-story roofs of the huge building. The Jo-kang was within sight of the Nechung Temple, where the State Oracle lived (PLATE 122). So many monks had to be served the buttered tea during the Monlam rites in the Jo-kang that huge iron caldrons, each holding a hundred pounds of butter, had to be set up (PLATE 123).

The travelers also visited Sera Monastery, the not always friendly rival of Drepung, and the second largest monastery in Tibet, with some seven thousand monks. The name *Sera* was sometimes translated as "Merciful Hail." The Tibetans liked to suggest that perhaps Sera was called Merciful Hail because hailstorms killed *rice* crops. Drepung, of course, was called the "Rice Heap." At times in their long histories, the monks of the two rival monasteries had been known to fight pitched battles over political issues.

Tolstoy and Dolan witnessed an eerie, beautiful tantric ceremony in the Nagpa College of Sera (PLATE 124). The major celebrants of the rite were seated on the floor in two rows, facing each other. Each participating monk had a ceremonial instrument called a *dorje*

197

("thunderbolt scepter") and a bell. At various intervals the monk rings his bell and, with a graceful hand gesture, moves his *dorje* in ritual circular movements. The monks were literally visualizing themselves as Bodhisattvas. First, they donned the robes of the deities whom they sought to "become." Then they put on the conical headdress of a Bodhisattva and, finally, the crown of the deity. At that point the monks will visually and mentally represent the deity. The ceremony ends by the monks removing the symbolic trappings of the Bodhisattva, piece by piece, until they have resumed their familiar monks' robes.

Tantric practices were part and parcel of Tibetan ritual and "respectable" within the confines and control of a proper temple or monastic atmosphere. However, Tibet also had advanced *nagpas*, or tantric practitioners. Some of these men were wanderers and some lived within the context of a monastic community. Because of their high development in tantric practices, they were considered beyond the ordinary disciplines of conventional monks. They could remain celibate or take a wife—the choice was theirs. Tolstoy and Dolan saw a rather typical-looking group of *nagpas* gathered outside Sera Monastery (PLATE 125). These men were wandering *nagpas*. Each man carried a bell in one hand and a *damaru*, a Tibetan drum, in the other. The drum was made from two half skulls (human) with thin leather stretched over them. There was a leather-covered metal disk attached to the drum by a string. When the *nagpa* turned the drum with a circular motion, the disk beat a rhythmical tattoo on both sides of the drum. A *nagpa* wore his hair long and in the style of the Indian siddhas—the famous wandering holy men. This *nagpa* tied a small book with the essentials of his guru's teachings written in it to the top of his headdress. A *nagpa* always wore a band of white fabric across his robe to symbolize the way of the Buddhist doctrine of diamond white light.

A *nagpa* was believed to be capable of performing the more overtly magical rites of Tibetan Buddhism. One practice, called Tum-mo, enabled the *nagpa* to generate an inner heat or warmth that could keep his body warm in the coldest of weather without the aid of clothing or a fire. The great saint of Tibetan Buddhism—Milar-

198

epa—is called the "Cotton Clad One." This is because he was a skilled practitioner of Tum-mo, which really has a great deal to do with breath control. He lived for many years in a mountain cave clothed only in a sheer, white cotton cloth. Milarepa, who lived in the eleventh century, was also a poet and wrote *A Hundred Thousand Songs*, one of the masterpieces of Tibetan literature.

"Space walking" is another feat of the *nagpas*. In this practice one is said to be able to cover amazing distances on foot in a short length of time. The "rainbow body" is a highly transcendental spiritual practice. The yogi can pass through solid objects, it is said, and walks in space, emanating rays of light; he has no shadow.

All these feats involve the *nagpa* merging with a meditational deity and, as a result, breaking the bonds of the physical body. The Tibetan teachers always have emphasized that these practices are potentially dangerous and can only be undertaken with the guidance of a competent guru. And the person who would become a *nagpa* must attain purification and a high level of virtue. There have been European travelers who maintain that they have seen these feats performed. Although the basic Tibetan attitude toward these matters is one of belief, there are those *nagpas* whose practices are considered to have crossed the boundary from religion to old Bön shamanistic magic and sorcery, for which the Tibetans had much respect. In Tsang Province in southern Tibet, the *nagpas* customarily were asked to control hailstorms that damaged the barley crop and were paid only if the harvest was brought in successfully. The Dalai Lama himself has commented on these practices: "In certain Tantric practices, there is one stage where there's no sort of inhibition or prohibition, and there's a lot of freedom. But that is only when you reach a very high stage; then the usual conventional rules don't apply—the whole thing changes."[23]

Every year at the Monlam festival the Dalai Lama or the acting regent made a ceremonial visit to the State Oracle in the Nechung Temple. In 1943, while Tolstoy and Dolan were in Lhasa, it was the regent who made the visit, since the Dalai Lama was so young.

The regent went to the temple in a palanquin, a covered sedan chair carried through the streets by twelve elegantly uniformed

bearers (PLATE 126). The palanquin was covered with rich brown velvet patterned with gold thread.

Tolstoy and Dolan were allowed to see the oracle in trance making his predictions for the coming year. When he had gone into trance, a huge bonnet weighing eighty to ninety pounds was lowered onto his head (PLATE 127). It was actually a tall headdress built on an iron base. It was decorated with peacock feathers, cock feathers, and vulture feathers (especially the fluffy feathers from the legs of the vultures—but when these were not available, cotton was substituted), gold, precious stones, and, in the center of the crown, an odd piece of red glass said to have an unearthly glow when the oracle was in full trance. The entire headdress was attached to his head by leather cords wrapped in silk. When he was not in trance and not endowed with superhuman strength, the oracle's attendants had to untie the bonnet or headdress quickly and lift it at once from his head. Its enormous weight could break his neck in his normal state. The oracle wore a thick, cloth bracelet on his left arm whose design was one of human eyes. This design indicated, symbolically, that the oracle could see into the future.

When the bonnet was in place and he was in full trance, one of the oracle's attendants pulled off a silk scarf that covered the oracle's polished steel mirror. The oracle was supposed to see the future in the mirror. In the center of the mirror the Sanskrit word *khri* was written; it meant "attention." As he began to enter the trance, musicians played. Gradually his body was possessed by the Nechung spirit. Brooke Dolan described the height of the trance in his journal: "On his face is an expression of anguish and his breath issued regularly in tortured hissing sounds. With a rush he gains the throne of the regent and sinks down before it inclining his head . . . he delivers in a barely audible voice the augury for the coming twelve moons. . . . A monk clerk trained to record the oracle voices takes down the messages as they are delivered. . . . But before the presentation of the scarves is completed . . . the Nechung faints dead away."[24]

Brooke Dolan went on to report that the oracle they met was a simple monk who, after the death of his predecessor, suddenly found himself possessed of the old oracle's voice. It was believed

that the oracle would retain the karma of the man that he was before becoming oracle. When he was not prophesying, the oracle was said to revert to the simple man he once was, interested in playing Mah-Jongg and in going to parties. He was very fond of gardening and was extremely pleased when the local British consul gave him some tomato plants. The Tibetans viewed him as a rather unfortunate man, valuable as his service to the state was, and he was thought to suffer a good deal in his trances. He also was said to be unhappy to have to live in the temple complex, since it was far from the center of the city and his friends had to travel a great distance to gamble with him—one of his chief enjoyments.[25]

In 1783, the Eighth Dalai Lama, who followed the then current custom of spending the month of September in tents in a park outside Lhasa, decided to build permanent buildings on the site. The complex of pavilions was called Norbulingka, literally, "Jewel Park." Since the time of the Eighth Dalai Lama, all the Dalai Lamas spent the summer months at Norbulingka.

Tolstoy and Dolan went to pay a ceremonial call at the favorite pavilion and residence of the Dalai Lama in the Norbulingka. They were met at the beautiful doors of the pavilion by Doring Teiji, the chief lay custodian of the palace complex, and by the palace's monk administrator (PLATE 128). When they passed through the doors, they found the pavilion ornately furnished by Tibetan standards. Instead of the oiled clay floors found in many Tibetan buildings, there were polished walnut floors. The walls were covered with *tankas*. They saw the bed of the Dalai Lama and, in the pavilion's altar room or chapel, there was a life-sized sculpture of the Thirteenth Dalai Lama. They convinced one of the monk attendants to bring out the Dalai Lama's official cup so they could photograph it in a courtyard, in better light (PLATE 129). The cup was made of jade and had a gold stand and cover. The monk who carried the cup covered his mouth with his robe so he would not profane the precious object with his breath. It was the custom in Tibet to "protect" the holiest objects in this way. And it applied especially to the possessions of incarnations. There were hundreds of incarnations, or *tulkus*, in Tibet in addition to the Dalai Lama. All of the major monasteries had several. They were found in the country's four religious sects: the

Nying-ma-pas, who trace their heritage back to Padmasambhava; the Sakyapas, who were organized in the late twelfth century and were firmly established by Sakya Pandita in the thirteenth century; the Kargupas, who were organized at about the same time as the Sakyapas and whose lineage goes back to Marpa, the translator whose main disciple was the famous poet Milarepa; and, finally, the Gelukpas, who were organized by Tsong-kha-pa in the fifteenth century.

By the twentieth century, the Gelukpas were the most numerous and powerful monks, since they ruled the country through the office of the Dalai Lama. During the Dalai Lama's childhood, the time when the Dolan and Tolstoy party was in Tibet, regents ruled for the little boy. They were chosen from Gelukpa monasteries and they were usually incarnations themselves. The first regent to rule Tibet after the death of the Thirteenth Dalai Lama was the Rating Regent, so called because he came from Rating Monastery. He ruled from 1934 until 1941. He was a young and popular regent, but after the state astrologer predicted he might die if he did not retire for meditation, he resigned his post and went back to his monastery. It was here that he received Dolan and Tolstoy (PLATE 130). Still a revered figure, he was richly enthroned. In Chinese porcelain vases around the throne were paper flowers representing roses, zinnias, and marigolds. He wore brocaded silk robes trimmed with fur. Brooke Dolan and Ilya Tolstoy spent a week at Rating and grew to be very fond of the Rating Regent. They found him very intelligent, charming, a crack shot on the rifle range, and an experienced horse fancier.

The expedition's last encounters before they left Tibet for China were simpler than those they had had in the great palaces of Lhasa and in the famous monasteries. Toward the end of their time in Tibet, on May 7, as they traveled on the Great Chang Plain, they met a group of unordained Kargu monks—analagous, perhaps, to lay brothers in Christian monasteries (PLATE 131). These men were driving a caravan from their monastery, Dsogchen Gompa, to another monastery, Gesche Tsuru Gompa. They were happy, serene, smiling men, dressed in simple sheepskins instead of the usual monastic robes.

Until the twentieth century Tibet had no clocks. Tibetans used the lunar calendar, which had to be altered every third year by the addition of one month. Tibetans lived in a tightly knit, medieval world. They were backward in technology, but their society and religion gave them a oneness with their world that most modern people have lost. It seemed to some people that Tibet and its way of life were eternal and frozen in time. But time did not stand still in the rest of the world. In 1959 the world of Tibet ended and there were no clocks that could turn back time and restore the place that Brooke Dolan and Ilya Tolstoy found.

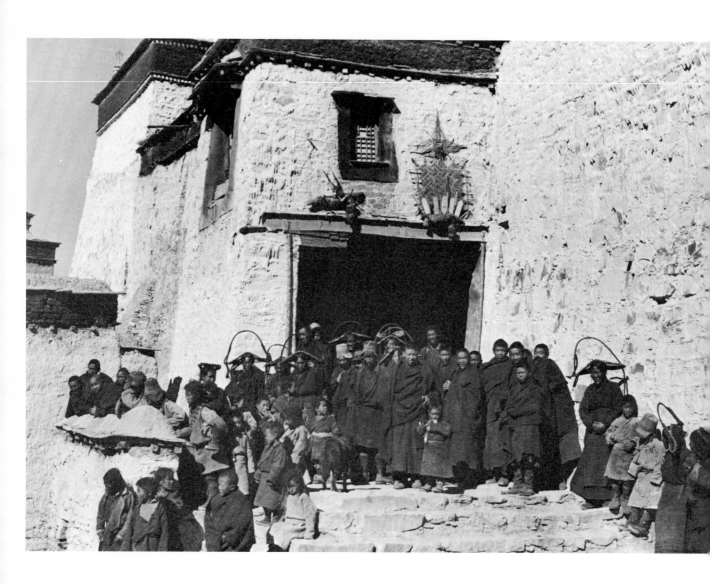

PLATE 114. *Above the entrance of Samding, the monastery of Tibet's only woman incarnation, hangs a spirit trap made from sticks woven with colored yarn. An evil spirit thus ensnared can neither enter the holy place nor escape to do more mischief. The women are wearing the traditional headdress of Tsang province, in south central Tibet.*

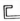

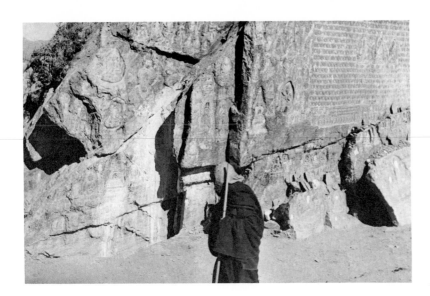

PLATE 115. *A religious pilgrim to Lhasa begins his ritual circuit of the city at the base of the Chokpuri.*

PLATE 116. *The very devout made the complete circuit of the Linghor, the ceremonial pilgrimage road that went around Lhasa, by full prostrations.*

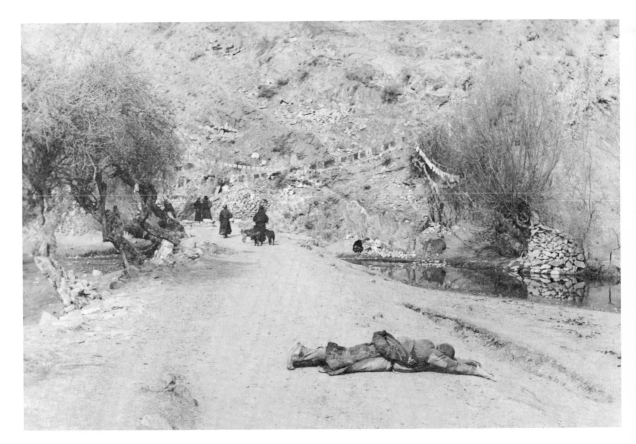

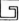

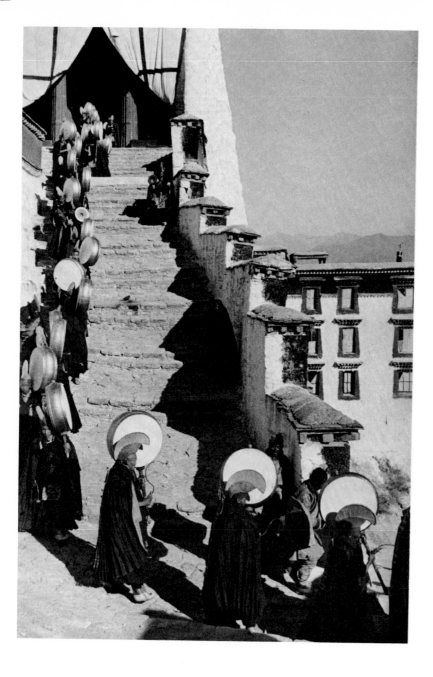

PLATE 117. *On the nineteenth day of Monlam, the monks of the powerful Gelukpa order marched in ritual procession down the steps of the Potala, each wearing a stylized yellow hat and carrying a ritual drum.*

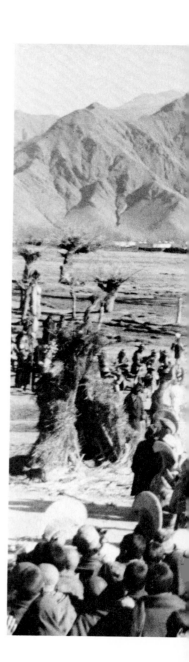

PLATE 118. *A brushwood fire was built at the foot of the steps of the Potala and* torlma *(giant butter sculptures) were offered to the fire as a symbolic means of cleansing the ills of the year just past.*

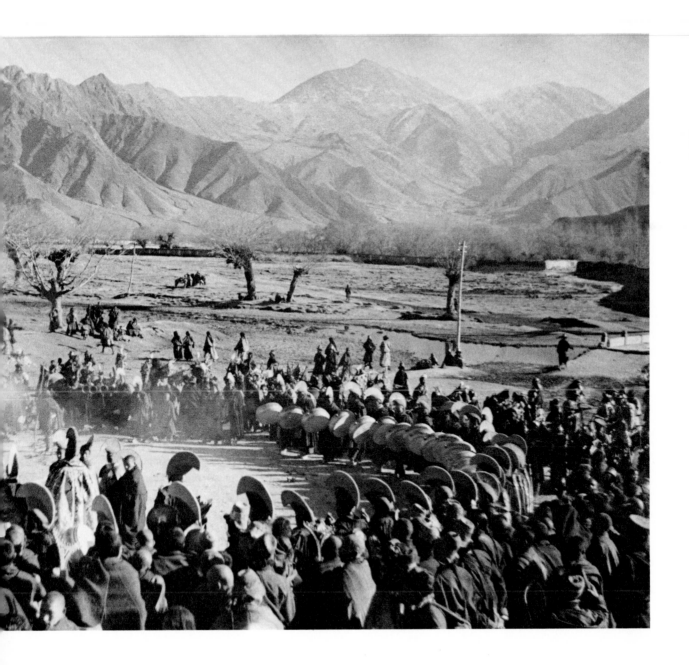

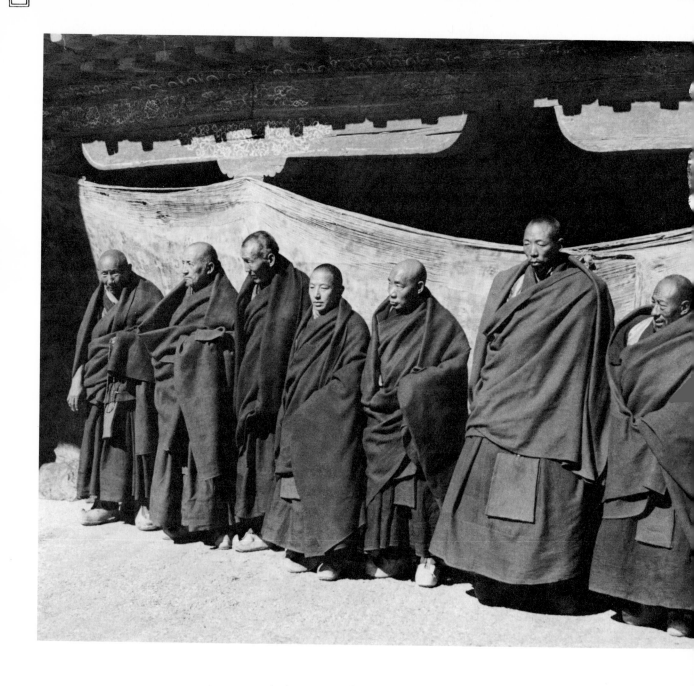

PLATE 119. *At Drepung, the largest monastery in Tibet, Brooke Dolan photographed (from left to right) the heads of the establishment's five colleges, the chanting master and the administrative head of the monastery (with traditionally padded shoulders), and a very young novice.*

PLATE 120. *The administrator of Drepung preceded by his official mace bearer.*

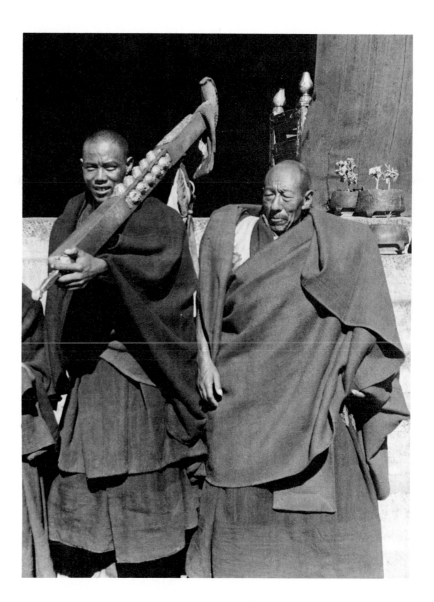

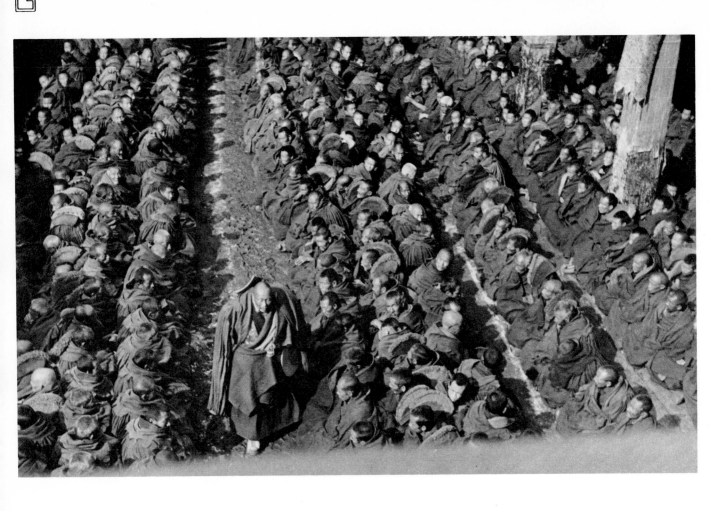

PLATE 121. *A ritual meal for thousands of monks at the Jo-kang had to be regimented to avoid chaos. The lines of white sand in front of each row of monks absorb spilled food.*

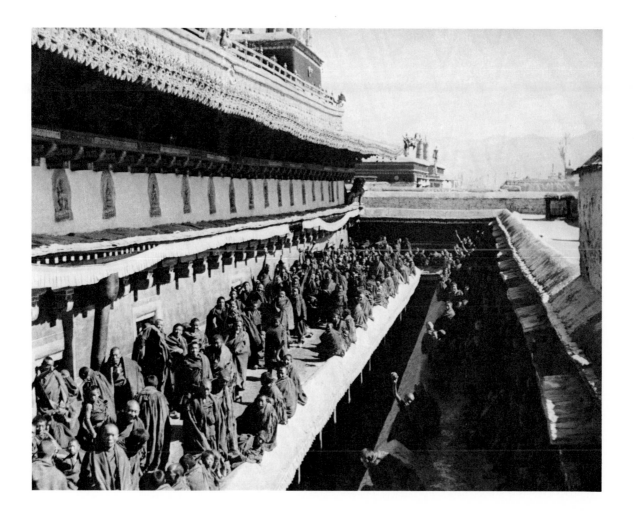

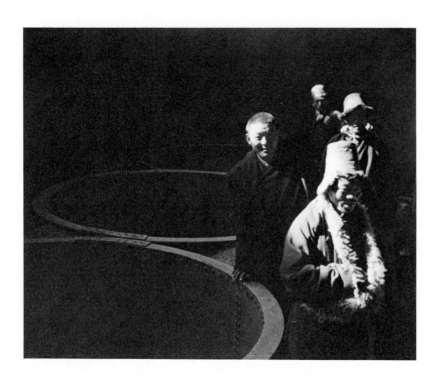

PLATE 123. *Huge caldrons of melted butter were set up at the Jo-kang during Monlam for the monks.*

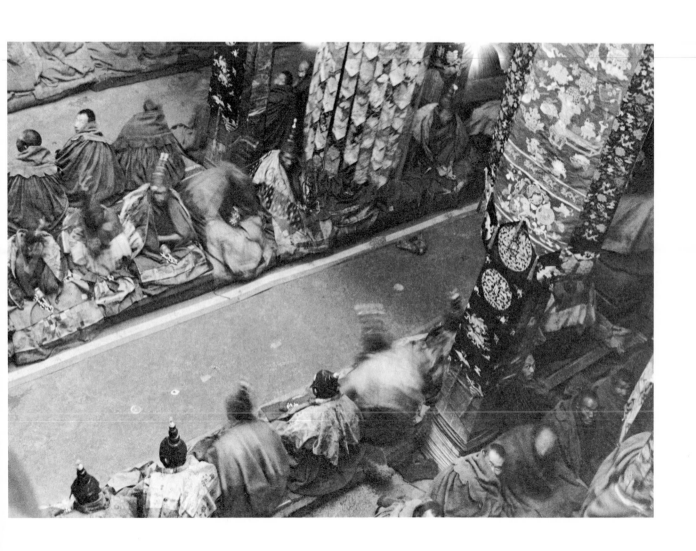

PLATE 124. *An extremely rare view of a tantric ceremony at the Nagpa College of Sera Monastery. The monks gradually "became" the tantric deity they were invoking, partly by assuming outward aspects of its appearance.*

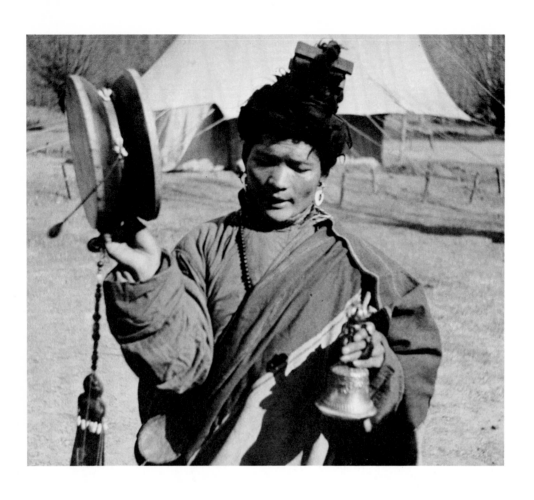

PLATE 125. *A wandering* nagpa *who is simultaneously ringing this ritual bell and drum while he chants.*

PLATE 126. *The regent of Tibet is carried in a sedan chair on his New Year's visit to the Nechung oracle, the official state oracle.*

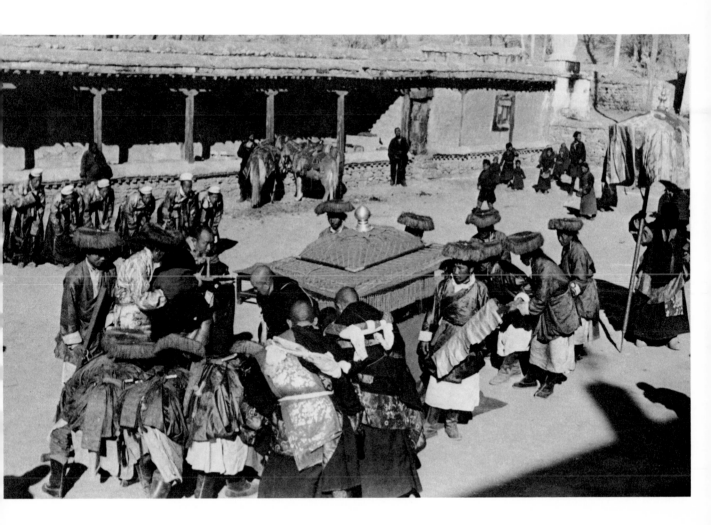

PLATE 127. *The Nechung oracle, his fabulous headdress in place, sees the future in the surface of a polished steel mirror. In the center of the mirror the Sanskrit word* khri, *which means "attention," is incised in the steel.*

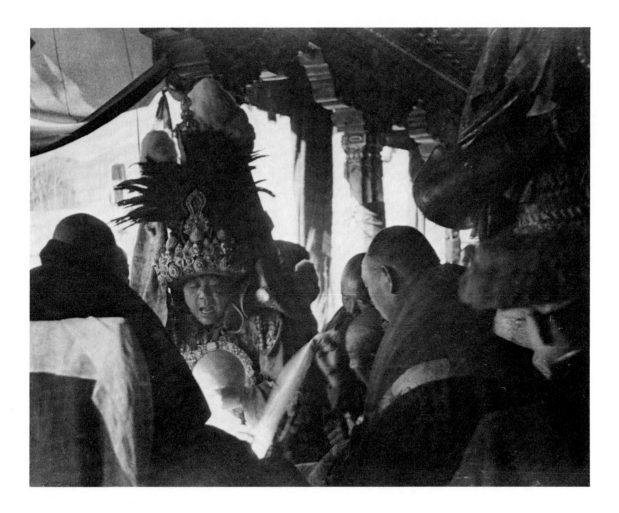

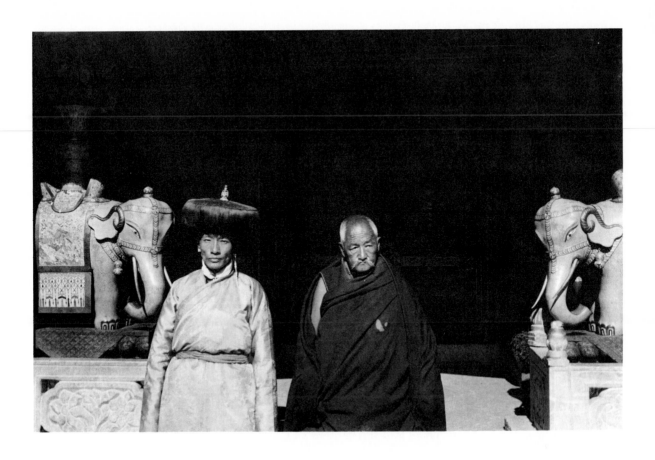

PLATE 128. *The palace's chief lay custodian (left) and its monk administrator stand before the entrance to a pavilion in the Norbulingka flanked by cloisonné elephants given to an earlier Dalai Lama by an emperor of China.*

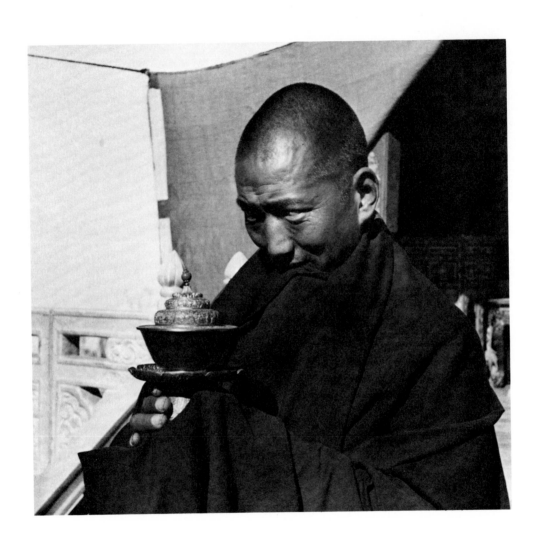

PLATE 129. *A monk holds the cup of the Dalai Lama, jade with a gold cover and stand, to be photographed in the sunlight. He carefully avoids breathing on it, so as not to profane it.*

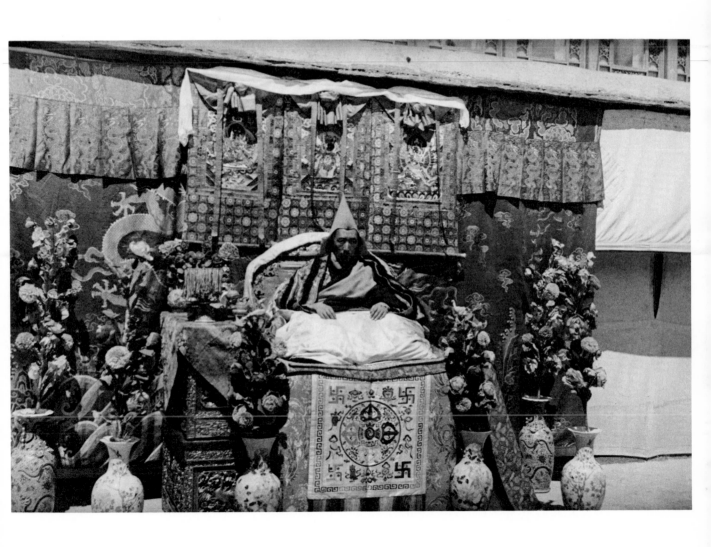

PLATE 130. *The Rating Regent on his throne. He already had stepped down as the Dalai Lama's regent but still wielded great influence in Tibet.*

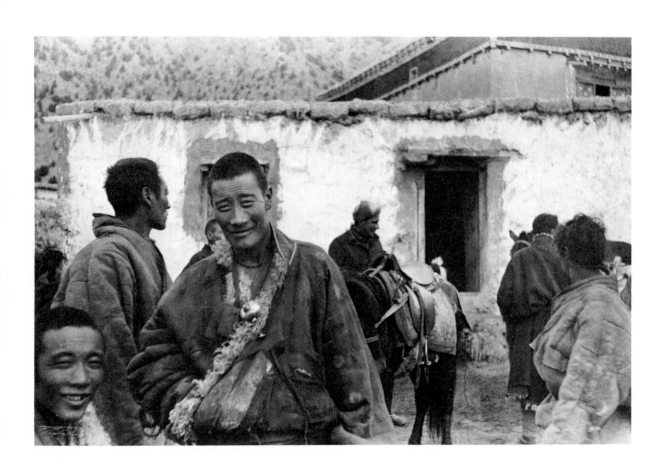

PLATE 131. *These Kargu monks in civilian dress were among the last Tibetans the Tolstoy-Dolan party met before they left Tibet and entered China. Tolstoy is saddling up in the background.*

NOTES

The citations to *Dolan* refer to the several volumes of unpublished diaries which Brooke Dolan kept on the expedition. The citations to *Tolstoy* refer to the magazine article about the expedition that Ilya Tolstoy wrote for the August 1946 issue of *National Geographic* magazine. Complete information on sources can be found in the Bibliography.

1. In the photograph of Leo Tolstoy with his grandchildren Ilya and Sophie (Plate 1), the great writer is actually telling the children his instructive tale called "The Cucumber." The text of the tale is as follows:

 > Once upon a time a peasant went to steal some cucumbers of a gardener. He crept down among the cucumbers and said to himself: "Let me just get away with a bag of cucumbers; then I will sell them. With the money I will buy me a hen. The hen will lay some eggs, and will hatch them out, and I shall leave a lot of chickens. I will feed up the chickens, and sell them, and buy a shoat—a small pig. In time she will farrow, and I shall have a litter of pigs. I will sell all the little pigs and buy a mare; the mare will foal, and I shall have a colt. I will raise the colt and sell it; then I will buy a house and start a garden; I will have a garden and raise cucumbers; but I won't let them be stolen, I will keep a strict watch. I will hire watchmen, and will station them among the cucumbers, and often I, myself, will come unexpectedly among them, and I will shout, 'Hello, there! Keep a closer watch.' "

 > As these words came into his head he shouted them at the top of his voice. The guards heard him, ran out, and belabored him with their sticks.

2. Tolstoy, *National Geographic,* p. 197.

3. Dolan, vol. 2, p. 24.

4. Tolstoy, *National Geographic,* p. 180.

5. Dolan, vol. 6, p. 176.

6. Harrer, *Seven Years in Tibet,* p. 132.

7. David-Neel, *My Journey to Lhasa,* p. 255.

8. The information on Frank Lloyd Wright's interest in the Potala was substantiated in a letter from John H. Howe, once a student of Wright's, to the author. The excerpt is from that letter.

9. Norbu, *Tibet Is My Country,* p. 132.

10. Dolan, vol. 7, p. 59A.

11. Dolan, vol. 2, p. 36A.

12. Tolstoy, *National Geographic,* p. 222.

13. Dolan, vol. 2, pp. 79A–80A.

14. Bell, *Tibet, Past and Present,* p. 188.

15. Dolan, vol. 5, pp. 107A and 109.

16. The quotation is from an interview conducted by Philip Hemley, an American, with the Dalai Lama in 1978.

17. Norbu, *Tibet Is My Country,* p. 91.

18. Shakabpa, *Tibet, A Political History,* p. 112.

19. Dolan, vol. 3, pp. 46–47.

20. This quotation from Leo Tolstoy's diaries appears in Head and Cranston, *Reincarnation: The Phoenix Fire Mystery,* p. 592.

21. Dolan, vol. 2, pp. 83A–84.

22. Dolan, vol. 2, pp. 31A–32.

23. This quotation is from an interview conducted by Philip Hemley with the Dalai Lama.

24. Dolan, vol. 3, pp. 71–72.

25. Dolan, vol. 2, pp. 144–146.

BIBLIOGRAPHY

Bell, Charles. *The People of Tibet.* Oxford: Clarendon Press, 1928.

———. *Tibet, Past and Present.* Oxford: Clarendon Press, 1924.

Dalai Lama, XIV. *My Land and My People.* New York: McGraw-Hill Book Company, 1962.

Das, Sarat Chandra. *Journey to Lhasa and Central Tibet.* London: John Marray, 1902.

David-Neel, Alexandra. *Magic and Mystery in Tibet.* New York: Claude Kendall, 1932.

———. *My Journey to Lhasa.* London: William Heinemann, Ltd., 1927.

Dolan, Brooke. *Proceedings of the Philadelphia Academy of Sciences,* vol. 90, 1938.

———. *Journals* (unpublished). 1942.

Ekvall, Robert B. *Fields on the Hoof.* New York: Holt, Rinehart and Winston, 1968.

Ford, Corey. *Donovan of O.S.S.* Toronto: Little, Brown & Company, 1970.

Harrer, Heinrich. *Seven Years in Tibet.* New York: E. P. Dutton & Company, Inc., 1954.

Head, Joseph, and Cranston, S. L. *Reincarnation: The Phoenix Fire Mystery.* New York: Julian Press/Crown Publishers, Inc., 1977.

Nebesky-Wojkowitz, Rene de. *Oracles and Demons of Tibet.* Gravenhage: Mouton, 1956.

Norbu, Thubten Jigme. *Tibet.* New York: Simon and Schuster, 1968.

———. *Tibet Is My Country.* New York: E. P. Dutton & Company, Inc., 1961.

Olschak, Blanche Christine. *Mystic Art of Ancient Tibet.* New York: McGraw-Hill Book Company, 1973.

Pallis, Marco. *Peaks and Lamas.* New York: Alfred A. Knopf, 1949.

Rato, Khyongla Nawang Losang. *My Life and Lives.* New York: E. P. Dutton and Company, 1977.

Rockhill, William Woodville. *The Land of the Lamas.* New York: The Century Co., 1891.

Shakabpa, Tsepon W. D. *Tibet, A Political History.* New Haven: Yale University Press, 1967.

Sierksma, Fokke. *Tibet's Terrifying Deities.* The Hague: Mouton, 1966.

Snellgrove, David, and Richardson, Hugh. *Tibet.* New York: Frederick A. Praeger, 1968.

Stein, R. A. *Tibetan Civilization.* Stanford, Calif.: Stanford University Press, 1972.

Taring, Rinchen Dolma. *Daughter of Tibet.* London: The Camelot Press, Ltd., 1970.

Tolstoy, Ilia. "Across Tibet From India to China." *National Geographic,* August 1946.

Trungpa, Chogyman. *Born in Tibet.* Baltimore: Penguin Books, Inc., 1971.

Tucci, Giuseppe. *Indo-Tibetica* (4 vols.). Tome: 1932–41.

———. *Shrines of a Thousand Buddhas.* New York: Robert M. McBride & Co., 1936.

Tuchman, Barbara W. *Stilwell and the American Experience in China, 1911–1945.* New York: The Macmillan Co., 1970.

Waddell, L. Austine. *Buddhism of Tibet.* Cambridge: W. Heffer & Sons, Limited, 1939.

———. *Lhasa and Its Mysteries.* New York: E. P. Dutton, 1905.